MEDIA STUDIES
A Complete Introduction

Teach
Yourself®

MEDIA STUDIES
A Complete Introduction

Joanne Hollows

First published in Great Britain in 2016 by Hodder and Stoughton. An Hachette UK company.

This edition published in 2016 by John Murray Learning

Paperback 9781473618985

eBook 9781473618992

1

The publisher has used its best endeavours to ensure that any website addresses referred to in this book are correct and active at the time of going to press. However, the publisher and the author have no responsibility for the websites and can make no guarantee that a site will remain live or that the content will remain relevant, decent or appropriate.

The publisher has made every effort to mark as such all words which it believes to be trademarks. The publisher should also like to make it clear that the presence of a word in the book, whether marked or unmarked, in no way affects its legal status as a trademark.

Every reasonable effort has been made by the publisher to trace the copyright holders of material in this book. Any errors or omissions should be notified in writing to the publisher, who will endeavour to rectify the situation for any reprints and future editions.

Cover image © Shutterstock.com

Typeset by Cenveo® Publisher Services.

Printed and bound in Great Britain by CPI Group (UK) Ltd., Croydon, CR0 4YY.

John Murray Learning policy is to use papers that are natural, renewable and recyclable products and made from wood grown in sustainable forests. The logging and manufacturing processes are expected to conform to the environmental regulations of the country of origin.

Carmelite House
50 Victoria Embankment
London EC4Y 0DZ
www.hodder.co.uk

Also available in ebook

Contents

How to use this book

This Complete Introduction from Teach Yourself® includes a number of special boxed features that have been developed to help you understand the subject more quickly and remember it more effectively. Throughout the book, you will find these indicated by the following icons.

 The book includes concise **quotes** from other key sources. These will be useful for helping you understand different viewpoints on the subject, and they are fully referenced so that you can include them in essays if you are unable to get your hands on the source.

 The **case study** is a more in-depth introduction to a particular example. There is at least one in most chapters, and hopefully they will provide good material for essays and class discussions.

 The **key ideas** are highlighted throughout the book. If you only have half an hour to go before your exam, scanning through these would be a very good way of spending your time.

 The **spotlight** boxes give you some light-hearted additional information which will liven up your learning.

 The **fact-check** questions at the end of each chapter are designed to help you ensure you have taken in the most important concepts from the chapter. If you find you are consistently getting several answers wrong, it may be worth trying to read more slowly, or taking notes as you go.

 The **dig deeper** boxes give you ways to explore topics in greater depth than we are able to go to in this introductory level book.

1

Introduction: Why Study the Media?

For most people in developed societies, it is difficult to imagine life without the media. They are a fundamental part of contemporary life. Indeed, rather than ask why we should study the media, it might make more sense to ask why on earth we wouldn't want to make sense of them.

Unless you reached for this book the moment you woke up, it's highly likely that you will have engaged with a range of media today. It is worth taking a moment to make a list of all those you've used and encountered in the past 24 hours.

The first thing to notice about your list is *which* media you have encountered. You have probably been confronted by a wide range of forms. You may have used Twitter, turned on the TV for a favourite show, listened to a podcast, played games on your phone, checked out online news or read a magazine. Some of your encounters with the media might have been more accidental. There may have been a radio on in the café, billboards along the side of the road, MTV in the gym, a video about healthy eating in the doctor's waiting room, a free newspaper through your letterbox or music in the elevator.

This quickly alerts us to the fact that the media are not one thing. The word itself is the plural of the word 'medium'. There are a wide variety of media forms and we need to understand what makes them different as well as what they have in common.

The second thing you may notice about your list is just how much the media saturate our lives. They are part of the experience of living in the modern world. To understand the significance of this, it is worth imagining a day *without* the media. What would that day be like? What wouldn't you be able to do?

It should become clear that media and communications devices are central to your everyday life and part of the structure of your days. Your smartphone may be your alarm clock. By the

time you've eaten breakfast, you may have checked email, messages or social media such as Facebook or Twitter, listened to the radio, watched TV or checked out online news.

This raises a third issue in relation to your list: *why* have you used different media? Media play a wide range of roles in modern society. You might have used different forms for information or entertainment, to kill time, to maintain connections with friends and family or to express your opinion. If you start to pick these activities apart, they become increasingly complex. Seeking out information can take a variety of forms. You might want to know about a war on the other side of the world or whether your local football team won, about this summer's must-have shoes or how to cook a chicken, about the crime wave in your town or your friend's blind date.

This helps us to understand how many people depend on the media in modern societies. They use the media for information, for pleasure and leisure, for continuity and security. If you were to spend a day without media, you would probably feel unsettled and disoriented. Without a sense of connection, you might quickly feel lonely and excluded from wider society.

Media are entangled with our experience of the modern world. This means media have considerable power over our lives. Media Studies aims to make sense of these issues.

Spotlight: Time for media and communications

A study by Ofcom in 2014 (Ofcom 2014a) revealed that people in the UK spend more time 'using media and communications' than they spend asleep. On average, UK adults spend 8 hours 41 minutes per day on media and communications. In 2013, 3 hours 52 minutes of that time was spent watching TV. Radio listeners spent an average of 21.5 hours a week on the activity.

Ten reasons why we should study the media

How do we assess the ways in which the struggles over and within the media are played out: struggles over the ownership and control of both institutions and meanings; struggles over access and participation; struggles over representation; struggles which inform and affect our sense of each other, our sense of ourselves?

Roger Silverstone 1999: 5

1 **The media are a crucial source of information and knowledge about the world.** When they want information, many people will turn to the media for an answer. Because we have little direct experience of most aspects of the world, media have considerable power to shape what we know – and how we think – about it. This makes it essential that we understand how media construct knowledge and the nature of the power they exert over our lives.

2 **The media play a key role in the political life of modern societies.** Many commentators argue that the media should provide space for information, debate and public participation. These functions are indispensable in democratic societies. If these functions are not fulfilled, it can have a profound impact on how societies are governed and how power is exercised.

3 **We need to understand who owns and controls media production.** In some nations the government owns the media, but in much of the world they are owned by a small number of large corporations. The activities of the people who own the media – and the people who work for them – shape the texts that are produced.

4 **We need to understand who has access to the media.** Not everyone has the opportunity to produce media texts. Media

Studies investigates who can participate in media cultures and whether the media represent the views and experiences of a diverse range of people. Similarly, not everyone has the same opportunities to use media. Media Studies examines whether the media address all types of audiences and whether different social groups have the same access to the media.

5 **The media play a key role in defining values and ideas.** Media representations shape how people understand, experience and live in the world. It is crucial to study them in order to understand which values and ideas are defined as being important and which are marginalized.

6 **Media representations shape how people understand identities.** They shape how we view ourselves and other people. The media can unite a group around common identities and common aims but can also produce divisions and conflict.

7 **We need to assess whether, and how, media should be regulated.** Some commentators argue that there is little need for regulation. However, many others argue that the media have so much power in society that it is essential to regulate their actions and practices. Media Studies therefore involves thinking about whether the media should have particular responsibilities and how we should guard against the misuse of media power.

8 **We need to understand what impact media have on audiences.** We cannot understand how media shape modern life if we do not understand how people use and make sense of them. Audiences are not just passive consumers of the media but actively engage with, and interpret, media texts.

9 **The media shape the experience of everyday life.** People use the media in living rooms, cafés, cars and workplaces, alone or with families or friends. It is necessary to understand how media shape people's experience of the world around them.

10 **The media are an important employer.** You may be reading this book because you want a career in the media. If this is the case, it's crucial that you understand the media industries and the impact they have on society. This will help you to think about what contribution you could make to the media.

What does Media Studies involve?

A common misconception about Media Studies is that it involves little more than the everyday talk about the media that most people engage in. In fact, similar concerns were once raised about the study of literature. Commentators asked why literature needed to be an academic discipline when everyone could debate the merits of a good book.

Talking about media is not the same as studying them. We might discuss the plots of favourite TV shows, make judgements about good and bad movies or ridicule magazine stories about celebrity diets. There is nothing wrong with these discussions but it is not the same as doing Media Studies.

It is the sheer familiarity of media that can make them so challenging to study. Media Studies demands that you adopt new ways of looking at the familiar. The theories, methods and approaches that you will encounter in this book will help you to do this.

[M]edia are the starting point, not the sum, of media studies. Analysis of the media provides a means of investigating the politics, economy, culture, social relations and imaginative life of society... This requires students to assimilate different areas of knowledge and to make sense of different disciplines with distinctive technical terms and referents. Far from being a soft option, this is enormously demanding.

James Curran 2013

Media Studies is interdisciplinary. It brings together theories, methods and approaches from a wide range of subjects in order to make sense of the media. This requires you to engage

with ideas from sociology, economics, history, literature and politics. Although Media Studies has now established its own theories and methods, its approaches are still informed by a range of disciplines.

Media Studies requires you to always look at the media in context. One of the reasons that Media Studies is interdisciplinary is because it rarely only involves studying just the media. We cannot understand their significance without thinking about their wider role in our society and culture.

Doing Media Studies involves getting to grips with theories. Although initially theory can seem intimidating, all theories are simply an attempt to make sense of 'what is going on' (Williams 2003: 16). Theories are explanations of how and why things happen.

Sometimes students find Media Studies frustrating because there are lots of competing answers to a single question. This shouldn't really surprise us. People often explain the same phenomena in different ways. You need to be prepared to evaluate different theories and assess which offers the most convincing explanation.

Media Studies can be challenging because media often appear to be in a state of continual change. Contemporary media landscapes seem very different to those of twenty years ago. However, it is important not to be so focused on what is new that we miss continuities with the past. Although new media technologies and genres emerge, they often have much in common with older technologies and genres. Studying the media involves engaging with reoccurring patterns as well as novelty.

This book examines more established forms of media, such as television and the press, alongside relatively new forms of digital media. However, the boundaries between 'old' and 'new' media are often blurred. You need to be aware of both the similarities and differences between broadcast TV and streaming services such as Netflix, printed newspapers and online news.

Spotlight: A 'Mickey Mouse' subject?

James Curran observes how the British press often condemn Media Studies as a 'Mickey Mouse' subject (Curran 2013). Media Studies is caricatured as just commonsense chat or narrow training in vocational skills. The press often use a logic that suggests that because a reality show is lightweight entertainment, studying a reality show must be lightweight education. These articles misrepresent Media Studies and are ignorant of what students taking a degree in it actually do. Think about what you've already learned is involved in Media Studies. How would you defend the subject?

The structure of this book is based on a model called 'the circuit of culture' (du Gay et al. 2013). The circuit is made up of five processes: production, regulation, representation, identity and consumption. By exploring the media in relation to these different processes you can examine them from a wide range of perspectives.

The book takes you through the circuit of culture, starting with media production. You should quickly notice, however, that these processes are not easily separated; they form a circuit where everything is connected. A discussion about production quickly raises issues about how it is regulated, the types of texts or representations that get produced and for whom media industries produce texts.

In Media Studies, 'text' does not just refer to written texts such as novels or messages. A text is anything that is primarily organized around communicating meanings. It could be a film, a song, an advert or a website.

Each chapter of the book introduces you to key ideas and theories from a particular area of Media Studies. However, you are also encouraged to make connections between different aspects. If you are studying for a degree, this will help you see how different parts of your course are inter-related. More generally, it will allow you to develop a sense of 'the bigger picture' and to build your knowledge of the wide range of relationships between media and society.

Dig deeper

Albertazzi, Daniele and Cobley, Paul (2009), eds, *The Media: An introduction*, 3rd edition, London: Routledge.

Branston, Gill and Stafford, Roy (2010) *The Media Student's Book*, 5th edition, London: Routledge.

Hodkinson, Paul (2011) *Media, Culture and Society: An introduction*, London: Sage.

Long, Paul and Wall, Tim (2012) *Media Studies: Texts, production, context*, 2nd edition, London: Routledge.

Williams, Kevin (2003) *Understanding Media Theory*, London: Bloomsbury.

2

Histories of Media and Communication

The media are often associated with the new. Press reports celebrate the launch of new Apple products. Apps offer to change our lives. Blockbuster movies are associated with the latest technologies. Cable and satellite providers compete to offer us new media experiences.

This emphasis on the new leads to a view of media history as relentless and continuous change. Once you study media, however, you quickly learn that their history is characterized by both change and continuity. As James Curran argues, older media forms and practices still have a presence in contemporary forms and practices (Bailey 2009).

Some debates about the role of media in society have been replayed across centuries. Studying this history will help you identify recurring patterns and themes and help you to understand contemporary media.

Media history is a huge sub-field within Media Studies. There isn't space in this book to begin to do justice to some of the excellent work in this area. Different media forms, such as radio, TV and newspapers, have their own detailed histories and these vary across countries. Because the media are products of specific contexts, it is unsurprising that different media have different histories in different places.

This chapter, therefore, has modest ambitions. It begins by offering you a sketch of when various media forms, from printing to the Internet, developed. If you're studying the subject for the first time, this is invaluable. Without this information, it's easy to make inaccurate guesses about the development of different media.

However, knowing when something developed doesn't tell us much about its significance. History isn't just about facts and dates. As you move through the chapter, you'll encounter different interpretations of how the media developed. These interpretations will help you to start to think about the significance of media in society.

This chapter will help you to understand:

▶ The extent to which media technologies cause change.

▶ How changing media forms relate to different types of communication.

▶ How changing media provoke fears about their impact on society and culture.

▶ How the history of the media relates to questions about politics and democracy.

Key idea

The history of the media is characterized by both change and continuity.

An extremely brief history of the media

Many people associate the birth of the media with the development of the printing press in the 1450s. Although printing already existed, this was when Johannes Gutenberg invented moveable type which enabled more things to be printed far more quickly and cheaply. Ideas could be distributed on a much wider scale than before.

Issues related to the impact of commerce on media, and about access to media, were evident even in these early stages. First, most of the new printing presses that opened up were commercial enterprises. From the outset, the media were caught up in a system in which texts were produced to be sold. Second, cheaper printing didn't mean that most people had access to books and pamphlets. The ability to read was largely restricted to elite groups and the cost of books was prohibitive for most people.

The time spans of the development of newspapers, radio and television are quite different. Newspapers as we know them in North America and Europe can be traced back to the Seventeenth century. The technology of wireless telephony was worked out in the late Nineteenth century, and its widespread social application as radio begins after World War 1. The technology of television dates from the early Twentieth century, and the history of its social usage begins properly after World War 2.

Paddy Scannell 2002: 199

NEWSPAPERS

By the end of the seventeenth century, with increasingly regular postal services in some countries, print was used to spread news. Regular weekly journals developed during this period. *The Daily Courant*, the first regular English daily newspaper, was founded in 1702 and the first British Sunday newspaper, *The British Gazette and Sunday Monitor*, in 1779. These early newspapers were largely restricted to the middle classes. They were relatively expensive to purchase and often shared in public spaces such as coffee houses.

Between the late eighteenth and mid-nineteenth centuries, newspapers boomed. New titles championed working-class political causes, and newspapers in general played a vital role in political life.

By the end of the nineteenth century, this had changed. Ownership of newspapers was concentrated in the hands of powerful groups and individuals. Advertising became increasingly important. Most newspapers were businesses whose primary purpose was to make money.

CINEMA

The first short films were projected in the 1890s to fascinated audiences. Early films were often treated as curiosities, shown at fairs and on nickelodeons. Although films were shown in theatres in the 1890s, the first purpose-built movie theatres were opened in the early 1900s. The major film producer at this time was the French company Gaumont who developed

sensationalist short movies such as 'chase films'. In the US, the establishment of film exchanges in the early 1910s enabled exhibitors to hire films –
rather than purchase them – laying down the blueprint for future film distribution.

The first feature films were exhibited in the 1910s and changed the reputation of cinema. For example, *Birth of a Nation* (1915) was considered to be an epic, prestigious film. By 1920, 50 per cent of Americans went to the movies on a weekly basis. US film production boomed during the 1920s in the 'Golden Age' of the Hollywood studios. The public were fascinated by the glamorous lives of stars such as Rudolph Valentino and Greta Garbo.

BROADCASTING

Regular radio broadcasts started in nations such as the US and the UK in the 1920s. Radio was viewed as a powerful medium because it reached into people's homes.

In the UK, the government decided that a single organization should be given responsibility for broadcasting. The British Broadcasting Company, the BBC, was founded in 1922. By 1927, it had become the British Broadcasting Corporation and operated under a Royal Charter. It was funded by a licence fee that owners of radios were required to purchase. These arrangements were meant to ensure that the BBC was free from political pressure from the government.

A rather different model was adopted in the US where there was little attempt to regulate who could broadcast. The number of radio stations proliferated, resulting in overcrowded airwaves. US radio also developed under a very different economic model. Early broadcasters were commercial enterprises, funded by selling airtime to businesses who wanted to advertise their products and services. The US and the UK, therefore, established very different models of broadcasting. Commercial radio did not start in the UK until 1973.

Some similar patterns emerged in relation to television. In 1929, the BBC was given permission to develop an experimental TV service and it started to trial regular broadcasts in 1936. These were halted during World War II and resumed in 1945.

However, radio remained the dominant media form for many years. Indeed, despite the novelty of television, many early TV series were based on formats that were first developed for radio.

The coronation of Queen Elizabeth II in 1953 is often considered to be the first major television event in the UK. At this stage, less than one third of households had a television but estimates suggest that 50 per cent of the population watched the ceremony, gathering in the homes of people who had a TV set.

The BBC's television broadcasts were funded in a similar way to radio. Television owners were required to purchase a TV licence. However, the BBC's monopoly ended in 1955 when the government allowed a new commercial television channel, ITV, funded by revenue from advertising. Although the BBC launched a second channel (BBC2) in 1964, there wasn't a second commercial channel until the launch of Channel 4 in 1982.

Regular broadcasting took off at a slower pace in the US but quickly gained momentum. Like radio, most US television was based on a commercial model that was funded by advertising. TV stations were far more localized than in the UK and the number of TV stations proliferated much more rapidly. By 1955, 50 per cent of US households had a TV set.

THE INTERNET

The Internet is based on the technical ability to connect computers through high-speed networks. These networks are used for a wide range of content and forms of communication. Although the development of these technologies dates back to the 1960s, widespread use of the Internet is associated with the development of the World Wide Web and web browsers in the 1990s. Whereas most media developed at national levels, the Internet is a 'global communications medium' (Flew 2014: 9).

In the mid-2000s, the term 'Web 2.0' was used to describe a new phase in Internet history. This development was marked by increased opportunities for participation, interactivity and social networking, commonly associated with sites such as YouTube, Wikipedia and Facebook. This period is also associated with the increasing commercialization of the Internet (see Chapter Five). More established media forms such as

television and newspapers were increasingly delivered through the Internet.

Technological determinism

People often claim that new media technologies have revolutionary effects on society. For example, some commentators argue that the 'print revolution' created the modern world by enabling the widespread circulation of ideas. More recently, many social changes have been attributed to the 'Internet revolution'. In both cases, the claim is that new media technologies cause fundamental changes in society.

The idea that technology is the primary cause of change in society is known as technological determinism. Claims that the Internet, for example, has revolutionized life as we knew it make it appear as if technology is separate from society. It seems as if new technologies come along and fundamentally change the way we operate. From this perspective, media technologies determine the history of both the media and society more generally.

This might seem like a seductive idea but it is based on strange assumptions. Media technologies are a product of society. Each stage of their production involves people making complex decisions about what form the technology should take, how it should work and what functions it should have.

For example, portable transistor radios offered an inexpensive and popular way to listen to radio broadcasts in the 1960s and 1970s. However, some people argue that these devices could have been easily manufactured to allow two-way – rather than one-way – communication. The nature of this technology was shaped by the decisions that made radio primarily a one-way system of communication.

Technologies are shaped by society, and this means that they cannot be the sole force driving changes in it. This is not to say that media technologies have no effects, but the effects they have are influenced by how they are designed, produced, distributed and used. These are all the result of social and cultural processes.

Spotlight: What is recording tape for?

The history of the music industry is littered with technologies that were not used for their original purpose. Magnetic tape was used as part of the recording process in the 1950s. Initially, record producers were enthusiastic about tape recording because they believed it would help them to faithfully capture the sound of a live orchestra. By the 1960s, it was used in pretty much the opposite way: pop producers used tape to generate studio sounds that would have been impossible to create live (Frith 1986).

Key idea

Technological determinism, the idea that technology is the primary driver of change in society, is problematic because technologies are created through social and cultural processes.

Changing modes of communication

A useful way of understanding the history of the media is to examine how changing media intersect with different modes of communication. As we shall see, although new media forms are used to create new forms of communication, this does not mean that older forms of communication disappear.

Raymond Williams (1966: 17) defines communication as 'the process of transmission and reception'. In order for ideas to be communicated, they must be passed on from at least one person to at least one other person. But transmission is only one half of the equation. In order to be received, communications must be picked up and interpreted by people.

Key idea

Communication requires messages to be both transmitted and received.

The way ideas and information are communicated is shaped by the form they take. For example, a tweet is different to a letter, a movie or a song. Institutions can also shape the process of communication. For example, publicly funded broadcasting associated with institutions like the BBC may have different values and practices to commercial broadcasters such as the Fox Broadcasting Company.

Small-scale societies that primarily communicate via speech are associated with face-to-face conversation. Here, communication is usually a two-way process (although we all might recall situations when it feels like people are just talking at us). Face-to-face conversation is still a central part of everyday life for most people even though modern societies have developed much more complex forms of communication.

For societies that largely rely on face-to-face communication, people need to be in the same place at the same time to pass on ideas and information. Prior to fast transport links, this made it difficult to communicate over large distances. Ideas could only be transmitted across generations by word-of-mouth, usually by people who shared the same geographical location.

When systems of writing developed, then ideas were no longer as tied to time and place. Written communication enabled them to be recorded for future generations. By writing a message, someone could directly communicate over a distance with other people. These forms of communication depended on literacy – the ability to read and write – which was largely restricted to elite groups.

People used printing to create new forms of communication. The spread of books – and later newspapers – enabled people to share ideas and distribute them on a much wider scale. Even in the seventeenth century, there was a sense that distances were shrinking as newspapers spread reports of events across Europe. Ideas were exchanged at an increasing speed. As daily papers became more familiar, people came to expect up-to-date and regular news.

Broadcasting had a major impact on the speed and scale of communication. For the first time, events at a distance could be shared pretty much simultaneously with people across a wide geographical space. This produced a sense of the world speeding up as information became more immediate. It also made the world seem as if it was shrinking because news of distant events could be relayed into people's homes.

Broadcasting was the first real form of mass communication. Radio and television brought together large audiences who listened to and watched the same broadcast. This didn't just connect people to distant events but also created relationships between audience members who shared experiences in common.

Spotlight: The 1969 moon landing

Broadcasting can create events shared by millions of people. In 1969, over 500 million people worldwide watched television as Neil Armstrong walked on the moon. If radio listeners are included, an estimated 25 per cent of the world's population was part of the audience for the event.

Mass communications are associated with a one-to-many model of communication. Media forms such as TV are largely one-way modes of communication. While some shows allow audiences to participate or air their comments, there is little opportunity for them to engage in a dialogue. People can talk back to television programmes in their living rooms but there are few opportunities for them to engage in two-way communication with broadcasters.

Because broadcasting was based on a mass and one-way form of communication, there were fears about the power of the media over audiences. Radio and TV gave political figures direct access to the audiences' living rooms. As you will learn later in this chapter, there were widespread concerns about the potential for leaders to abuse this power. There were also fears that broadcasting offered advertisers tremendous power over audiences.

Internet technologies create opportunities to challenge these one-way flows. Web-based applications offer people the opportunity to talk back to more established forms of media. For example, online newspaper articles can provoke thousands of comments creating a sense of dialogue. Other sites enable people to publish and spread news stories ignored in mainstream media.

The Internet has enabled new forms of many-to-many communication. Increasing numbers of people have the opportunity to share their writing, music and videos with large audiences through applications such as blogs and YouTube. This increases the number of voices in the media.

At the same time, web-based technologies are used to maintain other forms of communication. Applications such as Skype enable forms of one-to-one, face-to-face communication at a distance. Television networks use the Internet to stream their programmes, maintaining existing forms of one-to-many communication.

Some commentators argue that the Internet offers people the opportunity to take back power over the media. More people can produce media content and share their views and ideas with other people. Unlike earlier media forms, they claim, web-based technologies enable mass participation in media production. In Chapter Five you will explore whether or not there are grounds for such optimistic views.

Key idea

Broadcasting is associated with a one-to-many form of mass communication.

Fear of the media

The history of the media is also a history of fears about the media. Each new technology brings fears about the dangers it poses to society. You may be familiar with stories about the dangers of computer games or social networking, but earlier

commentators warned about the threat to society posed by newspapers and novels. You will get the chance to explore contemporary panics about the media in Chapter Thirteen.

> *The centrality of the mass media in everyday life has led people to blame the media for a range of social ills ... Complaints about the influence of the mass media are often underpinned by the assumption that this is something new. However, history shows that the emergence of every new medium of mass communication or popular amusement has been accompanied by great claims about the impact of the medium on the behaviour of men, women and children as well as on the values and mores of society.*
>
> Kevin Williams 2010: 1

Although 'the media' is a term that we use widely today, it did not become common until the 1960s. Early debates about forms such as television and radio often used the term 'mass communications'. These debates were an attempt to make sense of the impact of the media in what felt like a rapidly changing world. Although some of the concerns about the power of broadcasting might appear strange to you, remember that contemporary fears about social networking or videogames may appear similarly strange to future generations.

The rest of this section introduces you to three key fears about the media that emerged from the late nineteenth century onwards.

1 **The media threatens high culture.** Some commentators argued that the media threatened to wipe out high culture. High culture, they argued, connected people to timeless values such as truth and beauty. These values were viewed as being indispensable to a healthy society.

The media were associated with what these commentators called 'mass culture'. For them, mass culture wasn't really culture at all. It was mass-produced, thoroughly commercial and offered cheap entertainment rather than connection to timeless values.

These critics were particularly concerned about the popularity of sensational novels and films that had working-class audiences. They argued that, as the working class embraced these new forms of popular culture, they would lose all connection to 'proper' cultural values. Such critics believed that the working class needed to be educated to appreciate high culture.

In many ways, these were also concerns about the 'dumbing down' of culture that are still alive today. For example, there are complaints about the way news stories are increasingly sensational and entertaining rather than informative. Likewise, claims that Media Studies is a 'Mickey Mouse' subject link the very study of media to the 'dumbing down' of education.

These representations of popular media texts as a threat to high culture are problematic. Intellectuals who make these claims often use their own privileged position to dismiss the tastes of those who are not like them. As you move through this book, you'll encounter further arguments that will help you to challenge these ideas.

2 **The media change people's behaviour.** Another set of concerns focused on the effects of the media on audiences. These fears grew following the creation of a mass audience for broadcasting. Commentators worried about how the media shaped people's behaviour and how the audience might react as a group.

These claims rested on two key assumptions. First, critics assumed that media texts were homogenized and lacked complexity. Because the media were run as an industry, critics thought media texts were mass-produced and standardized, just like other industrial products such as cars. Such texts, they argued, didn't require their audiences to think because the audience's reaction was built in.

Second, commentators assumed that audiences passively consumed media. They argued that the audience simply absorbed media messages. This was not just because texts were standardized with audience reactions built in but also

because audiences were often portrayed as mindless, gullible and easily persuaded.

In this book, you will encounter research that challenges these ideas about media texts and media audiences so please do not accept them at face value! But what is key is the idea that the media create a mass of viewers who are unthinking and easily controlled. This is the basis of a whole series of fears about the media's effects on behaviour, and has led to concerns which are still widespread today.

3 **The media can be abused by the powerful.** Because many critics believed audiences were passive and gullible, they argued that they were therefore vulnerable to political influence. This provoked a variety of fears about how the media could be used to seize or maintain political power.

These worries are understandable. In the 1930s and 1940s, critics were trying to make sense of the rise of fascism in nations such as Germany. They feared that the media could be instrumental in creating a mass of supporters for dangerous political regimes.

Two of the best-known theorists of the political consequences of the rise of the media were the German thinkers Theodor Adorno and Max Horkheimer. They were Jewish and left-wing intellectuals who fled from Nazi Germany to the US in the 1930s. In their new home, they identified a mass-produced media culture which, they argued, had dangerous political consequences.

Like many other thinkers of the period, Adorno and Horkheimer (1997) believed that media texts did not require their audiences to think. Instead, they argued, texts compelled people to react to them in particular ways. For these theorists, media texts teach audiences to conform and condition them to accept their domination by other people.

The power of the media over a conforming audience offered an explanation of how fascist movements could gain power. However, Adorno and Horkheimer also identified how the media maintained the domination of a powerful ruling class.

By teaching audiences to conform, media texts taught people to accept inequalities and do nothing to resist them.

Fears about the political power and influence of the media have not disappeared. As you progress through this book, you'll encounter a range of concerns about the power of the media and its relationship to political life. The next section introduces you to some of these ideas.

Key idea

There is a long history of fears about the media's power to destroy high culture, to transform people's behaviour and to condition audiences to conform to political regimes.

Spotlight: The Martians are coming

On 30 October, 1938, the US radio station CBS broadcast a radio dramatization of H. G. Wells' science fiction novel about a Martian invasion, *The War of the Worlds*. The radio broadcast interrupted the drama with simulated news reports, documenting the invasion. After the broadcast, newspaper headlines reported how a terrified nation panicked because they thought the invasion was real. This was used as proof of the power of the media and how audiences would believe anything they heard. However, it turns out to be a myth and there is little evidence of a mass panic. The story may instead have been a panicked response by the newspaper industry to the threat posed to its profits by radio (Campbell 2011).

Politics and democracy

Many debates about the media, past and present, focus on the role they play in political life. One central concern is about the media's role in democratic societies. For media to function effectively in political life, they should enable a free exchange of ideas rather than serving the interests of powerful groups.

> *There are two related considerations: the right to transmit and the right to receive. It must be the basis of any democratic culture... that these are basic rights... On the right to transmit, the basic principle of democracy is that since all are full members of the society, all have the right to speak as they wish... This is not only an individual right but a social need, since democracy depends on the active participation and the free contribution of all its members. The right to receive is complementary to this: it is a means of participation and common discussion.*
>
> Raymond Williams 1966: 128–9

Raymond Williams raises fundamental questions about the role of the media in a democratic society. In theory, democratic societies should allow all citizens the right to participate in the communication process. They should have the opportunity to both voice their ideas and have access to the ideas of other people.

The history of the media often demonstrates that there are declining opportunities for ordinary people to participate in public discussion. For example, the range of viewpoints in the press declined as ownership was increasingly concentrated in the hands of powerful people (see Chapter Six).

People cannot participate in media communication if they cannot 'receive' media. They must be able to understand, to access and to use the media. As you have already learned, literacy rates had a significant impact on who could read books and newspapers. However, reading written texts is not the only form of literacy. Different media demand different forms of literacy, which people do not always possess. For example, 20 per cent of the British population lacked basic online skills in 2014.

People's opportunities to use the media also depend on their access to texts. As the history of the press demonstrates, economic inequalities shape people's ability to buy a newspaper. However, access is not simply about whether people can afford to purchase media texts and technologies. For example, weak transmitters meant that parts of the UK did not receive any television until at least the mid-1950s. This parallels more recent issues surrounding the availability of broadband.

Key idea

In democratic societies, media communications should allow all people the right to both express and receive ideas.

Case study: British newspaper history: Power, politics and freedom

Established histories of the British press construct a narrative in which newspapers increasingly win freedom from state control and gain freedom of expression. By imposing taxes on newspapers, the government aimed to make them more expensive and prevent the spread of revolutionary ideas. By the mid-nineteenth century, the press had won the battle against high taxes. From this point on, it is often argued, newspapers had independence. They could represent the people, speak out against the abuse of power and criticize the government.

James Curran challenges this traditional view of press history. While the press might appear to have won one form of freedom in the mid-nineteenth century, he argues, this was undermined by new forms of control and censorship. As newspapers became more dependent on revenue from advertising, they lost any radical edge because they attempted to please advertisers and increase profits.

The increasing reliance on advertising revenue, Curran argues, killed off the truly radical elements of the British press. From the late eighteenth century through to the mid-nineteenth century, there was a thriving radical press in the UK. Despite concerted attempts by the state to suppress them, there was a wide range of newspapers that championed working-class political causes.

As the newspaper industry became increasingly commercialized in the late nineteenth century, the radical press could no longer survive. They had maintained their independence through freedom from advertising. But as advertising expanded so did the budgets of the mainstream press. The newspaper industry increasingly became big business geared to maximizing its readership (Curran and Seaton 2010; Williams 2010).

In this chapter, you have learned that the history of the media is characterized by change and continuity. New technologies do not wipe out previous media forms, instead older forms are adapted to new times.

Different technologies are associated with different forms of communication. New media technologies do not eradicate earlier forms of communication. Although the Internet enables many-to-many communication, one-to-one and one-to-many forms of communication are still important. Whatever the type of communication, it is important to think about who has the ability to transmit and share ideas and who has the opportunity to access them.

The history of the media is also characterized by increasing commercialization. In the next chapter, you will explore in more detail questions about the impact of advertising, commerce and business on the media.

Dig deeper

Briggs, Asa and Burke, Peter (2010), *Social History of the Media: From Gutenberg to the Internet*, 3rd edition, Cambridge: Polity.

Curran, James and Seaton, Jean (2010) *Power Without Responsibility: Press, broadcasting and the Internet in Britain*, 7th edition, Abingdon: Routledge.

O'Sullivan, Tim, Dutton, Brian and Rayner, Philip (2003) *Studying the Media*, 3rd edition, London: Bloomsbury, Chapter Seven.

Scannell, Paddy (2002) History, media and communication. In Klaus Bruhn Jensen, ed., *A Handbook of Media and Communication Research*, London: Routledge.

Williams, Kevin (2010) *Get Me a Murder a Day! A history of media and communication in Britain*, 2nd edition, London: Bloomsbury.

Fact-check

1 Media history is best characterized in terms of:
- **a** A continual technological revolution
- **b** The replacement of old forms of communication with new forms of communication
- **c** Continuity and change
- **d** Technology as the main driver of change

2 How was the BBC funded in the twentieth century?
- **a** By money raised from advertising
- **b** By the Government
- **c** By a licence fee
- **d** By large media corporations

3 As broadcasting developed in the US in the early to mid-twentieth century, what was the primary source of funding for programming?
- **a** Money generated from advertising
- **b** Government grants
- **c** A licence fee
- **d** Direct payments by viewers

4 Technological determinism refers to the idea that:
- **a** Technology is the driver of social and cultural change
- **b** Technologies are produced through social and cultural processes
- **c** Technologies are always human creations
- **d** The effects of technologies are shaped by how they are designed, produced, distributed and consumed

5 Raymond Williams argues that communication:
- **a** Only occurs in face-to-face interactions
- **b** Is the process of transmission and reception
- **c** Should be a one-way process
- **d** Should ideally be based on a one-to-many model

6 Many-to-many communication tends to be associated with:
- **a** Radio
- **b** Television
- **c** Cinema
- **d** The Internet

7 Critics of mass culture claimed that:
 a It was a threat to high culture
 b It was a way of bringing high culture to the masses
 c It offered a way to raise standards in society
 d It restricted media use to elite groups

8 Which of the following arguments would you associate with Adorno and Horkheimer?
 a The Internet enables more public participation in media production
 b Media texts teach audiences to conform
 c Twentieth-century media are based on many-to-many communication
 d From the mid-nineteenth century, newspapers increasingly spoke out against the abuse of power

9 According to James Curran, why was there increased censorship and control of the press in late nineteenth-century Britain?
 a Because of the rise of the radical press
 b Because of the increasing importance of advertising revenue
 c Because of government taxes on newspapers
 d Because of the spread of revolutionary ideas

3

Understanding Media Industries

Media industries produce media texts. Without these industries there would be no blockbuster films and no music hits, no *Grand Theft Auto* and no *South Park*. If we want to make sense of the media, clearly it is crucial to understand *how* these industries operate and also *why* they operate in particular ways.

Media industries are businesses. They compete with each other to win audiences, sell products and make money. This probably sounds fairly obvious. However, what is less obvious is how this impacts on the types of media texts that are produced and the types of audiences they are produced for.

In this chapter you will learn about how a small number of huge corporations play a major role in shaping media production. These business empires are powerful. You will examine how their power operates and how they shape the media texts that you get to consume. You will also explore whether or not the economic power of these businesses over the media gives them a wider power to shape the way people understand the world around them.

This is the first of a series of chapters that examines media production. This chapter will help you to understand:

▶ How the media industries operate as businesses.

▶ Political economy approaches to media industries.

▶ The distinctive features of media industries.

▶ The relationship between ownership and control of the media.

Media industries are businesses

The obvious starting point for a political economy of mass communications is the recognition that the mass media are first and foremost industrial and commercial organizations which produce and distribute commodities.
Graham Murdock and Peter Golding 1973: 205

In capitalist societies, media industries exist to make money. In order to make profits, they produce and distribute commodities, things that can be exchanged for money. If there were no profits to be made from producing films or videogames, then large parts of the media industry would have no interest in making them.

The large corporations who dominate the media industry aim to maximize their profits. They attempt to produce the texts that will make them the most money. This has a significant impact on the types of text that get produced.

This does not mean that everyone involved in producing media – musicians, scriptwriters, journalists, etc. – is only interested in making money. Many people in media industries view their work as a way of being creative rather than in terms of its commercial potential (see Chapter Four). However, texts that do not have the potential to generate profit are less likely to be produced or distributed.

Key idea

On the whole, media industries are organized around maximizing profits.

Media industries make profit in three key ways:

1 **Media industries sell texts to audiences.** This is the most obvious way in which media industries make profits. When we buy a video game or a movie ticket, we pay money for them.

2 **Media industries produce audiences as a commodity to sell to advertisers.** By creating audiences for their products, media industries produce audiences. These audiences are then transformed into a commodity that can be sold to other businesses. This advertising revenue is a key source of profit for many media industries.

 For example, in the case of magazine publishing, there are two key sources of profit: sales of the magazine and advertising revenue. Businesses pay magazines for space

where they can advertise their products to the magazine's readers. In the case of a fashion magazine aimed at young women, the publishers have created a space for the fashion and beauty industries to target consumers.

However, in the case of free-to-air commercial TV channels – for example, Channel 4 in the UK and NBC in the US – advertising revenue is the key source of profit. Audiences do not pay to watch their shows, but businesses pay them for the opportunity to target their products at audiences.

3 **Media industries sell rights to use and distribute texts.** Media industries also own the rights to use the texts they produce. For example, if someone wants to broadcast a recording of a song, re-record that song, take a sample from it or use it in a movie, then they must pay to do so. This increases a company's ability to generate profit from their back catalogue.

There is nothing natural about the idea that producing media should be primarily about making profit. We might consider films, music and news to play such a valuable role in society that they should be freely available to everyone. Therefore we need to examine why media industries operate in this way and think critically about the consequences.

Key idea

Media industries generate profit by selling texts, selling rights and selling audiences to advertisers.

Approaches to the media industries

Political economy is a key approach to the study of media industries. In getting to grips with this approach, you will understand the impact of the distinctive ways that media industries operate as businesses.

Unlike traditional economists, political economists do not try to explain how to make industries more efficient. They are interested in economic questions about how industries are structured and

organized. They explore the relationship between the economics of industries and wider social, cultural and political factors.

Most political economists are concerned with the power of the media and how the media industries contribute to wider inequalities in society. They investigate how the organization of media industries has an impact on the types of texts that are produced. This means that the activities of the media industries can have a powerful role in shaping how people make sense of the world.

> *The commodities produced by the media and communications industries are not the same as those produced by other industries. Media goods provide accounts and images of the world in which we live that can determine our ways of understanding that world. Thus the ownership and control of the media is identified not only as an important factor in determining the structure, working and output of the mass media but also the production of meaning in society.*
>
> Kevin Williams 2003: 73

The following sections draw on insights from political economy to think in more depth about the key characteristics of the media industries.

Key idea

Political economy examines the ownership, structure and operation of media industries and explains how these reproduce inequalities between social groups.

Key features of the media industries

In many ways, the media industries operate like other industries. They produce goods to sell in order to make a profit. However, media texts differ from other commodities such as cornflakes and toilet rolls. This means that media industries face particular

problems which they respond to in distinctive ways. This section draws on the ideas of the political economist Nicholas Garnham (1987, 1990) to think through these issues.

One problem faced by the media industries is that media texts do not get used up when they are consumed. If you drink a can of cola, you need to buy another can if you want to repeat the experience. However, if you buy a CD you can listen to it many times and you can share it with friends so they can experience it too. While people might get pretty bored if they listened to one album repeatedly, the media industries have to persuade us to pay – and to give up some of our limited leisure time – to consume different albums, films or videogames.

It is rare for media audiences to make repeat purchases of the same thing. If you like a brand of coffee you may well buy lots more of it, but you're unlikely to buy the same DVD again and again. The media industries use various strategies to deal with this. First, they try to prevent people making copies of texts such as films or music by taking steps against piracy. Second, they produce texts that very quickly become dated in order to encourage repeat purchases. This is called built-in obsolescence. Newspapers and magazines are clear examples of this. Few people want news that is three weeks' old or to find out about last season's fashions.

In order to create a sense of predictability, media industries may try to persuade audiences to buy *similar* products. Movie franchises such as *Star Wars* and *X-Men* are an example of this strategy. More generally, the media industries attempt to get audiences to repeat a previous experience by marketing films in terms of genres or stars. For example, if you have enjoyed romantic comedies or Denzel Washington movies, the film industry works on the expectation that you are likely to want to watch more of them.

However, this is risky. It is difficult to predict and control exactly what audiences will like and they do not want entirely familiar texts. Therefore, media industries offer what Garnham calls a 'cultural repertoire': a range of texts which audiences choose between. Most profit is generated from a small number of hits. These profits offset the costs of the vast majority of media texts that have relatively low sales and audiences.

Spotlight: Box-office flops

Stories of spectacular box-office flops illustrate just how difficult it is to predict what will be a hit. Disney is a hugely profitable media empire but *The Lone Ranger* (2013) became best known for its low box-office takings, even though it boasted a star actor (Johnny Depp) and a star producer (Jerry Bruckheimer). However, many box-office flops still go on to make a profit when factors such as international box-office takings, DVD sales, merchandising, TV broadcasts and on-demand sales are taken into account.

In the media industries, production costs are high but reproduction costs are low. Production is expensive in most industries – for example, it takes a lot of research and development to produce a new car or washing machine. However, cars and washing machines are also relatively expensive to manufacture which means there are significant costs in reproducing them.

In contrast, reproducing a song in the form of a CD or as a download is relatively cheap. Therefore, given the risks involved in decisions about *what* to produce, the media industries attempt to maximize the audience for their texts. Once initial costs have been covered, additional sales bring significant profits. For example, while all-star action movies might be expensive to produce, they are often worth the risk because they can attract huge audiences.

Producing media texts is frequently high-cost and risky, and large, wealthy corporations are best able to handle these risks. This partly explains why huge business empires have a dominant role in the media industries.

Key idea

Major media companies attempt to maximize audiences for media texts because production costs are high but reproduction costs are low.

Concentration of ownership of the media

A small number of companies dominate the media industries. In 2011, there were seven major players: Vivendi, Walt Disney, Comcast, News Corporation (now divided into News Corp and 20th Century Fox), Time Warner, Sony and Bertelsmann (Hesmondhalgh 2013). Smaller, more 'independent' companies have an important role to play in media production but the global giants use their power to try to make the media industries operate in their interests.

This section explains why these companies have high levels of economic power in the media industries. While you will encounter quite a lot of new concepts along the way, these will help you to develop a more precise and rigorous understanding of how the media industries work.

▶ **The media industries are an oligopoly.** This means they are dominated by a small number of firms. This is not new: Hollywood was dominated by eight studios in the mid-twentieth century. These studios used their power to try to ensure the film industry operated on their terms. Today – and to a lesser extent in the past – these oligopolies exist across media industries.

▶ **Vertical integration** is a key strategy used by media companies to strengthen their economic position and minimize their risks. Vertical integration refers to expansion of a company into all aspects of production and distribution. This enables media companies to control the whole process of creating texts and, crucially, getting these texts to audiences.

▶ **Controlling distribution** is very important for the media industries. If you create texts and you want to make a profit from them, you need audiences to be able to gain access to them. If you control distribution networks, this process is straightforward. As you have learned, the media industries generate high profits by maximizing audiences for the texts they produce. Controlling distribution increases the chances of getting a text to a large audience.

▶ **Horizontal integration** is another strategy that is used to increase audiences, profits and control. It has two dimensions. First, the major players in particular media industries attempt to gain ownership of other companies in their sector. For example, a company specializing in TV production may attempt to buy other TV production companies. Second, the major players in contemporary media industries extend across a range of media, and have often expanded by buying or merging with other companies.

This gives major companies opportunities to promote their products across different media forms. For example, the launch of a new movie may be accompanied by various associated products such as a soundtrack album and a video game. It also enables these media empires to *diversify* the range of activities they engage in.

▶ **Internationalization** is a strategy that enables the media industries to increase audiences and increase profits. These businesses do not just operate in one country but sell their products internationally. Because the cost of reproducing media texts is relatively low, new audiences in different parts of the globe can have a significant impact on profits (see Chapter Seventeen).

▶ **Conglomeration** is the end result of many of these strategies. Major media empires own and control a whole range of other companies. They may buy, takeover or merge with other businesses to expand their economic power within the media industries. Alternatively, they may start up new companies in areas they wish to develop.

All of these factors help to strengthen the position of those companies that already have power and make it virtually impossible for new companies to challenge their dominance. It also means that to enter the media industries as a key player requires vast amounts of money. This limits who has access to ownership of the media.

However, it would be a mistake to think that such empires own all media production and distribution. Below the major media companies is a group of smaller, but still very large,

media companies. Below them is a wide network of smaller media companies who may specialize in particular areas such as television production or games design.

Spotlight: Selling Harry Potter

The first Harry Potter movie – *Harry Potter and the Sorcerer's Stone* – was released in 2001 by Warner Bros, at that time owned by AOL Time Warner. AOL promoted the film via its web pages and its magazines such as *Time*, *People* and *Entertainment Weekly*. Cable networks owned by AOL Time Warner also promoted it, and their music division, Warner Music Group, released the soundtrack. This demonstrates how major players in the media industries can promote their own products across different types of media in order to increase their profits (Croteau and Hoynes, 2014).

Key idea

Ownership of the media is concentrated in the hands of a small number of large media conglomerates who have expanded their interests through oligopolies, integration and internationalization.

Case study: Comcast

Who owns the media you use? At first glance, it is far from clear. Large media conglomerates often own – or part-own – many brands across a range of different media forms.

By looking at the example of Comcast Corporate Holdings, you can start to get a sense of the scale and diversity of activities within one media empire. At the time of writing, Comcast's business ventures included:

▶ XFINITY, a major provider of video, high-speed Internet and phone service for residential use in the US.

▶ Various cable television networks in the US including Bravo Media, E!, MSNBC, NBC Sports Network, Universal Sports, SyFy, Oxygen

Media, USA Network and the Weather Channel Companies as well as various regional sports and news networks.

- ▶ Broadcast television networks NBC and Telemundo, and broadcast production unit Universal Television, responsible for series such as *Parks and Recreation* and *Grimm*.

- ▶ Universal Pictures, a major film studio which both produces and distributes films and owns a significant back catalogue, together with Focus Features which produces less mainstream films such as *Brokeback Mountain* and *Moonrise Kingdom*.

- ▶ A range of Internet sites including movie ticket retailer Fandango and part-ownership of online television service Hulu.

- ▶ Universal Studios theme parks and other sports and entertainment companies.

(Croteau and Haynes 2014; Comcast 2015)

Why concentration of ownership matters

The fact that several large conglomerates own so much of the world's media has a series of important and worrying implications. These media empires have a significant amount of power over which types of texts are produced and distributed.

First, high market entry costs exclude resource-poor groups from starting and owning their own mass media. This limits competition, and encourages the marginalization of their interests and viewpoints. Second, there is a recurring tendency for media concentration to develop, leading to reduced choice and less consumer control. Third, advertising is distributed disproportionately in favour of media reaching affluent audiences, which encourages media producers to privilege their concerns. Finally, the economic benefits of size create a magnetic pull, it is argued, towards the terrain of maximum sales and, consequently, the ideological middle ground.

James Curran 2002: 92

Concentration of ownership limits the diversity of the media. This occurs in four key ways.

1 Large media companies who are motivated by profit do not tend to produce a diverse range of texts. As you have learned, such companies exist to make profits and they tend to produce and distribute what they are pretty sure will sell. This means they tend to play it safe and produce texts that are similar to those which have sold in the past.

 As a result, they are less likely to produce and distribute more experimental or innovative texts. Some critics argue that this results in media texts that are standardized, uninteresting and of little aesthetic merit.

2 Concentration of ownership also limits the diversity of ideas that are available. As you learned earlier in this chapter, texts produced by the media industries are one of our key resources for making sense of the world. Industries geared around profit are unlikely to create texts that challenge commonly held views.

 It requires vast economic resources to compete with the major players in the media industries. This makes it difficult to build alternative platforms that feature different voices and viewpoints. Some people argue that the Internet has the potential to remedy this situation because it offers many people the opportunity to express their ideas. You will explore this argument in more depth in Chapter Five.

3 Because large media conglomerates maximize profits by targeting their products at mass audiences, niche audiences tend to be overlooked. This has particular consequences in media industries such as TV where advertising revenue is a key source of profit. Advertisers want to reach people who will buy their products, so they are attracted to TV shows which reach either mass audiences or affluent niche audiences.

 Audiences who aren't desirable to advertisers are unlikely to find TV programming that is targeted at them. Furthermore, when information and entertainment are commodities that

must be bought, the media industries are unlikely to target their products at audiences with lower spending power.

4 Finally, the internationalization of major conglomerates produces fears that ideas and cultures across the world may become less diverse as people consume similar media texts. In particular, there have been fears that the world will become less diverse as people increasingly adopt American values. There has been considerable debate about these ideas and you will explore them in more detail in Chapter Seventeen.

Key idea

Concentration of ownership limits the diversity of media texts and limits the range of voices and ideas expressed in the media.

Ownership and control of the media

Owners of large media empires have a significant amount of control over how the media industries operate. However, many people are concerned that owners of the media also have the power to shape the content of the media. Owners of the media could use the media texts they own to express their own political interests and shape the ideas, knowledge and information that is available to audiences. However, do the owners of the media exert direct control over the content of the media?

There is a history of powerful individuals who have tried to use the media to promote their own political beliefs and political power. In the early to mid-twentieth century, a number of British newspaper owners, known as the Press Barons, used their papers to promote their own political views. More recently, Silvio Berlusconi used his Italian newspapers and TV stations to promote his own right-wing political party. The case of Berlusconi, who served nine years as Italian Prime Minister, appears to support the argument that owners can use the media for their own political agendas.

Rupert Murdoch is another frequently cited example of an owner who has directly intervened in the content of his newspapers to promote his own political views. Proprietors who own a large number of newspapers cannot make frequent and direct editorial interventions across all their titles. However, Murdoch has appointed staff who are prepared to espouse his political ideas and, on occasion, he continues to intervene directly. It is alleged that Murdoch told staff on the British newspaper *The Sun* to vigorously attack the Labour party during the 2015 elections because he feared the party wanted to break up part of his business empire and challenge his power (Sherwin and Wright 2015).

Spotlight: One murder a day

In the 1920s and 1930s, many British newspaper owners tried to exert high levels of control over the content of their papers. This wasn't limited to overtly political issues. Lord Northcliffe, who owned the *Daily Mail*, had a fascination with torture and death and told his staff to find 'one murder a day'. Lord Beaverbrook, who owned the *Daily Express*, was a hypochondriac. He told his editor that 'the public like to know... what diseases men die of – and women too' (Curran and Seaton 2010: 41–2).

These examples should give us considerable cause for concern. Given the power of the media to shape which ideas are available to us, it is obviously worrying if they are used to promote the political views of their owners. This is particularly the case when ownership of the media is concentrated in relatively few hands.

However, examples such as these are relatively rare. There are many counter-examples in which journalists or film-makers have produced texts that are critical of media conglomerates' broad economic or political interests. For example, many commentators identified themes that were critical of corporate business practices in *The Lego Movie* (2014) produced by Warner Animation, owned by a subsidiary of Time Warner.

Most owners of major media conglomerates are business people who are distant from the day-to-day activities of the media. Their main interest is in the economic performance of

the companies they own. As Nicholas Garnham argues, these business people want to increase their economic power by increasing their profits. They are less interested in directly using ideas and information to strengthen their power. It doesn't matter that *The Lego Movie* has anti-business and anti-capitalist themes because it took $468 million worldwide at the box-office. Perhaps unsurprisingly, it also boosted Lego's worldwide sales by 13 per cent.

Most owners of the media do put pressure on their workers to create texts that will be profitable. However, as you have already learned, this has an impact on the type of texts that are produced. When media texts are produced primarily to make a profit, this constrains the diversity of media texts and the range of ideas and views they contain. While these are more subtle forms of control than direct editorial intervention, they still have a significant impact on the nature of the texts available to audiences.

Concentration of ownership is also still a major political concern. If there is a narrow range of views and information in the media, this impacts on how political life is conducted. If only those media texts that are likely to be profitable are created and distributed, alternative voices are excluded.

Key idea

Most media owners do not directly intervene in the content of the media. Media corporations tend to produce and distribute media texts that maximize their profits and strengthen their economic power.

Of course, not all media texts are produced with profit in mind. Although profit-oriented companies dominate, there are alternative forms of production and distribution. These can help to increase the diversity of texts, information and viewpoints in the media. They may also address audiences the media industries tend to ignore because they are not seen as profitable.

Publically funded media is one key alternative. In the UK, this is strongly associated with the BBC. Although the activities of the broader media industries shape the BBC's practices, the legal framework governing television in the UK does try to address

the issue of diversity. You will examine these issues in much more detail when you explore public service broadcasting in Chapter Six.

Small-scale media such as radical magazines and newspapers also present alternative viewpoints, ideas and information. They follow in the footsteps of the nineteenth-century radical press that you learned about in the last chapter. Alternative media struggle to find distribution outlets that give them access to wider audiences. They also frequently struggle for financial survival. However, the Internet offers possibilities that reduce production costs and make distribution much easier and cheaper (see Chapter Five).

In this chapter, you have learned about some of the key features of media industries. On the whole, the media industries are businesses that aim to maximize profit. They try to produce texts which appeal to large audiences. This limits diversity. The media industries are dominated by a small number of large conglomerates who expand their interests through strategies such as integration and internationalization. While few owners of the media directly intervene in the political content of the media, most owners pressurize media workers to produce texts that will make money.

Dig deeper

Garnham, Nicholas (1990) *Capitalism and Communication: Global culture and the economics of information*, London: Sage.

Hardy, Jonathan (2014) *Critical Political Economy of the Media*, Abingdon: Routledge.

Hesmondhalgh, David (2013) *The Cultural Industries*, London: Sage, especially 'Introduction' and Chapter Two.

Wasko, Janet (2004) The political economy of communications. In John D. H. Downing, Denis McQuail, Philip Schlesinger and Ellen A. Wartella, eds, *The SAGE Handbook of Media Studies*, London: Sage.

Williams, Kevin (2003) *Understanding Media Theory*, London: Bloomsbury, Chapter Three.

 Fact-check

1 Audiences are commodities because:
 a They do not pay for advertising
 b The media industries sell audiences to people who want to advertise their goods
 c They need to buy media texts
 d They need advertising revenue

2 Which of the following is **not** included in a political economy approach to studying the media industries?
 a How media industries are structured and organized
 b The relationship between media industries and the types of texts that get produced
 c How to make media industries more efficient and profitable
 d Ownership and control of the media

3 Why do media industries offer a 'cultural repertoire'?
 a It is difficult to predict exactly what audiences will buy
 b To give audiences as much choice as possible
 c To diversify media production in order to serve diverse audiences
 d To increase the range of views in the media

4 The primary aim of large media conglomerates is:
 a To produce quality media texts
 b To serve diverse audiences
 c To make a profit
 d To include a diverse range of ideas

5 Control of distribution is important in the media industries because:
 a Distribution gives access to audiences
 b Distribution cuts the cost of production
 c Distribution requires little financial investment
 d Distribution increases diversity

6 Concentration of ownership of the media in the hands of relatively few powerful companies:
 a Limits diversity
 b Creates diversity
 c Limits the power of major conglomerates
 d Serves the interests of a wide range of audiences

7 Large media companies become vertically integrated in order to:
 a Concentrate on the control of production
 b Control all aspects of production and distribution
 c Increase their financial risks
 d Promote increased diversity in the media

8 Horizontal integration can enable large media companies to:
 a Diversify the markets they operate in
 b Pursue increasingly narrow markets
 c Target niche markets
 d Increase the range of political views in the media

9 Critics of the concentration of media ownership do **not** focus on:
 a How concentration of ownership limits diversity of viewpoints
 b How concentration of ownership limits profitability
 c How concentration of ownership limits experimentation
 d How concentration of ownership limits the range of media texts

4

Producing Media

Understanding who owns the media only tells us part of the story. Media texts are also shaped by the practices of the people and institutions that produce them. Owners – and the commercial pressures to make a profit – have an impact on media texts, but so do other institutional practices and values.

People often associate texts such as films or music with the work of one creative genius like a director or musician. While Martin Scorsese or Beyoncé might get a lot of the attention, their films and music are the result of the work of many people including producers, editors, lawyers, marketing staff and technicians. All of their contributions shape the final song or film.

This chapter examines how practices in the media industries shape the texts that are produced. It also looks at the people who produce them and explores what it's like to work in the media industries. While media jobs often appear to be glamorous and well-paid, the reality for most people does not live up to this image.

One of the key attractions of working in the media is the opportunity to be creative and express your ideas. However, as you learned in the last chapter, media texts are commercial products designed to make financial profits. This produces a key tension. Can media workers be creative, or do commercial pressures limit or destroy their creativity? Outside academic debates, this tension is often expressed in terms of whether people need to 'sell out' to achieve commercial success. This chapter explores debates about this tension.

This chapter will help you to understand:

▶ How media texts are produced within institutions.

▶ The practices, routines and values that shape media production.

▶ The working conditions of the people who produce media.

▶ The tensions between creativity and commerce in media production.

Media production and media institutions

Studying media production involves studying how media texts are made and who makes them. It involves investigating how media production is organized and structured. And it involves thinking about the range of factors that shape what gets produced. Making money is one factor but not the only one.

We have already considered how the owners of the media have the potential to influence the ideas that circulate in society. But how production is organized – and who is involved in it – also shapes the media texts that are available to audiences. Thinking about media production, therefore, involves thinking about power.

Media production takes place in institutions. Texts are not produced by individuals but by a wide range of workers employed by these institutions. Institutional practices, routines and procedures have more influence than individual workers. As one study revealed, 'news changes very little when the individuals who produce it are changed' (Golding and Elliott cited in Williams 2003: 97).

Key idea

Media texts are not produced by individuals but by complex teams of people working within media institutions.

Institutions regulate, organize and structure behaviour. They have histories that shape the working practices of staff. These institutions shape the taken-for-granted assumptions and expectations that workers within a particular area of the media have. These assumptions influence ideas about, for example, what makes a good news story or what sort of people should be interviewed in a news report.

Institutional practices and values can be formal. They might be written into staff handbooks and training manuals, or be part of legal frameworks regulating behaviour. However, these values may also be unwritten assumptions that are part of the culture of a particular media industry and workers may learn them in more informal ways. New entrants to an industry are socialized into its particular culture.

Key idea

Media institutions organize and structure the production process and the values, practices and routines of media workers.

The television and newspaper industries are institutions with their own values and working practices. There are also specific institutions within these industries such as *The Washington Post* and the BBC. To take a British example, *The Sun* and *The Times* share the same owners. However, they are very different newspapers. Each has its own specific institutional culture that shapes how employees produce news stories. Journalists on both papers might share common working practices with others in the newspaper industry. At the same time, each paper will have different ideas about what makes a good news story for their target audience.

Specific institutions are also shaped by the industry they are part of. For example, the BBC cannot ignore the wider television industry. If the BBC wants to make popular series, then it needs to take account of what its rivals are doing and the shows that are current audience hits. For example, when ITV had a hit with the televised singing contest *Popstars* in 2001, the BBC countered with their own competition, *Fame Academy*.

Media institutions are also shaped by wider social, cultural, political and technological changes. Institutional values and assumptions about how to make media texts are influenced by these wider changes. The BBC's guidelines on offensive language, for example, respond to shifting ideas about gender, race and sexuality.

Producing media at the BBC

By taking a closer look at one media institution, you will develop a deeper understanding of how institutional practices shape media cultures. In the late 1990s, Georgina Born (2004) investigated how the BBC produces television. Through interviews and observation, Born discovered the assumptions and values of the BBC. Her study, *Uncertain Vision*, demonstrates how the features of an institution shape decisions about the type of television that gets produced.

The BBC is a huge organization. In 2003, it had a staff of 27,000 people. In order to coordinate this number of people and bring them together as BBC employees, an institution like the BBC needs its employees to have common goals.

Born discovered that the BBC's longstanding mission to 'inform, educate and entertain' the public still shaped the values of many staff. (You will learn more about this mission in Chapter Six.) Traditionally, the BBC did most of its work in-house. This produced a shared culture across the production process with 'common professional ethics and standards' (Born 2004: 151). The BBC also used internal training to socialize workers into its institutional values, codes of conduct and collective goals. The organization had 'its own distinctive ethos and language' that shaped the type of media it produced (Born p. 66).

However, at the time of Born's study, the BBC was forced to change in response to shifts in the wider media industries. It faced more competition for audiences because the number of TV channels multiplied as satellite and cable television expanded. Independent TV production companies boomed during this period, creating another form of competition. New legislation required the BBC to take 25 per cent of its

programming from these independents. The government believed that the BBC would become more efficient if it were more competitive.

Key idea

Media institutions, and their production practices, are shaped by the wider changes in the media industries and society.

BBC managers responded to these changes by installing competition and commercial success as new core values of the institution. They emphasized commercial success over creativity. Programme ideas were increasingly developed with audience ratings in mind. The 'best' programmes were those with the biggest audiences.

Marketing and audience research were increasingly part of the BBC production process. Marketing teams didn't just promote finished products but were involved in generating programme ideas. Producers had to learn to pitch their ideas in a few words and increasingly pursued types of programme which were already audience hits. 'Clones and hybrids ruled' (Born 2004: 349).

Another result of these changes was 'marketing-led schedules.' Series were increasingly produced to fit predefined slots in the TV schedules which were associated with specific types of programming. If you take a look at TV listings, you should be able to identify which types of programmes are associated with specific days and times.

Media texts are rarely the expression of one person's creative vision. Born's study illustrates the complexity of the production process. Workers involved in producing media occupy a range of different roles within institutions. The input of these different workers influences the texts that are produced.

Key idea

Marketing and audience research play an increasingly important role in the production process.

Spotlight: TV about TV

TV shows such as *30 Rock*, *W1A* and *UnREAL* offer a glimpse into TV production processes. All are heavily fictionalized accounts of TV production, often spoofing media cultures for comedic or shock effects. Yet these series highlight some of the key tensions in TV production including the dominance of marketing and branding, the pressure to maximize audiences and tensions between creativity and commerce.

Born's study also demonstrates how institutional cultures change. From the late 1980s onwards, there was a huge drop in the number of permanent full-time staff employed by the BBC. The organization increasingly employed casual and freelance workers. There was also a decline in in-house training during the same period. This made it more difficult to maintain common values, practices and goals. There were also clashes between the values of creative workers and those of management.

Although media texts are the product of a range of people and processes, Born's research into the BBC demonstrates how institutions shape media production and the impact that the values of an institution have on the types of texts that are produced. Media texts are the product of a range of people and processes. The values of an institution have an impact on the types of texts which are produced.

Who produces the media?

Recruitment to the BBC, career consolidation and pathways to promotion continued to be disproportionately captured by those from traditional elite and establishment backgrounds – the private schools and top-drawer universities – and this was accompanied by movement through typical networks of patronage and influence... While it is impossible to point to such tacit routes and networks in any but the most generalized terms, their reality is engraved in the experience of those excluded,

In the last chapter, you learned who owns the media. In this section, you will find out about the type of people who work in the media and how the characteristics of media workers shape the texts they produce.

In the UK, white middle-class men are more likely to hold senior positions in the media industries. The values and assumptions that this group bring to their work shape the types of texts that are produced. Their values also affect whose voices are heard in the media and the wider culture of media organizations.

In 2012, *New Statesman* magazine reported that all UK national newspaper editors and political editors were white. They tracked the British press over one week and found that three national newspapers – the *Telegraph*, the *Mail* and the *Express* – did not contain any columns by non-white writers (Press Gazette 2012). Although some media organizations such as the BBC have stringent targets for recruiting black and ethnic minority employees, these groups are still under-represented in senior positions.

At first glance, women – or, at least, white women – appear to be relatively well-represented in the media. However, in many countries they tend to be under-represented in more senior jobs. In particular sectors of the media, women fare particularly badly. In 2013, a US study found that only '16% of all directors, executive producers, writers, cinematographers and editors' in the film and entertainment industry were women (Women Make Movies 2014). In the UK, a 2010 study by Ofcom found that women were under-represented among senior managers and board members in the media industries (Select Committee on Communications 2015).

These statistics matter because they suggest that there are not equal employment opportunities for people seeking work in the media industries. They also matter because lack of diversity

among staff can lead to a lack of diversity in the types of texts produced by the media. The background and experiences of middle-class white men will inform what they view as interesting, important and worth producing and also shape whose viewpoints get heard in the media and whose voices are excluded.

However, increasing diversity in senior roles will not automatically change media organizations. For example, just because a senior news journalist is female does not mean that she brings a feminine point of view to her work. Many studies document how some sectors of the media have a macho work culture based on male bonding. Female journalists often feel excluded because they are not accepted as 'one of the boys'. They may face comments on their looks or other forms of harassment. Therefore, in a masculine culture, women may try to fit in.

Class background also limits access to media work. Creative and senior roles at the BBC still tend to be dominated by people from relatively elite groups. As the next section demonstrates, the changing nature of employment in the media industries creates new informal barriers to people from working-class backgrounds.

Key idea

Senior roles in many media industries are occupied by middle-class white men and this influences the types of texts produced.

Spotlight: Expert voices in the media

In 2014, a study of British television news by academics at City University revealed that men were four times more likely than women to act as experts on flagship news programmes. The difference becomes more striking in political news. City University found that only one in ten experts commenting on political news stories were female. One key explanation for these inequalities is that media workers in important decision-making roles tend to select experts who are like them (Select Committee on Communications 2015).

Working in the media

You may be reading this book because you want to pursue a career in the media. If so, you are not alone. The industry is one of the most popular choices when young people are asked about their ambitions.

There are a number of reasons why media jobs are so attractive. Some people view them as cool or glamorous. Other people are attracted because media industries offer them the opportunity to do rewarding and meaningful work and to get paid for doing what they enjoy. The end result is an over-supply of people who want to work in the media. Large numbers of people chase a limited number of jobs.

Gillian Ursell (2006) explains how this has consequences for those trying to start a career in the media. With very few on-the-job training schemes, many young people have to bear the costs of acquiring skills. This involves doing unpaid work experience or internships. In order to work for free, you need other people who can support you financially. This kind of support is more available to people from middle-class backgrounds.

Even when you secure a job in the media, entry level posts are often low paid. David Hesmondhalgh and Sarah Baker (2011) observe that, in 2009, UK union rates for a runner in TV production were £354 ($584) for a week that could include up to 48 hours work. Many employers do not pay these rates. This makes it difficult for young media workers to recoup the money they have invested in developing their careers.

Finding work often depends on social capital, the networks of contacts and relationships people have available to them. Gaining entry to media work – and continuing freelance employment – depends on who you know. Young people from middle-class backgrounds are more likely to share networks with people employed in the media (Ursell 2006).

Although some go on to secure well-paid and stable employment in the industry, the position of most media workers today is rather different. Many jobs are on short-term contracts or a freelance basis. For some workers, this has benefits. It gives them

a sense of freedom because they are away from what can seem like the dull routines of 9–5 employment. But it can also mean that there is little job security or guarantee of work. Too many people are in competition for too few jobs and this tends to drive down wages. Even when they are employed, workers need to be on the lookout for the next job (Hesmondhalgh 2013).

This paints a rather depressing picture of what it's like to work in the media! However, while it can be a precarious existence, many people consider that the rewards they get from their work outweigh the potential problems.

Key idea

Work in the media is often underpaid and insecure, with many workers on short-term or freelance contracts.

Case study: The experience of media workers

In 2006–7, David Hesmondhalgh and Sarah Baker (2011) carried out a study of media work in three industries in the UK: television, magazine journalism and music. They asked 'What kinds of experiences do jobs in the cultural industries offer their workers?' (p. 15). For many workers, their jobs brought them a combination of pleasure and frustration.

Many media workers experienced unpredictable and long working hours. While this could be exciting, it could also lead to exhaustion. Some workers felt frustrated because they could not command the wages they felt their work was worth. This was a particular problem for freelance workers. They believed that they would not get work in the future if they demanded union rates.

Feelings of insecurity were also common. As one interviewee put it, 'you are constantly living sort of on the edge' (p. 121). The necessity to always hunt for new leads and new jobs caused some workers to feel stressed. Many workers experienced feelings of doubt about their own worth and how good their work was. They worried about whether they had a future in the media

industries. Concerns about long-term career prospects were common.

However, many workers gained a great deal of pleasure from their work. Some people enjoyed doing a job that other people viewed as cool and interesting. A lack of routine had benefits because it gave workers the opportunity to be always working on something new. Some workers gained satisfaction and pleasure because their jobs were complex, challenging, exciting and intellectually stimulating. The rewards of media work could lie in the enjoyment of the process of creating something or in satisfaction with the finished product.

Many workers also valued the social aspects of their work. They enjoyed working on collective projects and the opportunities for having fun. But some workers viewed socializing as an obligation. Going out with fellow workers could end up as 'networking masquerading as socializing' (p. 155).

Hesmondhalgh and Baker (2011: 198–9) argue that the media industries offer their employees the opportunity to do creative and skilled work. Many workers also enjoy doing work 'they consider to be of social, cultural and political significance'. However, not all aspects of media work are positive. The authors argue that workers often feel frustrated and disappointed. Some workers feel that they work on meaningless projects or that good ideas get distorted as projects progressed.

Creativity or commerce?

In the last chapter you learned about how the media industries are largely organized around making a profit. Media production is shaped by commercial factors. Yet many media workers are motivated by the desire to be creative and to produce inspirational or meaningful texts. Media production is characterized by this tension between creativity and commerce.

> *Cultural work is routinely presented as an arena of political struggle, principally in terms of how artistic desires for creative autonomy and independence exist in uneasy tension with capitalist imperatives of profit generation.*
>
> Mark Banks 2007: 6

If the media industries are organized around making profits, do media workers have creative freedom to shape the texts they produce? Many researchers think about this issue in terms of autonomy. Autonomy refers to independence, control and freedom to shape your own practices.

Hesmondhalgh and Baker (2011) distinguish between two types of autonomy. Workplace autonomy refers to the level of control that workers feel they have over their working life and the things they produce. Creative autonomy refers to the level of artistic freedom that workers have to create texts, free from the pressures of commerce and political control.

Autonomy takes different forms in different media industries. Journalists often use the term professionalism to refer to ideas about journalistic integrity and freedom. Journalists want to view themselves as independent not only from the demands of owners but also from commercial pressures, powerful groups and dominant values (Hesmondhalgh 2013).

In fields such as music, autonomy is linked to creative independence. Many musicians view themselves as artists who express a creative vision rather than employees of the media industries. They want to put their artistic aims before commercial pressures.

The tension between creativity and commerce informs popular debates about the value of media texts. Bands that are driven by the promise of commercial success are often seen as 'sell outs'. TV shows such as *X Factor* and *American Idol* are associated with singers who are commercial products rather than 'authentic' artists.

However, these ways of framing debates about the value of media texts ignore the fact that 'all creators have to find an audience' (Hesmondhalgh 2013: 82). They are dependent on commerce to do this. Many workers want the autonomy to pursue their own creative interests. But media workers must manage their desire to be creative with the demand to produce profitable and commercial work (Banks 2007).

Spotlight: Selling out

When artists are accused of selling out, they are seen to be selling their souls for financial rewards. Recently Adele stated that 'I don't want my name anywhere near another brand... I don't want to sell out in any way.' A year later Adele was the voice of the James Bond franchise when she sang the title track for Skyfall. Having your music used for adverts, TV shows and movies is a key source of income for many artists, and a way to make a living. This may explain why John Lydon, a former singer with the punk band The Sex Pistols who has an alternative star image, featured in adverts for homely and traditional Country Life butter.

Lynskey 2011

Key idea

Media work is structured around a tension between creative autonomy and commercial pressures.

In this chapter, you have learned about how working practices in media institutions shape production. Media institutions are complex organizations with specific values that influence the texts they produce.

You have also learned about what it is like to work in the media industries. Class, gender and race impact on the opportunities workers have in these industries. While the media industries offer opportunities to be creative and express ideas, workers are often frustrated by their conditions of employment.

Not all media texts are produced in large organizations and institutions. Digital technologies offer people the opportunity to produce and distribute their work to audiences. In the next chapter, you will learn more about the impact of digital technologies on the media industries.

Dig deeper

Born, Georgina (2004) *Uncertain Vision: Birt, Dyke and the reinvention of the BBC*, London: Secker and Warburg.

Havens, Timothy and Lotz, Amanda (2012) *Understanding Media Industries*, New York: Oxford University Press.

Hesmondhalgh, David (2013) *The Cultural Industries*, London: Sage, especially Chapter Seven.

Ursell, Gillian (2006) Working in the Media. In David Hesmondhalgh, ed., *Media Production*, Maidenhead: Open University Press.

Williams, Kevin (2003) *Understanding Media Theory*, London: Bloomsbury, Chapter Four.

Fact-check

1 Media institutions:
 a Shape the values, practices and routines of media workers
 b Focus on individuals
 c Exist to promote creativity
 d Have little impact on the production process

2 Media institutions:
 a Are completely independent of external forces
 b Are autonomous
 c Are shaped by wider social and cultural changes
 d Do not respond to wider historical changes

3 When workers are socialized into an institutional culture:
 a They learn how to be more sociable
 b They learn how to be more independent
 c They learn the values and codes of behaviour in their place of work
 d They learn how to become more autonomous

4 Within the media industries, marketing:
 a Has little impact on the production process
 b Is increasingly involved in the production process
 c Only becomes involved after production is finished
 d Is rarely used

5 Using marketing-led schedules involves:
 a Producing TV shows to fill predefined slots in TV schedules
 b Producing TV shows to fit workers' schedules
 c Increasing autonomy to develop new types of programming
 d Increasing innovation in developing new genres

6 Employment in the contemporary media industries tends to be based on:
 a Jobs for life
 b Increasing unionization
 c Steady and predictable working patterns
 d Short-term contracts and freelancing

7 Media workers often experience their work as being:
- **a** Based on predictable hours
- **b** Boring, dull and overpaid
- **c** Insecure, competitive and underpaid
- **d** Too inflexible

8 Creative autonomy refers to:
- **a** Producing media using machines
- **b** Artistic freedom and independence from external pressures
- **c** Lack of control over the creative process
- **d** Strong forms of external control over the creative process

9 Media work is often characterized in terms of a tension between creativity and:
- **a** Independence
- **b** Artistry
- **c** Autonomy
- **d** Commerce

5

Changing Media Industries

Popular stories about new media often claim that they have revolutionized the media industries. These stories suggest that digital technologies have transformed the way media are produced, distributed and consumed. However, the real story is rather more complicated. There have been fundamental shifts in the media industries since the 1990s, but older patterns also remain in place.

Digital technologies offer more people opportunities to get involved in producing and distributing media. As you learned in Chapter Two, Web 2.0 is associated with new forms of user-generated content. Music and editing software give ordinary people the chance to produce films and music in their homes. People can use web-based applications to share these with others. This offers the potential to diversify the range of both texts and voices in the media.

However, 'older' forms of media, such as television and newspapers, have not disappeared. A small group of large conglomerates still dominate the media industries. As you have already learned, media history is characterized by continuity as well as change. It is important to keep this in mind while studying 'new' media.

This chapter introduces you to key debates about the impact of digital technologies on the media industries. You will explore whether these technologies are used to strengthen the power of large conglomerates or whether more people now have power to shape the media. You will also learn about the new media industries and forms of commerce that are associated with digital media technologies.

This chapter will help you to understand:

▶ The characteristics of digital media.

▶ How new media have democratized media production.

▶ The digital divide.

▶ Changing forms of circulation and distribution of media texts.

▶ The commercialization of the Internet.

▶ Whether new media strengthen or weaken the power of large media corporations.

New media as digital media

'New' media are no longer particularly new. If you're a younger reader of this book, you probably grew up with 'new' media. But new media are – like the media more generally – still transforming and changing. To make sense of these changes, it is necessary to understand some of the distinctive features of new media.

Before the 1980s, most media production and distribution used analogue technologies. These technologies rely on physical reproductions of sounds and images. For example, sounds are etched on to the grooves of a disc. Sounds and images are reproduced through creating physical replicas of the original item. This might take the form of a vinyl disc or the electronic waves used in broadcasting. (Branston and Stafford 2010).

With digital media, there is no need to physically reproduce sounds and images. Sounds and images are transformed into binary computer code. This enables texts to be stored, reproduced and circulated much more easily and inexpensively.

Key idea

The term 'new media' is associated with media forms based on digital technologies.

Digital technologies enable sounds and images to be reproduced more accurately. For example, with older recording technologies the quality of the musical sound deteriorated on transfer from the original 'master' tape or disc to the tape or disc that was available to buy. Vinyl discs and cassette tapes also deteriorated over time, leading to further loss of sound quality. With digital technologies, copies can be exact reproductions of the original.

Digital texts are much easier to reproduce and circulate. This reduces reproduction and distribution costs, creating the potential for increased profits. However, it also makes it easier for people to share texts for free by file-sharing or online streaming. The media industries interpret this as a threat to their profits and demand increased regulation to prevent people from circulating texts without paying for them (see Chapter Seven).

With analogue technologies, specific devices are needed to consume each type of media text. For example, you need a turntable to play a record and a video player to watch videotapes. However, the same digital data can be used across a range of media devices.

Digital technology enables convergence between different media devices and forms. Convergence refers to the ways in which, once technologies can be networked together, the distinctions between different media start to break down. Media forms, industries and content increasingly intersect with each other.

Media that were once distinctive are now used on the same device. For example, you can use an iPad to watch a movie, play computer games, listen to music and watch TV. However, despite this, many people use a large number of media devices such as music players, tablets, smartphones, laptops and so on.

Media forms do not just converge within media devices. '*Content* has converged' (Lister et al. 2009: 202). Media industries use digital technologies to supply elements of the same content across multiple platforms. Some movie franchises are developed as transmedia products. For example, the narrative of *The Matrix* is developed not only in later films but also across comics and computer games (Jenkins 2006).

Key idea

Convergence usually refers to the new forms of interconnection between previously separate media technologies and texts.

Since the late 1970s and early 1980s, digital technologies have been used to change production practices in the media industries. However, when personal computers became more affordable in the mid to late 1980s, a greater number of people had the ability to create media texts. For example, music production and desktop publishing software made it much easier for people to produce songs and magazines in their own home (Hesmondhalgh 2013).

Of course, this does not mean that people could not produce their own media texts prior to digital technologies. For

example, bands could create their own music in a garage and play concerts. They could use tape to record themselves and reproduce these tapes to share with other people.

However, digital technologies not only make it easier for more people to produce media texts but also make it much easier for people to distribute them. If you are in a band, you can digitally record tracks and immediately upload them to the Internet where they have the *potential* to be heard by millions of people. Digital technologies, therefore, offer ordinary people more opportunities to distribute their work.

Some researchers argue that all these changes mean that digital technologies enable a new participatory and interactive media culture. This creates opportunities to challenge the dominance of the large media industries that are driven by commercial interests.

> *[The Internet] is reproduced by a mix of fandom, community, commerce and business... Its ongoing development must therefore be seen as a product of these tensions... We can note the way that the development of the Internet has not only given rise to new cultural practices that have actually become a threat to the interests and business practices of huge corporations but at the same time given rise to new media behemoths in online distribution, retailing and services.*
>
> Martin Lister et al. 2009: 163

In the rest of this chapter, you will learn more about these debates. Have digital technologies given ordinary people more power to shape the media? Or have digital media been used to strengthen the power of the media industries and create new forms of commerce and control?

'New' and 'old' media

It is important to remember that digital media have not caused more established media forms to disappear. Newspapers, film, television, radio and music are still key media industries, although they are also delivered in new ways.

Despite competition for leisure time from new media forms, many people still spend a large amount of time watching television. Statistics from the US suggest that audiences spent 20 per cent more time watching TV in 2013 than in 2010. These statistics do not give us information about what devices people use to watch television but live broadcasting is still important. In the UK, 90 per cent of television viewing in 2013 was live. Statistics suggest similar patterns in the US (Freedman 2015).

The television industry uses digital technologies in production and to develop new modes of delivery. These include catch-up services, such as the BBC iPlayer, and on-demand streaming, from providers such as Netflix. While these forms of delivery compete with 'live' television, other forms of new media are used to increase the importance of 'liveness'. For example, Twitter and liveblogs are used to stimulate comment about television as it happens.

The impact of digital technologies on the newspaper industry is uneven. While some countries have seen newspaper sales increase, in the US and UK sales have declined severely due to competition from the Internet. Many newspapers have adapted by developing a multi-platform approach, delivering content over a range of platforms. For example, people can still buy a print version but they can also access a newspaper's website or their Twitter feed.

Because more established forms of media make use of digital technologies, it is difficult to separate old and new media. Digital technologies have been used to create new media forms such as computer games. However, digital technologies are used across the media industries, both old and new.

Key idea

There is no clear distinction between 'old' and 'new' media because more established media industries employ digital technologies in the production and distribution of texts.

Digital optimism

Many people claim that digital media democratize the production and circulation of media. In these debates, democratization refers to the idea that the ability to produce and distribute media texts is increasingly available to everyone. This argument suggests that, once there is wider participation in media production, the media will no longer be controlled by powerful groups.

David Hesmondhalgh (2013) describes the people who make these arguments as 'digital optimists'. They focus on the positive potential of digital media and their arguments centre on two key themes:

1 New media create opportunities for large numbers of people to participate in – and have more control over – media production.

2 New media create opportunities for more democratic forms of many-to-many communication, allowing everyone to share their views and ideas.

Manuel Castells offers one argument supporting digital optimism. He argues that ownership of 'old' media is concentrated in the hands of the powerful. The majority of people have no option but to consume media texts that are produced for them. New media, he argues, offer ordinary people the opportunity to take control of the media. They can use media to challenge dominant ideas and to fight for liberation and freedom (Hesmondhalgh 2013). For example, campaigning groups use the Internet to communicate viewpoints that oppose dominant ideas and to organize for change.

Spotlight: The Arab Spring

Some digital optimists highlight the role of digital media in organizing protest against oppressive political regimes. The Arab Spring is the term used for a wave of protest in Arab nations that started with the Tunisian Revolution in 2010. Protesters in countries like Tunisia and Egypt used mobile phones and digital media to share ideas and organize resistance. International media broadcast some of this online content, creating wider awareness of the protests (Allagui and Kuebler, 2011).

Henry Jenkins (2006) is also optimistic about how digital technologies democratize the media. He describes new media cultures as participatory cultures, where everyone can be actively involved in production. Older forms of media, he argues, encouraged people to consume texts in isolation. However, new media audiences are engaged in 'a networked practice'. People use digital media to make connections with other people. They share ideas and information on fan sites, through blogs, and via Twitter and Facebook.

Jenkins argues that, by working together, new media users produce 'collective intelligence'. There is now so much information available to us that we need to work with other people in order to make sense of it. Wikipedia is a clear example of collective intelligence, with people cooperating to map the complex world in which they live. However, collective intelligence can take a variety of forms. For example, sports fans who share information, insights, criticisms and gossip on Twitter work together to make sense of the sport they love.

> *By convergence, I mean the flow of content across multiple media platforms, the cooperation between multiple media industries, and the migratory behaviour of media audiences who will go almost anywhere in search of the kinds of entertainment experiences they want ... I will argue here against the idea that convergence should be understood primarily as a technological process bringing together multiple media functions within the same devices. Instead, convergence represents a cultural shift as consumers are encouraged to seek out new information and make connections among dispersed media content.*
> Henry Jenkins 2006: 2–3

For Jenkins, convergence is much more than the way in which different media become interconnected. Convergence also applies to our activities as media users. As we roam the web seeking out information from multiple sites, we also make connections between a wide range of texts and ideas. Jenkins argues that doing so makes audiences active participants in new media cultures.

Key idea

Digital optimists argue that digital technologies can be used to democratize the media and to enable users to become creative participants in new media cultures.

Hesmondhalgh (2013) identifies three key problems with digital optimism.

1 Digital optimism does not take sufficient account of **digital divides**. Not everyone has an equal opportunity to participate in digital media cultures (see Case study).

2 Digital technologies create new forms of power and do not significantly challenge the dominance of large conglomerates in the media industries.

3 Digital media create opportunities for new forms of commerce and surveillance.

You will learn more about these issues in the rest of the chapter. Although digital media are used to create new forms of participatory media culture, they are also used by large business enterprises to create new forms of profit and control.

Case study: The digital divide

There are stark divisions between people who have the opportunity to take full advantage of digital technologies and those who do not.

At a global level, there are vast inequalities between nations in terms of their access to the Internet. For example, a 2014 report by the International Telecommunications Union showed that 11 per cent of households in Africa had Internet access compared to 78 per cent of households in Europe (ITU 2014). These inequalities can exacerbate existing forms of deprivation. If you have access to the Internet, try to think about some of the ways you would be disadvantaged if you did not have it.

There are also inequalities within nations. In 2014, 19 per cent of households in the UK had no Internet access and 27 per cent of adults did not have access to a fixed broadband connection.

Internet usage was lowest among the over 75s and the working class. Figures from the US in 2013 show that 15 per cent of US adults did not use the Internet at all and 46 per cent of low-income households had no broadband access access (Ofcom 2014a, Smith 2013).

Although some people may choose not to use the Internet, in the majority of cases non-users have little choice. For example, in many countries, broadband provision first develops in areas that are profitable for broadband companies. This means that broadband is more likely to be available in places that are densely populated or that have an affluent population who would be willing to pay for broadband.

The Internet is now assumed to be a key way of participating in the world we live in and gaining information we need. Those nations and groups with lower levels of Internet and broadband access tend to be nations and groups who are already disempowered.

People also require skills to participate fully in rapidly changing digital cultures. The ability to post content, share ideas, make videos or create a blog depends on a wide range of skills that are often referred to as digital literacy (see Chapter Fourteen). The uneven distribution of these skills tends to reflect wider social inequalities (Flew 2014).

The videogames industry

Digital technologies have been used to create new media forms such as videogames. The early videogames of the 1970s and early 1980s were not a huge commercial success. However, since the mid-1980s the games sector has boomed. Estimates suggest that the global revenue from videogames in 2014 was over $80 billion.

Like other media industries, games publishers offer a wide range of titles in order to spread their risks. A few games will become hits, but the vast majority will make a loss. Successful titles such as *Call of Duty* and *Grand Theft Auto* generate huge profits that offset these losses.

While innovation can bring huge financial rewards, games publishers often focus on tried-and-tested ideas. They know there is a market for 'hardcore gamer' genres such as first-person shooter, sports and action games. Therefore, they will often target this market rather than create innovative products for niche audiences (Flew 2014). An even more conservative approach is to simply produce an upgrade to – or a spin-off from – an already proven success (Keogh 2015).

Games are designed and produced by games developers. Some developers work for smaller independent companies but games publishers and console producers also have their own in-house developers. Games publishers act in a similar manner to book publishers and are responsible for developing and marketing games. The industry is dominated by a small number of multinational companies. Some of the largest games publishers, such as Nintendo and Sony, also produce consoles while others, such as Electronic Arts (EA) and Activision Blizzard, do not (Flew 2014).

Independent games designers, just like independent music labels, are often seen to offer an alternative to mainstream games produced by large corporations. However, some independents have grown into large enterprises. Mojang, which designed and developed *Minecraft*, has grown from a one-man operation into a publisher for other designers (Keogh 2015).

There are close links between the videogames industry and the more established media industries. Sony, producer of the Playstation console and publisher of games such as *Tomb Raider* and *Gran Turismo*, is also a major player in the film and music industries. Games publishers also work on cross-platform content with other sectors of the industry. For example, film producer Dreamworks contracted Activision Blizzard to produce games associated with the films *Madagascar* and *Kung Fu Panda*.

The games industry has a distinctive relationship between designers, publishers and consumers. Since the mid-1990s, core gamers have worked collectively in online communities to modify computer-based games. More recently, games such as *World of Warcraft* and *Doom* 'have actively promoted and assisted user modification' (Flew 2014: 98).

These online communities fit with Jenkins' model of participatory communities producing 'collective intelligence'. However, some critics argue that gamers' modifications do some of the work of games development for little or no financial reward. Gamers provide free labour to the media industries.

Key idea

Videogames are produced through complex relationships between console producers, games developers, games publishers and consumers.

Spotlight: DIY game production

Games are not just created by professional developers. Some amateurs use game development software to create their own. Members of the DIY game scene diversify the range of games on offer and some produce games that challenge the male domination of the mainstream industry (Keogh 2015).

Transforming distribution: The long tail

You have already learned that profits in the media industries are generated by a small number of high-grossing hits. Much of what is produced makes a financial loss. The films on offer at most multiplex cinemas and the songs played on mainstream radio are a small proportion of the films and songs produced. The media industries tend to be motivated by the search for the next blockbuster hit.

Commentators such as Chris Anderson argued that the Internet can be used to change this emphasis on hits. The web enables a huge range of texts to be circulated, from the latest Beyoncé single to a singer songwriter in a Norwegian village producing tracks in their bedroom. Anderson claimed that this offers consumers much more choice. Using search engines and large online retailers, people can seek out diverse texts that meet their

own individual interests. The Internet enables more people to produce and distribute texts, further increasing the diversity of texts available. (Lister et al. 2009)

Anderson predicted that the media industries would no longer be dominated by hits. Instead, what he called 'a long tail' of diverse media texts would play a much more significant role. He predicted a huge market for niche products once they could be widely and easily distributed.

There is evidence to support Anderson's claims. Small bands generate income selling their music directly on the web, some with considerable success. The most high-profile bloggers make a living by selling advertising on their sites (Lister et al. 2009).

If you look at major online retailers such as Amazon, you will see evidence of 'a long tail'. Amazon sells an incredibly diverse array of media texts, from the biggest music hits to obscure texts aimed at niche audiences. Authors can bypass major publishers and create their own digital books for consumers to download on to devices such as the Kindle.

However, Anderson's argument only really works if potential audiences know that the texts they might want are out there. Although retailers such as Amazon sell a vast array of media texts, they also heavily promote bestsellers. Many people can start a blog or put music online but there is no guarantee that anyone else will find it on the Internet and consume it.

Hesmondhalgh argues that there is a huge range of texts available on the web but they do not have an equal chance of being seen or heard. Search engines tend to promote sites that are already highly ranked. Sites with a high number of visitors are guaranteed more visitors. A relatively small number of websites dominate Internet traffic. The range of ideas and information that reach most people remains limited.

Key idea

'The long tail' refers to the wide range of niche, non-mainstream texts that are available to consumers via the Internet.

Spotlight: YouTube and viral videos

There are high-profile cases of videos produced by ordinary people that reach massive audiences. Viral videos are examples of how users create their own 'hits' by recommending and sharing media. In October 2013, 'Charlie bit my finger – again!' – a 55-second video of a baby biting his brother's finger – was the sixth most viewed clip on YouTube. But if we look at other clips in the Top 100 most viewed videos at the same point in time, we see that ten were official music videos featuring Rihanna. This suggests that the texts that audiences watch on YouTube are often remarkably similar to those promoted by the media industries.

The Internet and advertising

As you learned in Chapter Three, the media industries are businesses that sell commodities for a profit. Digital media are not only used to create new commodities such as videogames, but they also have opened up new ways of creating profit from advertising. The Internet is a thoroughly commercial space and is used to sell audiences to advertisers.

Hesmondhalgh (2013: 331) observes that 'advertising encroaches on nearly all aspects of web communication'. Visit YouTube and you'll find display advertising on the web pages, adverts that promote videos, and adverts at the start of a video stream. Visit a newspaper website such as *The Guardian* and you will find banner adverts targeted at all readers, advertising features, and personalized ads based on your own browsing history.

This targeted advertising is the result of the commercialization of user information. Internet users leave traces of themselves behind when they move through different websites. This information is extremely valuable because it can be sold. In 2010, more than 90 per cent of Google's revenue came from advertising. Google works by matching the ads it displays to the knowledge it has built up about a user's tastes and habits.

> *Google and Facebook, with their instant personalization facilities, are vast storage containers of personal information that users 'freely' provide. Despite concerns over safety and privacy, this data is then mined for its commercial value, leading Vincent Mosco to argue that digital technologies, far from challenging the logic of commodification, are now used to refine the process of delivering audiences of viewers, listeners, readers, movie fans, telephone and computer users, to advertisers'… User-generated content, therefore, has a dual character: it is suggestive of a more participatory form of creativity and yet simultaneously very cost-effective as a means of generating free content that helps advertisers and marketers more precisely to identify and target desirable audiences.*
>
> Des Freedman 2012: 82–3

User-generated content on the Internet has a commercial value. When you post on Facebook or comment on a newspaper story, you create content. Most people are not paid for creating this content. However, it is used by businesses such as Google to generate profit through advertising sales. If you create content by posting on Facebook, you help to produce a rich online environment that is attractive to advertisers.

The information you reveal about yourself through your Internet use also enables advertisers to target you as a potential consumer. Sites such as Facebook compile vast amounts of data about their users. This data is used 'for *classifying* users into consumer groups' (Fuchs 2012: 58). Facebook generates profit by using this data to match users to advertising.

This generates concern about how the Internet is used as a form of surveillance. Companies such as Google and Facebook store vast amounts of information about people and their activities. When we use the Internet, we let powerful companies monitor us and sell the knowledge they have acquired about us. There are serious concerns about how this data is used and whether powerful groups can use this information to strengthen their position.

Key idea

Advertising saturates most aspects of the web, and personal information about web users is used to generate profit.

Hesmondhalgh (2013: 361) argues that the 'radical potential of the Internet' has been limited through 'its partial incorporation into a large, profit-oriented set of cultural industries.' Digital media offer opportunities to loosen the control of large media companies and give more people the ability to participate in the production and distribution of media. However, as with more established media, digital media are used to generate profits for large corporations. Activities in 'new' and 'old' media industries are closely intertwined.

Dig deeper

Flew, Terry (2014) *New Media*, 4th edition, Oxford: Oxford University Press.

Freedman, Des (2012) Web 2.0 and the Death of the Blockbuster Economy. In James Curran, Natalie Fenton and Des Freedman, (2012) *Misunderstanding the Internet*, London: Routledge.

Hesmondhalgh, David (2013) *The Cultural Industries*, 3rd edition, London: Sage, Chapters Nine and Ten.

Jenkins, Henry (2006) *Convergence Culture: Where old and new media collide*, New York: New York University Press.

Oakley, Kate and O'Connor, Justin (2015), eds, *The Routledge Companion to the Cultural Industries*, Abingdon: Routledge, Chapters Seven, Eight, Ten and Eleven.

Fact-check

1 Media convergence refers to:
 a Increasing interconnection between media forms and content
 b Increasing inequalities between media users
 c Analogue media technologies
 d The domination of new media by advertising

2 Which of the following best illustrates media convergence?
 a The media industries' focus on blockbuster hits
 b The long tail
 c The opportunities offered by digital media to decrease the dominance of the major players in the media industry
 d The way in which movies are now transmedia products that are developed across multiple platforms

3 Digital optimists tend to associate new media with:
 a Increased surveillance and control
 b Creating more democratic and participatory media cultures
 c The increasing concentration of ownership of the media
 d Passive media audiences

4 Why do some researchers view new media cultures as participatory cultures?
 a There is tighter regulation of media
 b There is an increasing digital divide
 c More people can produce and distribute media content
 d Search engines are important for filtering information

5 The digital divide refers to:
 a The ways in which media conglomerates compete for audiences
 b Inequalities in access to digital technologies
 c The division between digital optimists and pessimists
 d The increasing power of companies such as Google to divide audiences into groups to sell to advertisers

6 The long tail refers to the ways in which:
 a Large media conglomerates use their power
 b New media create a greater focus on blockbuster hits
 c Digital media are used to distribute niche texts to media audiences
 d Search engines promote highly ranked sites

7 Which of the following best describes the business strategies of major videogames publishers?
 a They try to produce innovative games for niche audiences
 b They aim to challenge the male domination of the games industry
 c They try to capitalize on existing successes
 d They try to produce new genres

8 Search engines such as Google are:
 a Set up to promote as wide a range of websites as possible
 b More likely to promote highly ranked websites
 c Give all websites an equal opportunity to be seen
 d Prioritize alternative viewpoints

9 Internet sites create data about people's tastes and habits in order to:
 a Sell this information
 b Create a public library of information
 c Support academic research
 d Create a participatory culture

6

Media, Politics and the Public Sphere

Media are such a normal part of everyday life that it is easy to take them for granted. Most people rarely think about what part the media should play in society or whether they should have particular obligations to the public. This chapter encourages you to reflect on what roles and responsibilities the media should have in the modern world.

One debate about these issues focuses on the media's responsibility to serve the public. In previous chapters, you learned how the activities of the media industries often focus on how to make a profit rather than how to serve the public. However, there are different ways of organizing media production. In many nations, profit-driven media industries exist alongside public service media providers such as the BBC. This chapter introduces you to key debates about public service broadcasting.

You will explore a series of debates about the role of media in the public life of nations. Media play an important role in connecting people to other members of their nation and enable them to share common experiences. You will learn how media create a sense of national belonging.

This chapter also introduces you to important debates about the role of media in political life. Without media, most people would have little knowledge of key political issues and the activities of government. People rely on the media for news that their country is going to war or that politicians plan to increase student tuition fees. In democratic societies, people do not expect the media to act as a mouthpiece for the government. Most people expect the media to act on their behalf and to investigate what is really going on, rather than simply presenting what politicians say is going on.

However, many people argue that media have another key political responsibility. They should not only inform the public, but should also enable people to be active citizens of a democratic society. This requires the media to offer a space where people can have their say, where different views and voices can be heard. In this chapter you will explore debates which assess how effectively the media fulfills these roles and carries out these roles and responsibilities.

This chapter will help you to understand:

▶ Public service broadcasting.

▶ How media enable people to experience the public life of nations.

▶ The media as a public sphere.

▶ Debates about whether the media enable people to participate in the political life of democratic societies.

Public service broadcasting

You have already learned that most of the media industries are businesses. They produce media to make profit. However, production does not have to be organized this way. Public service broadcasting was set up to serve the interests of diverse audiences rather than those of big business.

Although there is public service broadcasting in many countries, it is often inspired by the model developed in the UK by the BBC in the 1920s. As you learned in Chapter Two, the British government decided that radio was much too powerful a medium to be put in the hands of private companies motivated by commercial gain. However, they also believed that broadcasting must be independent from the government so that it could not be manipulated to serve political interests.

For this reason, the BBC was created as an independent institution. It was initially funded by a licence purchased by radio owners, but today television owners are required to buy a TV licence. In theory, this makes public service broadcasting independent of commercial influences such as advertising, and relatively independent of the government. However, because the government has the power to set the licence fee, the BBC has never been completely free from its influence.

Lord Reith, the first director general of the BBC, played a key role in shaping the principles of public service broadcasting. He believed that the role of public service broadcasting was to inform, educate and entertain. For Reith, this was the best way of serving the public's interests as it enabled people to become informed and

active citizens. Although early BBC radio did offer entertainment, it also prioritized programmes that aimed to educate the audience about their nation, culture and the wider world.

Public service broadcasting is associated with 'mixed programming' that is available to everyone. In the early days of BBC radio – and, later, BBC television – a wide variety of programmes covering a range of interests were combined in a single channel addressed to a national audience. While commercial broadcasting targets audiences who are attractive to advertisers, public service broadcasting is meant to treat all members of the audience equally. Even today, channels like BBC1 combine light entertainment, comedy and sport with documentaries, religious programming and politics.

Key idea

Public service broadcasting is based on the principles of providing mixed programming in order to inform, educate and entertain the public.

Commercial broadcasting, funded by advertising, was introduced in the UK in 1954 with the launch of ITV. However, this new channel was still required to address the principles of public service broadcasting and to serve a broad audience. Today, all of the five major free-to-air channels in the UK have a public service remit.

Paddy Scannell (1997) argues that public service broadcasting operates as a public service in three ways:

1 It creates 'a new kind of public life' by transmitting and creating events. Broadcasting gives access to already established events, such as a major football match or tennis at Wimbledon, that were previously only accessible to a minority. But broadcasting also creates public events such as charity fundraisers (in the UK, *Comic Relief* or *Children in Need*).

2 It is accessible to the public. Public service broadcasting is a national service available to everyone (although, in the UK,

TV viewers should have a TV licence). This is in contrast to subscription cable or satellite services that are only available to those with the ability to pay a substantial charge.

3 It presumes 'a general public' who are its audience. However, this can be problematic. Public service broadcasters like the BBC have been criticized for being elitist because they address white middle-class viewers and do not reflect the diversity of the public.

Many countries have adopted a version of the British model of public service broadcasting. Examples include ARD in Germany and DR in Denmark. A major exception is the US, where broadcasting is dominated by commercial interests. Nonetheless, some US channels have a public service remit that shapes their activities. Many other countries have one or more public service broadcasting channels. These coexist with commercial channels.

However, the idea that broadcasting offers a shared experience of public life to members of a nation is no longer straightforward. For example, government policy in the UK in the 1990s opened up opportunities to new commercial TV providers. There are now a vast number of channels available via digital and cable systems that do not have a public service remit. There was a similar pattern in many other nations.

As the number of channels proliferated, some people were concerned that audiences no longer shared a common television culture. People could choose to watch specialist channels devoted to specific interests such as horror, cooking or sport. However, although the TV audience has fragmented to some extent, television still enables people to share common experiences. For example, 80 per cent of the TV audience in the UK watched Andy Murray win the 2013 Wimbledon tennis championship on BBC1.

The future of public service broadcasting is also unclear. Businesses increasingly provide services such as electricity and education that were once provided by public institutions. Some politicians argue that broadcasters such as the BBC should no longer receive public funding. All radio and television providers should operate on an equal footing, they argue, and compete for audiences and revenue from sales and advertising. However, many people fear that crucial aspects of public service broadcasting would disappear without public funding.

Spotlight: Television events

Television events enable national audiences to share a common experience. Sporting events often attract the highest viewers. But television also creates its own must-see national events that attract massive audiences. By October 2015, the most-watched TV show of the year in the UK was BBC1's *The Great British Bake Off*, a baking competition. The show attracted exhaustive newspaper coverage and became a must-see event. Other nations follow a similar pattern. The 2010 season finale of *MasterChef Australia* was the most-watched entertainment show in Australian TV history. To avoid clashing with the show, politicians were forced to reschedule a national election debate.

Case study: The future of public service broadcasting in the UK

Public service broadcasting is under threat. Many Western governments believe that the most effective way of delivering media is through competition between different providers. They argue that public funding gives public service broadcasters an unfair advantage over their competitors. From this perspective, the media industries should operate as a free market.

James Curran (2010) summarizes some of the key arguments made against the continued public funding of the BBC. Those in favour of a free market argue that increased competition gives the public more choice. As consumers, audiences can choose which media they want. In this situation, the television and radio

providers who survive will be those who are most efficient and give the public what they want.

Curran argues that it is crucial to defend public service broadcasting because:

▶ Public service broadcasters have an obligation to deliver impartial news and to cover public affairs. This enables people to be informed citizens and active participants in a democracy. Market-driven media have no such obligation. They also tend to prioritize popular entertainment programming.

▶ Public service broadcasting doesn't just focus on what is profitable. It can devote resources to creating programmes that are expensive to produce but culturally worthwhile. It is also required to produce programming for minority audiences who are ignored by market-driven media.

▶ Public service broadcasting has an important role to play in creating a sense of community among its audience. It 'maintains a cultural space through which society can express itself and define its collective identity' (Curran 2010: 381).

Key idea

Public service broadcasting should provide objective news coverage that helps viewers be informed participants in the life of democratic societies.

Broadcasting and the experience of national public life

Debates about the importance of public service broadcasting highlight the key role that radio and television play in national life. This section uses the work of the media historian Paddy Scannell (1997) to develop these ideas. You will learn how the media enable ordinary people to participate in the public life of the nation. You will also learn how the media create a sense of national community.

Scannell argues that broadcasting brings public life into the private sphere of the home. Public and private life are often seen as separate. This is based on a distinction between public and private spheres that emerged in many Western countries in the late eighteenth century. From this time onwards, the public sphere was associated with the world of work, politics and the economy, and the private sphere was associated with the world of home and family. These ideas continue to shape the way in which many Western societies are organized.

> *Broadcasting has brought into being a culture in common to whole populations and a shared public life of a quite new kind... The fundamentally democratic thrust of broadcasting lay in the new kind of access to virtually the whole spectrum of public life that radio first, and later television, made available to all. By placing political, religious, civic, cultural events and entertainments in a common domain, public life was equalized in a way that had never before been possible.*
> Paddy Scannell 1997: 62, 65

Broadcasting enables people to experience public life within their homes. Scannell argues that this has a number of consequences:

1 **Radio and television democratize public life.** Public events that were once only accessible to few people become widely available to people within their homes. For example, few people will ever attend a sitting of parliament or the Wimbledon final but broadcasting enables large numbers of people to share in these events.

2 **Broadcasting helps to create a sense of national community.** This idea draws on the research of Benedict Anderson (1991) who argued that a nation is an 'imagined community'. The national community is 'imagined' because we will never meet all the other people who live in our nation. Nonetheless, people feel a sense that they share a common identity and interests with people who are part of the same nation.

This development of the media creates this sense of connection and belonging. Before there were national daily

newspapers, people had little sense of having something in common with others who lived in the same country. The newspaper highlighted shared interests and created a sense of shared identity. Broadcasting has developed this further.

3 **Broadcasting creates a shared history and experience of events.** These events enable communities who are scattered across a large geographical space to participate in the same public rituals. In the UK, this may be a royal wedding or a major international football match.

The estimated 26 million British people who watched the wedding of Prince William and Kate Middleton in 2011 is a tiny audience compared to those for major TV events elsewhere. For example, in China an estimated 700–800 million people watch the Spring Festival Gala on television at New Year (Chandran 2015). Other large television events also create a common broadcast experience. For example, the talent competition *China's Got Talent* has attracted audiences of over 400 million people (Sweney and Kaiman 2014).

4 **Broadcast news plays an important role in connecting audiences to public life and to each other.** Television news defines important events and issues for us as members of a nation. The regular time slots of news bulletins enable people to share not only the same information but also the common ritual of watching the news.

Key idea

The media make the experience of the public sphere available to ordinary people in the private sphere of the home.

Broadcasting does not just bring public life into our living rooms. It can also turn the everyday life of ordinary people into public viewing. There is a long history of TV shows that take ordinary people and their experiences 'and transform them into a public, shareable and enjoyable event' (Scannell 1997: 67). More recently, television has become increasingly fascinated with ordinary people. Reality shows such as *Wife*

Swap and *Gogglebox* enable the audience to watch ordinary people in a domestic setting.

Media, politics and the public sphere

There is considerable debate about the role of the media in the political life of societies. Many commentators believe that media have a responsibility to inform people about political life. People need this information in order to be citizens who can actively participate in decisions about how their society functions. Furthermore, many people argue that the media should offer a space where people can hear diverse opinions and engage in a dialogue about political issues.

If the citizenry is to play a role in a democracy then it needs access to an institutionally guaranteed forum in which to express their opinions and to question established power... The media now constitute the major forum for political communication. Thus the debate about public involvement of citizens in political communication leads to questions about the media as a public sphere where the relations between power and citizenry take place.

Sonia Livingstone and Peter Lunt 1994: 10

The German sociologist Jurgen Habermas (2006) argues that the media should act as a public sphere. It is important to note that he uses the term 'public sphere' in a much narrower way than Paddy Scannell. For Habermas, a public sphere is a

space where people come together to freely discuss political issues and formulate political strategy.

Habermas identifies how newspapers have acted as a public sphere. From the late seventeenth century onwards, the press created a public space for reasoned debate about political issues. The newspapers of the period did not just represent the views of the powerful but offered a range of viewpoints.

As the press developed in the eighteenth century, people used it to create new forms of public discussion about politics. People met in coffee houses to read newspapers and engage in political debate (although these opportunities were largely restricted to middle-class men). This enabled them to take an active part in shaping the direction of political life.

This relationship between newspapers and their readers offers a model for the role the media should play in political life. Habermas argues that the media should act as a forum for public debate, and also provoke it. This enables everyone to be involved in shaping public opinion.

Key idea

Habermas argues that media should operate as a public sphere which offers a forum for many people to participate in political debate.

By the end of the nineteenth century, Habermas argues, the media no longer operated as a public sphere. Politicians became increasingly skilled at using the press to give their version of events. Newspaper ownership became concentrated in the hands of powerful individuals who viewed the media as a business.

These owners viewed newspapers primarily as vehicles for advertising. The press no longer aimed to produce and reflect political debate. The communication process became increasingly one-way as advertisers targeted their products at consumers. Newspapers ceased to address their readers as active citizens but instead considered them an audience of potential consumers for the products they advertised.

Many people believe that contemporary media rarely operate as a public sphere. However, there are still spaces where audiences can participate and help to shape public debate. Letters pages offer newspaper readers the chance to give their views on events. Some TV series enable ordinary people to interrogate public figures. For example, on BBC1's *Question Time*, members of the public get the opportunity to demand that politicians listen and respond to their concerns.

Some researchers argue that contemporary media have drifted even further away from the ideal of a public sphere. They claim that there has been a tabloidization of news and broadcasting. This refers to a process in which media increasingly focus on sex, sport, celebrities and scandals. As people have fewer opportunities to access serious debates about political affairs, they are no longer equipped to actively participate in political life.

Key idea

Commercialization undermines the media's role as a public sphere because audiences increasingly are addressed as consumers rather than citizens.

The Internet as a public sphere

As you learned in the last chapter, the Internet offers new possibilities for public participation. Many more people have the opportunity to express their views. They can set up their own websites, comment on newspapers' websites and debate ideas using social media.

Some researchers argue that the Internet's participatory culture is a new form of public sphere. It enables people to enter into a dialogue about political and social life. For example, online newspapers allow far more readers to have their say than the letters columns in print newspapers. In 2012, *The Guardian* online

newspaper in the UK recorded around 600,000 reader comments a month. Readers do not just respond to articles in the newspaper but also engage with each other's comments (Elliott 2012).

Indeed, the Internet can appear to be more democratic than the eighteenth-century public sphere described by Habermas. The Internet offers a range of people a chance to voice their opinions although, as you learned in the last chapter, not everyone's voice has the same chance of being heard.

The Internet offers other new opportunities for people to become active citizens. For example, online petitions enable people to register their feelings about political issues with the click of a button. Some of these campaigns have shaped political debate. However, some commentators question whether clicking a link demonstrates serious political engagement and dialogue (White 2010).

The Internet seems liable to have a fragmentary effect... Rather than encouraging people to share content with or engage with diverse groups of others as part of broad publics, the ability to choose exactly what or who to engage with seems more likely to result in pursuit of particular interests and association with narrower groupings... Rather than encourage political interest, knowledge or participation among those for whom such subjects had little previous appeal, the Internet maximizes the ease with which people can opt out of the broader public sphere in favour of their existing interests.
Paul Hodkinson 2011: 189

Hodkinson suggests that the Internet does not promote the same form of public arena for widespread debate as some more established forms of media. The public sphere breaks down into multiple, more focused, communities who may not communicate with each other. People concentrate on issues that concern them but may be uninformed about wider political contexts.

Key idea

The Internet has the potential to operate as a public sphere by enabling opportunities for more democratic and participatory forms of communication.

Spotlight: One voice among many

Optimistic accounts of the sheer amount of participation on the Internet can sometimes ignore what happens when media users are faced with so many voices. This is neatly illustrated by 'Dancin Santa' in a post on Slashdot.org. 'If everyone has a voice, no one really has a voice. Any single voice will be drowned out by many thousands of "Gee, this is my blog, I thought it would be a good idea to start one because my cat is so cute. I'll post pictures of my cat and I love Jesus"' (cited in Hindman 2009: 38).

The media play an important role in the political life of democratic societies. They should enable the public to be informed about important issues and to provide a forum where different views can be heard. However, there is considerable debate about whether contemporary media live up to these standards.

Many people agree that the media should have some responsibilities to the public, although they often disagree about the nature of these responsibilities. The next chapter explores these issues by considering whether the media should be regulated to ensure they fulfill particular roles and obligations.

Dig deeper

Curran, James and Seaton, Jean (2010) *Power Without Responsibility: Press, broadcasting and the Internet in Britain*, 7th edition, London: Routledge.

Habermas, Jurgen (2006) The public sphere: An encyclopedia article. In Meenakshi Gigi Durham and Douglas M. Kellner, eds, *Media and Cultural Studies: Keyworks*, Oxford: Blackwell.

Hodkinson, Paul (2011) *Media, Culture and Society: An introduction*, London: Sage, Chapters Eight and Nine.

Livingstone, Sonia and Lunt, Peter (1994) *Talk on Television: Audience participation and public debate*, London: Routledge, 9–35.

Scannell, Paddy (1997) Public service broadcasting and modern public life. In Tim O'Sullivan and Yvonne Jewkes, eds, *The Media Studies Reader*, London: Arnold.

 Fact-check

1 Lord Reith believed that the role of the BBC was:
 a To educate, agitate and organize
 b To inform, educate and entertain
 c To offer a retreat from the public sphere
 d To focus on the political life of the nation

2 Public service broadcasting:
 a Offers mixed programming
 b Focuses on news and current affairs
 c Concentrates on specialist programmes serving minority audiences
 d Creates popular programmes for affluent audiences

3 Public service broadcasting should provide news that:
 a Is entertaining and enjoyable
 b Represents the views of the government
 c Helps audiences to be informed participants in democratic societies
 d Focuses on celebrities, scandals, sport and weather

4 Why did Habermas believe that newspapers once operated as a public sphere?
 a Because newspapers enabled powerful groups to express their views
 b Because newspapers offered a forum for many people to participate in political debates
 c Because advertising influenced the content of newspapers
 d Because newspapers were consumed in public places such as coffee shops

5 Habermas argued that the main threat to the ability of nineteenth-century newspapers to operate as a public sphere was:
 a The rise of the radical press
 b Their readers were becoming increasingly active citizens
 c They became a forum for public debate
 d Commercialization that caused readers to be addressed as consumers rather than citizens

6 Tabloidization is associated with:
- **a** The dumbing down of media news
- **b** The democratization of the Internet
- **c** The provision of objective news to create informed citizens
- **d** The ability for readers to debate the news in online newspapers

7 Which of the following is a criticism of the idea that the Internet operates as a public sphere?
- **a** Newspaper websites create spaces for people to comment and interact
- **b** Twitter enables people to create political campaigns and debate ideas
- **c** The Internet consists of multiple and fragmented communities who do not interact with each other
- **d** Online petitions enable people to register their ideas on political issues

7

Media Regulation

Media regulation exists in order to promote desirable forms of media activity and to discourage undesirable forms. This might sound straightforward but there is considerable disagreement about what is 'desirable' and what is 'undesirable'. It is worth pausing for a moment to reflect on which types of media activity you think should be promoted and which should be prohibited.

Most national governments have policies that set out their views on the role the media should have in society. Some forms of regulation aim to promote activity that is seen as beneficial to society. For example, some governments provide funding for film production in order to boost their nation's film culture. Other forms of regulation aim to restrict or prohibit certain activities. For example, a government may want to restrict the circulation of 'extremist' political views, clamp down on pirate radio stations or control how advertising targets children.

Because media regulation is a political issue, questions about how to regulate the media are fiercely contested. Many people argue that forms of regulation are an attack on freedom. This may be the freedom of individuals to express their ideas or the freedom of media corporations to seek ways of expanding their operations. In this chapter, you will learn how tensions between freedom and regulation structure debates about the media.

This chapter introduces you to different forms of media regulation and some of the institutions and bodies that regulate the media. You will examine arguments about why the media should be regulated and debates about whether regulation is desirable. As the chapter progresses, you will have the opportunity to explore some aspects of media regulation in more detail. These include press regulation and the phone hacking scandal, copyright and piracy, and censorship.

This chapter will help you to understand:

▶ Different types of media regulation.

▶ Debates about whether the media should be regulated.

▶ Debates about who should regulate the media.

- Copyright, piracy and the regulation of distribution.
- Censorship.

Forms of media regulation

Media regulation aims to maximize the benefits of the media while minimizing any potentially harmful effects (Branston and Stafford 2010). Regulation also promotes and encourages media practices that are viewed as beneficial to society.

Film quotas provide a good example of how regulation can encourage some practices and restrict others. Some nations use quotas to limit imports of foreign films in order to promote and support their national film industry. For example, China only allows 34 foreign films to be screened in cinemas each year. This offers a way to resist the dominance of Hollywood while ensuring the health of the Chinese film industry. Using regulation to support cinema can also offer a way of supporting the national economy and national culture.

There is considerable disagreement about how the media should be regulated. People disagree about what is harmful and what is beneficial. For example, some people claim that pornography should not be regulated because people should be free to explore their sexuality. Other people claim that pornography degrades and exploits women and should be censored.

Key idea

Media regulation aims both to prohibit or restrict what are seen as undesirable aspects of media and to promote other aspects of the media.

If media policy suggests the broader field where a variety of ideas and assumptions about desirable structures and behaviour circulate, then regulation points to the specific institutional mechanisms for realizing these aims [...] Media

Media policy is a way of imagining how the media should be and forms the basis of different forms of media regulation. Branston and Stafford (2010: 299–301) identify six main forms of media regulation that are used in contemporary societies:

1 **Direct government control.** Most governments do not take direct control of the media. However, countries with authoritarian governments often directly intervene in the practices of the media industries. For example, the North Korean government uses the state-run TV channel Korean Central Television to promote the views of the ruling party and celebrate its achievements.

 Even in democratic societies, the government may make direct interventions. For example, the British government sometimes attempts to stop news stories that they see as a threat to national security.

2 **Independent statutory regulators.** This is the most common form of media regulation in Europe. Governments award powers to an independent body that enacts legislation on specific aspects of media regulation.

 In the UK, for example, Ofcom regulates the communications industries. If a member of the public makes a complaint about a TV programme, Ofcom conducts an investigation. In the US, the Federal Communications Commission (FCC) oversees the communications industries.

3 **Self-regulation by the media industries.** Rather than being regulated by an external body, some media industries operate their own regulatory body. For example, the British advertising industry regulates itself though the Advertising Standards Association (ASA). The ASA issues guidelines for advertisers and examines complaints from the public. Many people have questioned the effectiveness of self-regulation. This has been a particular concern in relation to the press (see below).

Self-regulation also operates in more informal ways. For example, TV production teams are aware of the kind of material that generates complaints and may decide not to include it in the first place.

4 **Legal frameworks.** Legal frameworks constrain how the media industries operate. For example, individuals may take legal action against the media using privacy or libel laws. In one case, the actress Sienna Miller sued the British newspaper the *News of the World* for invasion of privacy after journalists hacked her phone and read personal emails. She was awarded £100,000 damages. There will be further discussion of the UK phone hacking scandals later in the chapter.

5 **Regulation by market forces.** Some people claim that the media do not need official forms of regulation. They argue that if consumers find some texts unacceptable, then they can choose not to purchase them. If many people find a text unacceptable, then it will no longer be financially viable.

6 **Audience pressure.** Pressure groups organize against media content that they consider offensive or dangerous. For example, in the mid-1980s, the Parents Music Resource Centre formed in the US to campaign against content in music that they saw as offensive and damaging to children. As a result, many record labels agreed to put 'Parental Advisory: Explicit Lyrics' stickers on their albums. Of course, these stickers possibly made the music even more appealing to some children!

Spotlight: No More Page 3

No More Page 3 is a campaign to change the content of the media. It targeted the photos of topless women that had been featured on page three of *The Sun* newspaper since the 1970s. The campaign claimed that the 'Page 3 girl' promoted outdated sexist attitudes where women are seen simply as sexual objects. They wanted the editor to voluntarily remove these images. Although *The Sun* has not made a formal policy change, it has not featured a regular Page 3 girl since January 2015.

Key idea

Media policies set out ideas about how the media should – and should not – operate and these policies underpin different forms of regulation.

Should the media be regulated?

Until the 1980s, media regulation tended to be organized at a national level. Many countries adopted strong forms of regulation to direct the role that the media had in national life.

Media regulation was viewed as important because:

1 Governments considered the media to be powerful. As you have learned already, there are longstanding concerns about the influence of the media on people's ideas and behaviour. In many democratic societies, governments used regulation to prevent the abuse of media power.

Some media are more strongly regulated than others. Broadcasting has been subject to the strongest regulations because of its potential power to shape people's beliefs and behaviours. The creation of public service broadcasting was one mechanism to regulate it.

2 Governments believed that the media play an important role in the cultural life of the nation. Media regulation can be used to promote national culture and limit foreign influence.

Such initiatives still exist. As you learned earlier in the chapter, China uses film quotas to promote Chinese cinema and limit the influence of Hollywood. Australia requires its free-to-air TV channels to ensure that 55 per cent of its programming is Australian. This is in order to develop and reflect 'a sense of Australian identity, character and cultural diversity' (Screen Australia 2015). Many other nations have similar schemes in place.

3 Many governments wanted to ensure that media production was not dominated by a small number of corporations. They introduced economic regulations to limit the concentration

of media ownership and to encourage diverse forms of production.

For example, the UK Film Council (2000–2010) used public funding to enhance the economic sustainability of the British film industry. Government funding helped to boost the industry, create employment and maintain a skilled film production workforce.

The public funding devoted to public service broadcasting is a means of promoting diversity. As you learned in the last chapter, the BBC has a responsibility to serve diverse audiences rather than simply delivering affluent audiences to advertisers.

Should the media be deregulated?

From the 1990s onwards, national systems of media regulation were under pressure. Peter Lunt and Sonia Livingstone (2012) argue that globalization of the media creates two problems:

1 **Digital media are much harder to regulate within national boundaries.** For example, a news story which is legally prohibited in one national context may be reported in news media elsewhere and accessible via the Internet.

2 **Large media corporations want to expand their operations across national borders.** These corporations claim that national systems of media regulation interfere with their ability to sell their products. For example, these corporations argue that regulations which limit how much television programming can be imported also limit their business opportunities.

Key idea

Since the 1980s, the spread of digital media combined with the internationalization of media industries means that it is harder to regulate the media at a national level.

> *The rhetoric of deregulation and liberalization was particularly powerful in the cultural industries because the notion of freedom from government intervention fed on anxieties about government interference in personal and political expression.*
>
> David Hesmondhalgh 2013: 126

Large businesses argue that media need to be deregulated. They claim that consumers benefit from deregulation because they get more choice. Of course, these businesses also benefit from deregulation because they have more opportunities to make a profit.

Deregulation has been a key feature of the media since the 1990s. For example, British broadcasting is no longer limited to a small number of TV channels with public service obligations. In the late 1980s and the 1990s, the Government enabled new satellite and cable channels to operate in the UK. This radically increased the number of television channels available. It also allowed large media corporations to develop their business interests in the UK.

These changes in British broadcasting reflect a wider shift towards deregulation of the media in many nations. Many governments have accepted the arguments made by media businesses about the benefits of deregulation.

However, Des Freedman (2008) argues that the media hasn't really been deregulated but has been re-regulated. Old forms of media regulation have been replaced with new forms. Governments still create legislation about how media should operate. But recent legislation tends to promote the benefits media industries bring to the economy rather than their cultural or social role.

Deregulation of the media sounds appealing because it is associated with fewer restrictions on the freedom of the media. However, deregulation is primarily about removing obstacles that prevent large media corporations expanding their business operations. As powerful media conglomerates gain even more power, diversity within the media is threatened.

Key idea

Deregulation of the media is associated with the removal of government controls that limit the media's activities.

Spotlight: The Great Firewall of China

Some countries have taken stronger measures to regulate digital media. China, using what has become known as 'the Great Firewall of China', has created mechanisms to block a vast range of websites that it regards as subversive. Access to international Internet sites is not prohibited but it is tightly controlled. Some users find creative ways to circumvent these controls.

Regulating the press

The idea of press freedom is central to modern democracies. The press can only challenge those in power if it is free from government interference. In many democracies, therefore, the press is subject to relatively light forms of regulation.

Freedom of the press is clearly an important idea that many people would defend. However, should newspapers and magazines be completely free to do as they please? There are strong arguments for some forms of press regulation.

1 **Economic regulation of the press.** Many people argue that regulation is needed to ensure that newspaper ownership isn't restricted to a small group of corporations. Concentration of ownership limits the range of voices in the press. It also gives their owners considerable power

 In the UK, just three companies control 70 per cent of national newspapers. News UK, owned by News Corp, controls one third of this market. For many people, this is a cause for considerable concern.

2 **Regulation of the press's relationship to government.** The idea of a free press is to give newspapers freedom to speak independently of the government and to voice criticisms.

However, if control of the press is concentrated in too few hands, it has the potential to exercise power over political life.

For example, there are concerns about the power of the press to influence the results of elections. In the UK, the vast majority of newspapers gave their support to the Conservative party in the 2015 election. Many commentators view the lack of diverse position on the election as a threat to democracy (Cammaerts 2015).

3 **Regulation of press ethics.** In most democratic countries, journalists' practices are governed by a code of conduct. This is to ensure that journalists act in an ethical manner.

However, there can be problems enforcing these standards, especially when unethical behaviour has few serious consequences. The demand for sensational stories to boost sales and profits can create pressure for journalists and editors to act in an unethical manner.

Key idea

There is a tension in democratic societies between the need to maintain a free press and the need to regulate the press to prevent threats to democracy and the public.

The phone hacking scandal and the Leveson Inquiry

The problems involved in regulating the press were dramatically illustrated in the phone hacking scandal in the UK. The British press became international news when it was discovered that newspapers had illegally hacked into the phone messages of celebrities and other public figures. The details of this case will enable you to identify some of the problems with self-regulation in the media industries.

The British newspaper industry developed a system of self-regulation in the second half of the twentieth century. From 1991 until 2014, self-regulation was carried out by the Press

Complaints Commission (PCC) which was made up of representatives of the British press. If anyone had a complaint, they could take it to the PCC but the body had no legal power. As a result, complaints about the press were also dealt with through legal frameworks such as privacy and libel laws.

Although there had been earlier investigations into the ethics of the British press, the phone hacking scandal became big news. Initially, it appeared that only one 'rogue' journalist was involved, employed by the News Corp-owned Sunday tabloid the *News of the World*. The journalist was convicted in 2006 after a police investigation discovered he had accessed the voicemail messages of numerous people, including members of the royal family and celebrities.

The PCC conducted their own investigation. They concluded that the phone hacking had been the work of this one journalist acting alone and there was no evidence of widespread or ongoing hacking.

It soon became clear that the practice was much more widespread and that self-regulation had failed to work effectively. The ethical conduct of staff working for the *News of the World* was seriously called into question when it was revealed that the newspaper had hacked the phone of murdered schoolgirl Milly Dowler. It was later revealed that more than 4,000 people might have had their phones hacked by the *News of the World*.

Once the hacking of Milly Dowler's phone was exposed, press regulation became a major national concern in the UK. Rupert Murdoch closed the *News of the World* (although he quickly opened *The Sun on Sunday* to fill the gap in the market). The newspaper's editorial staff were charged with phone hacking and taken to court. The prime minister said that it was evident that the PCC was not fit for purpose and called for an inquiry. This became known as the Leveson Inquiry.

The Leveson Inquiry was a major investigation into press ethics and regulation in the UK. It explored phone hacking and whether journalists used any other illegal practices. It examined relationships between the press and the police and between

press and politicians. The inquiry also investigated the extent to which the press operated in the public interest.

Nearly 2,000 pages long, the 2012 Leveson report recommended new forms of press regulation. Leveson reiterated the need for the press to be free from government interference. However, he recommended the establishment of a new statutory self-regulatory body with greater powers and more transparency than the PCC. The body proposed was to be independent from the government.

The press fought against Leveson's recommendations and a compromise solution offered by the government. Instead, the press set up its own regulatory body, the Independent Press Standards Organization (IPSO). According to many commentators, there are insufficient significant differences between IPSO and the PCC. Despite the scandal, police investigations and the inquiry, a similar system of self-regulation remained in place. IPSO fails to address the majority of the recommendations laid down in the Leveson report.

The phone hacking scandal highlighted problems with self-regulation in the media industries. Although freedom of the press is important in democracies, many people argue that the press needs to be accountable to certain ethical standards.

Copyright

Despite advocating deregulation, the media industries are not opposed to all forms of regulation. They support those forms that protect or enhance their ability to make a profit.

Large media corporations tend to argue for tighter regulations over the right to use, reproduce and distribute texts. These regulations relate to the issue of copyright.

Not all forms of government intervention work to constrain the moneymaking potential of large media corporations. Copyright laws, which establish the right to claim legal ownership of and exclusively publish and distribute original ideas and culture,

> *are essential to the ability of the producers and publishers of such works to make money. Without copyright laws, films, television programmes, pieces of music or other works would be allowed to be copied and either used or sold for profit by any individual or company across the world without any acknowledgement or payment to those who produced them. The prospect of having no control over who can use or sell their finished products would render it virtually impossible for those who invest in the production of original content to profit from doing so.*
>
> Paul Hodkinson 2011: 56

Copyright laws are centred on the ownership of media texts and the right to use them. Such laws date back to the eighteenth century. They were formulated to protect people who produced creative works, enabling them to generate money from their creations. These laws also provided mechanisms by which the public could access and use these works.

As Terry Flew (2014) observes, copyright law is complex. Creators such as songwriters or novelists maintain rights over their music or words. However, rights over the form in which their music or words are circulated tend to be owned by the media industries.

For example, if you wrote a novel, you would retain rights over your ideas – the words in the novel. But to get your novel published, you would give a publisher the right to reproduce your words in the form of a book. In return the publisher would give you royalties based on the book's sales and earn a profit from selling the novel.

Contemporary copyright laws do give users some rights. This is because many people believe that healthy societies depend on the ability of people to access and share ideas. For example, there are laws governing the 'fair use' of texts. Under British copyright law, you could photocopy one chapter of this book for your own personal use. However, you could not photocopy the whole book because the rights to reproduce the book are held by the publishers.

The media industries largely want to set limits on 'fair use' because it restricts their ability to profit from selling texts. If you can photocopy a chapter, you might not buy the book. However, many people believe that there should be far greater free public access to ideas. Creative works and ideas play such an invaluable role in society, they argue, that they should not primarily be produced for profit.

'Media piracy' refers to the reproduction or distribution of media texts by people who do not own the rights to them. The media industries argue that 'pirates' take content illegally and threaten the livelihood of creative workers who receive no royalties on the pirated product. Of course, piracy is also a threat to the profits of the media industry.

While campaigns against piracy pre-date the Internet, digital media complicate copyright issues in many ways. Reproducing digital texts is easy and costs little. A wide range of people share files online and stream content. As a result, there are more copies of many texts in circulation.

Because the media industries view unauthorized online distribution of their texts as a threat to their profits, legal action has been taken against file-sharing and streaming websites. However, it is not only the sites that can face prosecution. For example, over four million people in Germany have been fined for downloading or streaming content (Pimlott 2014).

In order to combat unauthorized reproduction of the texts they own, the media industries have fought for tough international laws on copyright. National regulations are of limited value to companies who also want to sell their products globally. Therefore, whereas most media regulation takes place on a national level, there are now complex international regulations governing copyright.

Ownership of the rights to use texts is often concentrated in the same hands as ownership of the media industries. This situation has provoked campaigns for more open circulation of information and ideas. Campaigners argue that knowledge should not be used to generate profit and that access to knowledge should not be tied to a person's ability to pay.

Key idea

Copyright laws regulate the right to use, reproduce and distribute media texts.

Censorship

Censorship is often associated with forms of regulation that prohibit particular forms of expression. Key targets of censorship include sex, violence, religion and politics. Advocates of censorship frequently argue that it is necessary in order to prevent harm, either to the nation or to specific groups of people.

Censorship is frequently criticized because it stops freedom of expression and the free exchange of knowledge and ideas. However, many people believe some forms of censorship are necessary. It is worth taking a moment to reflect on whether there are any images or forms of knowledge that you think should not be freely available.

In some political regimes, the government closely monitors the information that is circulated. Countries such as Eritrea and North Korea have high levels of political censorship where the state proscribes and tightly regulates the content of the media.

However, even in democratic societies, governments may engage in indirect forms of censorship. For example, although the British government does not dictate the content of the media, it will threaten legal action to prevent the circulation of material that is viewed as a threat to national security.

Censorship is often seen as a tension between 'the public right to know versus the public interest' (Dimbleby and Burton 1998: 185). Governments claim that when they try to prohibit the circulation of material they are acting in the public interest. However, campaigners against censorship often argue that it is in the public's interest to have full access to information.

Spotlight: The Snowden Affair

The British government does not directly censor the media. However, it offers advice that encourages the media not to proceed with specific stories related to national security. This promotes a form of self-censorship by institutions. However, in 2013, *The Guardian* published a story about the extensive surveillance carried out by British and US intelligence agencies, based on information leaked by Edward Snowden. *The Guardian* argued that this information was in the public interest. The government criticized the newspaper's actions, arguing that it was a threat to national security.

In many nations, legal frameworks and regulatory bodies govern which types of media content are permissible. These also govern whether certain forms of content should be restricted to specific age groups. Many concerns about 'appropriate' and 'inappropriate' content focus on representations of sex and violence, religion and other moral issues.

Ideas about what is appropriate are not just enforced by outside bodies. Many media professions and institutions have codes of practice that provide guidelines about what is suitable for particular audiences, and about what might cause harm or offence.

Censorship is not only a negative force. It may prohibit some forms of expression but it also helps to create other forms of expression. This becomes clear if we look at the development of film censorship in Hollywood. From the early 1930s until the late 1960s, the Production Code Administration (PCA) did not just prohibit certain content but also helped filmmakers to create films. The PCA was set up to ensure that films did not offend campaigners who were concerned about the nation's morals and who might call for state censorship. The PCA collaborated with filmmakers to find creative ways to work around images and themes that might offend these campaigners.

Case study: Film censorship in the UK

The British Board of Film Censors (BBFC) was established in 1912 as an independent body financed by fees paid by the film industry. In 1923, after a period of confusion over its role, the government recommended that no film should be exhibited without a classification from the BBFC.

The BBFC's role was not just to censor and classify completed films. In its early days, the board set out guidelines detailing the kinds of representations that would be subject to censorship. In the mid-1930s, it set up a system to assess scripts before they were made. This made the film industry more responsible for self-regulation and reduced the amount of censorship of completed films.

From the late 1950s, both cinema and censorship reflected changing ideas about sexual morality. Although the BBFC enabled the exhibition of films with far more 'adult' themes, it also demanded more cuts as films experimented with provocative material. In the case of some controversial films, the board left local authorities to decide whether a film could be exhibited.

Despite its important role, the BBFC was never granted a legal right to classify or censor films for cinema exhibition. However, in the 1980s, the board gained the right to do this for films distributed on video. Since then, films on video and DVD have been subject to much tighter regulation than those shown at the cinema. This reflects fears that video and DVD might get into the hands of the 'wrong' kind of audience (see Chapter Thirteen).

In the mid-1980s, the BBFC was renamed the British Board of Film Classification. This change was thought to offer a more accurate reflection of its remit which is to classify and label films, in particular with respect to their suitability for specific age groups.

Ideas on how cinema should be classified and censored change over time. In 1967, the BBFC allowed the word 'fuck' to be heard for the first time in British cinemas. Today, the board offers a service which details how many times the word is used in a particular film (Kuhn 2001).

Key idea

Censorship does not just prohibit forms of expression but can also produce new forms of creative expression.

Dig deeper

Branston, Gill and Stafford, Roy (2010) *The Media Student's Book*, 5th edition, London: Routledge, Chapter Ten.

Fenton, Natalie and Freedman, Des (2014) The politics and possibilities of media reform: Lessons from the UK. In Toby Miller, ed., *The Routledge Companion to Global Popular Culture*, New York: Routledge.

Freedman, Des (2008) *The Politics of Media Policy*, Cambridge: Polity.

Hesmondhalgh, David (2013) *The Cultural Industries*, 3rd edition, London: Sage, Chapters Four, Five and Ten.

Fact-check

1 Media regulation:
 a Focuses mainly on censorship
 b Focuses mainly on copyright law
 c Primarily aims to prohibit the media's activities and repress media freedom
 d Restricts some media practices while encouraging others

2 Which of the following is an example of an independent statutory regulatory body in the UK?
 a Ofcom
 b The Advertising Standards Authority
 c The Press Complaints Commission
 d IPSO

3 Which of the following is an example of self-regulation?
 a Government intervention in matters of national security
 b Legal frameworks governing libel and privacy
 c A body set up by the advertising industry to monitor public complaints
 d Independent statutory bodies such as Ofcom

4 National forms of media regulation are challenged by:
 a The internationalization of the media industries and the spread of digital media
 b The use of film quotas to limit the number of foreign imports
 c Freedom of the press
 d Public service broadcasting

5 Which of the following is a recommendation of the Leveson report?
 a The government should directly regulate the press
 b There should be less public intervention in the newspaper industry
 c There should be a statutory self-regulatory body to govern the newspaper industry
 d The Press Complaints Commission should continue to operate because it is an effective system of regulation

6 Which of the following is an example of deregulation of the media?

 a The recommendations of the Leveson report

 b The use of film quotas to limit the number of foreign imports

 c Government action to permit rapid expansion of satellite and cable television channels

 d Increased public funding to support public service broadcasting

7 It is often argued that press freedom is dependent on:

 a Extensive legal frameworks governing journalists' practices

 b Freedom from government interference

 c Freedom from self-regulation

 d Tight control by statutory regulatory bodies

8 Copyright laws are primarily concerned with:

 a Implementing tighter restrictions on the activities of large media corporations

 b Prohibiting forms of expression that may offend or harm audiences

 c Deregulating the media

 d The right to use, reproduce and distribute media texts

8

The Meaning of Media Texts

Studying media texts can be a challenge. In your everyday life, you interpret and make sense of a wide range of them. This can make it appear as if textual analysis is just common sense. However, in this chapter – and the ones that follow – you will learn to examine how these texts are constructed and organized. Once you develop these skills, you will also be able to identify how media texts encourage us to see the world in particular ways.

This chapter focuses on semiotic analysis. Semiotics provides a method for analyzing how meaning is constructed and organized in media texts. At the start, the terminology used may appear rather strange. However, the concepts will help you to develop your analytical skills and look at media texts in new ways.

Semiotic analysis also identifies how media texts construct myths. Myths provide ways of understanding the world and our place within it. These myths are powerful because they shape how people understand reality.

This chapter will help you to understand:

▶ The concept of representation.

▶ How to analyze media texts.

▶ Key concepts in semiotics.

▶ How media texts construct myths.

Representation and meaning

Media texts offer representations of the world. These representations shape how people understand and experience the world. However, the concept of representation is more complex than it might seem to be initially.

A common way of understanding representation is to think about how texts reflect or distort reality. Early studies of the media often took this approach, linked to the idea that media should be a 'window on the world' and reflect 'the real world' back to us like a mirror. Many critics claimed that the media offered distorted representations of the world and did not accurately represent reality. They focused on how the media *mis*represent reality.

But this misses the point about how representations work. Rather than reflecting or distorting reality, representations *construct* reality. It is only through various forms of representation that we can actually know – and make sense of – the world we live in.

Media Studies uses a range of methods and theories to analyze how representations work. Once you understand these ideas, you will be able to carry out your own analyses and identify how media texts work and why they work in particular ways.

Key idea

Representations do not simply reflect or misrepresent reality but instead construct what we understand as reality.

Semiotics and signs

Semiotics is the study of signs. At a basic level, signs are things we use to communicate. The most obvious examples are the words which make up a language. Words are signs that we use to communicate and convey meaning.

Words are not the only kind of sign. Visual images also communicate meanings. A smiley emoticon is associated with happiness while a swastika is associated with fascism and violence. Objects are also signs. For example, items of clothing are often associated with particular meanings. A smart men's suit suggests work while men's shorts are associated with leisure.

Ferdinand de Saussure formulated some of the key principles of semiotics. As a linguist, he was interested in how language works. For Saussure, languages were systems made up of signs.

He argued that signs are made up of two elements: the signifier and the signified. The signifier is the physical component of a sign. The signified is the mental component of the sign, the idea associated with it.

This might seem confusing initially but it becomes much clearer once Saussure's ideas are applied to examples. Take the word 'dog'. 'Dog' is a sign. This sign is made up of two parts.

The signifier is the letters 'd-o-g'. The signified is the idea we associate with those letters such as 'a furry four-legged animal'.

There are a number of other ideas that are implicit in Saussure's theories about signs:

1 **The relationship between the signifier and the signified is arbitrary.** In other words, there is nothing in particular about the letters d-o-g that suggests a furry animal. For example, in France a completely different set of letters – 'c-h-i-e-n' – signifies the same concept. There is nothing dog-like about the letters themselves.

2 **The relationship between the signifier and signified is based on convention.** In English-speaking countries, it is a convention – that is, normal practice – that the signifier 'd-o-g' is attached to the signified 'a four-legged furry animal'. When you learn language, you learn these conventions.

 This also applies to other kinds of signs, not just words. If you drive a car and see a red traffic light, hopefully you know that you should stop. This relationship between the red light and stopping is based on convention. It is arbitrary because there is nothing natural about the relationship between a red light and stopping.

3 **The meaning of signs is based on their difference to other signs.** The meaning of 'dog' is constructed through its difference to other words such as 'cat', 'rabbit' and so on. The meaning of a red traffic light is constructed through its difference to green or amber lights. Signs get their meaning from the wider system of which they form a part.

Key idea

Signs are composed of a signifier and signified and there is an arbitrary relationship, based on convention, between these two terms.

The idea that the meaning of signs is based on their difference to other signs may appear strange. However, it is one of the

fundamental ideas that shapes semiotics. By exploring examples from the media, this idea should become clearer.

Many adverts feature celebrities. This is a common feature of fragrance advertising because it is difficult to visually or linguistically represent a smell. Companies often want to associate their products with the qualities that a particular star represents. They may not suggest that their perfume will make you smell exactly like Julia Roberts or Natalie Portman, but they do imply that their perfume will endow you with the qualities associated with these stars.

> When Chanel chose the French star Catherine Deneuve to give their perfume an image of a particular kind of sophisticated traditional French chic, she became a sign in a system. And the meaning of Catherine-Deneuve-as-a-sign was determined by other beautiful stars-as-signs that she was not. She was not Susan Hampshire (too English); she was not Twiggy (too young, trendy, changeably fashionable); she was not Brigitte Bardot (too unsophisticatedly sexy); and so on.
>
> John Fiske, 2010: 43

Stars can be thought of as signs. Their name or their face acts as a signifier that is associated with particular ideas, or signifieds. For example, someone might associate the signifier 'Beyoncé' with a strong and sexy independence whereas they might associate the signifier 'Jennifer Aniston' with being 'the girl next door'.

Fiske's ideas can be applied to the use of stars in contemporary perfume advertising. Natalie Portman is the face of the fragrance Miss Dior. She is associated with ideas such as youth, intelligence, independence and a sexiness that appears to be natural. By using her in Miss Dior adverts, the qualities associated with her become associated with the perfume.

Because stars' images can be understood as signs, they are given meaning through their difference to other stars. The meaning of Natalie Portman is constructed through her difference to other female stars: she is *not* Beyoncé and she is *not* Jennifer Aniston.

Imagine that Dior had used Lindsey Lohan or Sarah Jessica Parker in their advert for Miss Dior: what different qualities would become associated with the perfume?

Key idea

The meaning of signs is constructed through their difference to other signs.

Spotlight: Casting James Bond

The casting of a new James Bond often prompts debate in the media. Arguments are made about which actors are right and wrong for the part based on what they signify. Stars such as Will Ferrell (too funny), Daniel Radcliffe (too boyish) or Johnny Depp (too quirky) are unlikely to be cast in the role. What about George Clooney, Robert Pattinson, Robert Downey Jr and Will Smith? What are their star images and do they signify the right ideas to play Bond?

Paradigm and syntagm

Paradigm and syntagm are two concepts from semiotics that are helpful tools for analyzing media texts. The words might sound a little alien but they offer ways of understanding how signs are combined to construct meaning.

A **paradigm** is a set of signs that have something in common. You have already examined some examples of a paradigm. Johnny Depp, George Clooney and Daniel Radcliffe are all part of a paradigm which could be labelled 'actors'.

When a sign is selected from a paradigm, the meaning of that sign is shaped by its difference to all the other signs in the set. As you have learned already, Natalie Portman forms part of a paradigm that could be labelled 'female stars'. The meaning of Natalie Portman is shaped by the fact that she is not Beyoncé, not Jennifer Aniston, and so on.

There are many different types of paradigm. For example, when you construct a sentence, you select words from various paradigms such as 'verbs' or 'nouns'. If you change the verb you use, a sentence changes its meaning. 'I miss my teacher' means something rather different to 'I kiss my teacher'.

Other paradigms work in similar ways. Imagine you are working in the wardrobe department of a TV drama. You are dressing a man who is going for a job interview as a teacher. You need to make a choice from the paradigm 'footwear' in order to communicate that he is a serious candidate for the job. Each type of shoe has particular signifieds attached to it. You reject trainers (too casual), slippers (too homely) and winter boots (too outdoorsy) in favour of smart black leather shoes (formal and professional). But although the 'teacher' only wears the black leather shoes, the meaning of them is shaped by the other choices you could have made from the paradigm 'footwear'.

A **syntagm** is a combination of signs from a range of paradigms used to communicate an overall meaning. A sentence – which combines a range of words or signs – is one example of a syntagm.

As a member of the wardrobe department, you couldn't just select shoes for the would-be teacher but would need to put together a whole outfit. The outfit is an example of a syntagm, a collection of items of clothing put together to communicate a particular meaning. In this case, you would need to select items from different paradigms (shirts, ties, trousers, jackets) and combine them to create a syntagm that communicated seriousness and professionalism.

You will find these concepts much easier to understand once you start to put them to use. Look at the brands that surround you in your home. Think about how the meaning of the brand might change if you changed the colour or images used on the packaging.

Key idea

In communication, signs are selected from a paradigm and assembled together to construct a syntagm.

Denotation and connotation

Denotation and connotation are concepts that will provide you with more tools to analyze media texts. These concepts offer you additional ways to identify how meaning is constructed.

Denotation refers to the literal or obvious meaning of a sign. It is a description of the sign. This might be the dictionary definition of a word or a description of a visual image.

Take the example of a print advertisement. The first stage of analysis is to identify the different elements of an advert and describe them. This helps to establish what the advert denotes. However, while examining denotation is a key stage in analysis, it explains very little about how signs communicate meanings.

Connotation refers to the implicit meanings of a sign. Connotations are the broader cultural ideas that become attached to a sign. For example, the colour gold is not just a yellow metal but often connotes wealth or prestige.

Imagine a hairspray in a gold container. The connotations of gold become attached to the product so it becomes associated with prestige or luxury. If the colour of the container changes to green, it would have very different connotations. Green is often used to connote freshness or naturalness.

The linguistic sign 'Rolls-Royce' denotes a particular make of car, or a photographic sign showing Buckingham Palace denotes a building in London. But along with the denotative, or labelling function of these signs to communicate a fact, come some extra associations called 'connotations'. Because Rolls-Royce cars are expensive and luxurious, they can be used to connote signifieds of wealth and luxury. The linguistic sign 'Rolls-Royce' is no longer simply denoting a particular type of car, but generating a whole set of connotations which come from our social experience. The photograph of Buckingham Palace not only denotes a particular building, but also connotes signifieds of royalty, tradition, wealth and power.

Jonathan Bignell 2002: 16

People need to use their cultural knowledge to interpret signs. In order to understand the meaning of Buckingham Palace, someone needs to recognize its association with royalty and tradition. Otherwise it could just be another large, old building.

The connotations associated with signs are, therefore, cultural and based on convention. There is nothing natural about the relationship between the colour gold and wealth. However, in many societies, this association is well established and many people will understand the connotations of gold in similar ways.

Key idea

Connotations are the broader cultural ideas that are associated with a specific sign.

Using the concepts of denotation and connotation, you now have the tools to analyze how media texts construct meaning. However, this is not the end of the story. It is also crucial to think about the *significance* of these meanings and the role they play in society. In order to do this, it is necessary to introduce one more concept – myth.

How signs construct myths

The French thinker Roland Barthes argues that signs work to construct myths. Myths provide ways of understanding the world and our place within it. Barthes does not view myths as false stories that mask some deeper reality. Instead, he argues, myths offer ways of organizing and framing what we think of as reality. The media are a key site for reproducing myths about our world.

The very principle of myth: it transforms history into Nature.
Roland Barthes 1972: 128

Although myths aren't false, they do present a particular version of reality as the truth. Myths are powerful because they turn something that is a cultural construction into something that appears to be *natural*. This makes it difficult to see the world

in alternative ways. Myths make particular ideas about reality appear to be facts (Bignell 2002; Fiske 2010).

Take an image of a red bus as an example. While the image might denote a colourful vehicle, for many people a red bus would connote 'London'. This connotation is fairly widely understood. This is why Hollywood films use a red bus to establish that a scene takes place in London. The red bus also had a pivotal role in London's contribution to the closing ceremony of the Beijing Olympics in 2008. It was used to conjure up an image of the city, the site of the 2012 Olympic Games.

It is worth remembering that the relationship between a signifier and signified is arbitrary. There is no reason a red bus should signify London. But London is the culturally constructed meaning attached to a red bus. Likewise, a yellow cab is often used to connote New York.

The red bus does not just signify London. It also conjures up specific myths about London. The red bus was frequently a symbol of 'Swinging London' in the 1960s and the 'cool' London of the 1990s. An image of the red bus calls on these associations of London as a modern, happening and vibrant city. However, the red bus is also used to represent London as a place of tradition. It is frequently used alongside images of Buckingham Palace, the River Thames and Big Ben.

The red bus, therefore, is associated with particular myths of London as a city that is both modern and cool *and* old and rooted in tradition. These were meanings reproduced in London's contribution to the closing ceremony of the Beijing Olympics. Of course, London *could* mean other things – poverty, inequality, crime or pollution – but the mythic qualities of 'red bus London' block out these other meanings.

Myths communicate ideas that have political and social functions. While they may appear innocent, they prevent people from seeing the world in alternative ways. They are often used to explain inequalities between different groups of people or to make these inequalities appear to be the way things are naturally. For this reason, myths are ideological. You will learn more about this concept in the next chapter.

Key idea

Myths are culturally constructed ideas that appear to be natural and self-evidently true.

Spotlight: One Direction on a Bus

One Direction made use of the red bus in their rise to global success. The video for the boyband's second single – 'One Thing' – opens with the band in front of a red bus. The bus then transports them around London, taking in famous landmarks like Big Ben. The established connotations of the red bus were transferred to the new boyband. The video also reproduced these mythic connotations. At the same time, the bus – and London – were associated with youth and vitality through their association with a youthful and fresh boyband.

Analyzing adverts

Semiotics is a particularly useful tool for analyzing advertising. Jonathan Bignell (2002) argues that adverts are designed to construct meanings which shape how we experience and interpret the world. Adverts do not just ask us to buy things but they also invite us to see the world in particular ways. In the process, they use – and reproduce – myths.

Adverts are made up of signs. You do not need to have studied semiotics to make sense of these. Adverts work on the assumption that the intended audiences can interpret the connotations of the signs that are used.

However, in order to *analyze* advertising, it is necessary to go beyond these more everyday skills of interpretation. The techniques and concepts used in semiotics can be used to demonstrate how adverts produce particular kinds of meaning.

Case study: Roland Barthes' analysis of a Panzani advert

Roland Barthes (1977) demonstrates how to carry out a semiotic analysis of an advert. In a famous example, he analyzes an advert for Panzani, a brand who manufacture 'Italian' products such as spaghetti and pasta sauces.

The Panzani advert features a string shopping bag, overflowing with food, on a red background. Fresh foods (onions, tomatoes, mushrooms) mingle with Panzani products (a pack of pasta, a bag of parmesan cheese, a tin of pasta sauce). The logo for the Panzani brand, repeated across the products, is red, white and green.

Barthes analyzes how the Panzani advert constructs particular meanings. He examines the connotations of different elements of the advert. Produce such as tomatoes signify meanings such as natural, fresh and wholesome. The string shopping bag is one that might have been commonly used for shopping in a market at the time. Again, this signifies fresh, natural food. By placing mass-produced Panzani products in among fresh produce, the advert suggests that Panzani products are as fresh, natural and wholesome as goods from the market.

The advert also draws on what Barthes calls 'Italianicity'. Italianicity is not the same as Italy but is a myth constructed from 'the condensed essence of everything that could be Italian' (Barthes 1977: 48). Panzani is a fabricated word but it sounds like it might be Italian. The red, white and green of the logo uses the colours of the Italian flag. Italy itself is associated with fresh and natural food. This suggests that the products are authentically Italian and full of Italian goodness. This draws on – and helps to reproduce – a wider myth of Italianicity.

In the process, the advert attempts to divert attention from the fact that Panzani products are convenience foods made in a factory. The advert invites the reader to accept the association between Panzani and fresh, natural produce.

The best way to understand semiotics is by using it to carry out your own analysis. Try to find a print advert that draws on the mythic qualities associated with Italy, or with another nation. Apply the concepts you've learned – paradigm, syntagm, denotation, connotation and myth – to analyze the advert. What myth of nation does the ad you have chosen use?

Spotlight: Semiotics in the workplace

Semiotics isn't just used by students and academics in Media Studies. It is also used in media professions such as marketing, advertising and brand management. For example, marketing professionals use semiotics to create clearly recognizable brand identities that are associated with distinctive and positive values.

The limitations of semiotics

Many forms of textual analysis in Media Studies draw on semiotics. As you read more on the subject, you should also discover that the language used in Media Studies is influenced by semiotics. However, many researchers combine semiotics with other methods for analyzing texts. This is because semiotics has a number of limitations:

1 Using semiotics to do a detailed textual analysis is very labour intensive. Semiotics can be a useful tool to analyze a print advertisement or a photograph. However, it is much more difficult to apply to more complex texts such as films and television programmes because there are so many images to analyze.

2 For similar reasons, it is difficult to use semiotics to analyze a large quantity of texts. Researchers who want to do this often turn to content analysis.

Content analysis usually focuses on clearly identifiable elements in texts. Often it is used to compare texts from different time periods or geographical locations. For example, content analysis could be used to identify if the

number of women in professional roles in TV dramas has increased over time.

Content analysis is often viewed as more scientific than semiotics. Using large samples, it can offer reliable results that enable researchers to make confident generalizations about broad trends in media representation. However, content analysis rarely provides the detailed analysis of how meaning is organized that is offered by semiotics.

3 Signs are open to a range of interpretations because they are polysemic. A single sign has the capacity to generate different meanings. For example, the colour red can signify stop, passion, danger or communism. Any semiotic analysis of the text will depend on how the analyst has interpreted signs.

4 Because signs are polysemic, semiotic analysis cannot tell us how different audiences might interpret the same text. For example, if someone didn't like Natalie Portman, they would associate her with different meanings to those Dior might hope for. A flag that might symbolize national pride for one group might represent oppression for a different group.

This is not to say people are free to read signs in any way they want. People within a culture – or within specific social groups – will often share the same cultural knowledge and ideas. Without these shared meanings, communication would be incredibly difficult.

However, different social groups might read the same text in different ways. You will learn more about this in Chapter Fourteen which focuses on audiences.

Key idea

Signs are polysemic. A sign can be associated with a range of meanings and be open to a range of interpretations.

In this chapter, you have learned how meaning is constructed in media texts. You have also developed skills that will help you to carry out your own analyses and to see texts in new ways. Barthes' ideas about myth demonstrate how media texts have

the power to shape how people view the world. You will return to Barthes in the next chapter as you learn about the ideological role of media texts.

Dig deeper

Barthes, Roland (1972) *Mythologies*, London: Paladin.

Bignell, Jonathan (2002) *Media Semiotics*, 2nd edition, Manchester: Manchester University Press, Chapter One.

Chandler, Daniel (2013), *Semiotics: The basics*, 2nd edition, London: Routledge.

Fiske, John (2010) *Introduction to Communication Studies*, 3rd edition, London: Routledge.

Hall, Stuart (2013) The work of representation. In Stuart Hall, Jessica Evans and Sean Nixon, eds, *Representation: Cultural representations and signifying practices*, 3rd edition, London: Sage.

Fact-check

1 Semiotics is:
 a The study of language
 b The study of visual images
 c The study of signs
 d The study of media texts

2 Saussure argues that a sign is made up of:
 a An index and an icon
 b A denotation and a connotation
 c A signifier and a signified
 d A paradigm and a syntagm

3 For Saussure, the meaning of a sign derives from:
 a Its difference to other signs within a system
 b The object that is represented
 c Its relationship to the real world
 d What it denotes

4 The relationship between a signifier and signified is:
 a Inexplicable
 b Arbitrary
 c Based on similarity to the real world
 d Inevitable

5 A syntagm:
 a Combines signs from a range of paradigms
 b Is a set of signs with something in common
 c Is a sign defined in relation to other signs
 d Is a description of an image

6 In semiotics, a paradigm is:
 a A combination of signs in a sentence
 b A set of stories about the world
 c A myth
 d A set of signs that belong to the same category

7 Connotation refers to:
 a The cultural ideas associated with a sign
 b The description of what is present in a sign
 c The combination of signs in a sentence
 d The study of visual images

8 For Barthes, myths are:
 a False stories that mask reality
 b No longer used in the modern world
 c Misrepresentations of the facts
 d Culturally constructed ideas that present themselves as natural

9 Signs are described as polysemic because:
 a There is a single correct interpretation of a sign
 b They have a clearly defined meaning
 c They can generate a range of different meanings
 d There are as many different readings of a sign as there are audiences

10 Which of the following is **not** usually associated with content analysis?
 a Detailed analysis of how meaning is organized within a text
 b Large-scale studies that enable media texts to be compared between countries
 c The ability to make generalizations about broad trends in media representations
 d The ability to analyze large samples of media texts

9

The Power of Media Texts

Media texts are a key source of information and ideas. Whether you are reading a newspaper or playing a computer game, you are offered interpretations of the world you live in. Media texts, therefore, have the power to shape how people understand the world.

Media Studies investigates how this power works. Media texts do not only offer people information. They also offer ways of explaining and interpreting it. A news story about a student protest against increased tuition fees could focus on the students' brave fight for the right to affordable education. Alternatively, it could represent the student protesters as troublesome and a threat to law and order.

The last chapter examined how media representations construct and define reality. You learned how myths provide ways of organizing meaning so they define reality in particular ways. By privileging one definition of reality, myths block out alternative ways of understanding the world. This chapter builds on these ideas and examines how media texts often define reality in ways that justify the power of dominant groups in society.

This chapter introduces you to two key concepts in Media Studies – ideology and discourse. While these concepts might seem daunting, they are necessary to make sense of the power of the media. They will also equip you with further tools to use when carrying out your own analyses of media texts.

This chapter will help you to understand:

▶ The concept of ideology.

▶ The concept of hegemony.

▶ The concept of discourse.

▶ The concept of neoliberalism.

▶ How these concepts have been used to analyze media texts.

What is ideology?

An ideology is a set of ideas that constructs ways of understanding the world. Ideologies encourage people to

understand reality in a particular way. These ways of seeing present themselves to us as normal and 'natural' so they appear to be the only explanation of the way things are.

Barthes' theory of myth offers one way of understanding how ideology works. As you learned in the last chapter, myths are cultural constructions that appear to be 'natural'. Barthes argued that, although myths present specific views of the world as commonsense or 'true', they are selective. Furthermore, they serve the interests of powerful groups in society.

In particular, Barthes identified how myths work in the interests of the dominant class. When myths – or ideologies – naturalize particular ways of understanding the world, they also make the power of the dominant class appear to be natural too. These ideologies crowd out alternative ways of thinking about how the world could be organized.

In Media Studies, many researchers use the concept of ideology to demonstrate how media texts help to maintain the power of dominant groups. Ideologies justify inequalities: between classes, between men and women, between different sexualities, and between different ethnic and 'racial' groups. They make these inequalities appear as if they are the only way things could be.

Karl Marx influenced many perspectives on ideology. His work focused on class inequality, so this is reflected in many later studies. For this reason, the following sections largely focus on how ideology supports the power of the dominant class and makes class inequality appear to be natural.

Key idea

Ideologies offer ways of understanding reality that present themselves as natural and maintain inequalities between different social groups.

Marx and ideology

Born in 1818 in Germany, Marx was one of the most influential thinkers of the nineteenth century. He argued that class inequality

was built into the structure of capitalist societies. The role of ideology was to make these inequalities appear to be inevitable, making it difficult to imagine how society could be organized in an alternative way.

In order to understand this in more detail, it is necessary to get to grips with some of the key terms used by Marx.

▶ **Capitalism.** Capitalism is an economic system in which goods are produced to be bought and sold in the marketplace. As you have already learned, this applies to the media industries. Most media are produced to be sold to audiences or to enable audiences to be sold to advertisers.

▶ **The bourgeoisie.** The bourgeoisie are the dominant class in a capitalist society. The have economic power because they own the wealth of society; that is, the land, factories, raw materials, etc. that are necessary to sustain human life. They sell food, clothes and other goods (including media texts) to everyone else in exchange for money. However, they do not produce these goods themselves but employ other people to do so.

▶ **The proletariat.** The proletariat is Marx's term for the working class, the people who are forced to work in order to survive. They sell their labour to the bourgeoisie in exchange for a wage. However, the value of their wages is much lower than the value of the goods they produce.

▶ **Class conflict.** Marx argues that capitalist societies are based on class conflict. The bourgeoisie strengthen their economic power by selling back to the working class the goods that they produced. The bourgeoisie sell these commodities at a profit. This enables them to increase their wealth. While it is not in the interests of the proletariat to continue to work in order to strengthen the power of the bourgeoisie, they have little option to do anything else. They have to work in order to survive.

The interests of the bourgeoisie and proletariat are in direct conflict in capitalist societies. The bourgeoisie benefit from a system organized in their interests. The capitalist system is organized against the interests of the proletariat.

Spotlight: Karl Marx

Marx argued that workers needed to unite in revolutionary struggle to overthrow capitalism. These ideas helped to inspire political struggle and revolutionary movements in many countries. It is rare for a political thinker to have such a direct impact on the world. He spent much of his life in London, where he died in 1883.

For Marx, ideology plays a major role in sustaining capitalist societies. Ideology prevents the working class from recognizing that society is unequal and organized against their interests.

The ideas of the ruling class are in every epoch the ruling ideas, i.e., the class which is the ruling material force of society, is at the same time its ruling intellectual force... The individuals composing the ruling class possess among other things consciousness, and therefore think. In so far, therefore, as they rule as a class and determine the extent and compass of an epoch, it is self-evident that they do this in its whole range, hence among other things rule also as thinkers, as producers of ideas, and regulate the production and distribution of the ideas of their age: thus their ideas are the ruling ideas of the epoch.

Karl Marx 2000: 192

Marx argues that the dominant class produces ways of thinking about the world that justify their dominance. Their ideas reflect their own experience and their own interests. This dominant ideology makes inequalities seem natural and inevitable.

In a Marxist model, the media play a crucial role in disseminating ideology. While Marx himself said little about the media, those influenced by his ideas highlight the media's increasingly important role in shaping ideas. According to some Marxists, the media reflect and promote the interests of the dominant class.

Marx believed that ideology prevented the working class from being able to see their true interests. Later commentators who

were strongly influenced by Marx argued that the media keep the working class in a state of false consciousness by ensuring they can only view the world through the ideologies of the dominant class. These ideologies prevent the working class from recognizing that society is organized in the interests of the dominant class.

Such an argument initially seems persuasive. For example, TV talent shows such as *American Idol* and *X Factor* offer a view of a world in which the most talented and hard-working contestants are rewarded with large cash prizes and glamorous lifestyles. This makes it appear that anyone with the talent, ambition and work ethic can succeed in a capitalist society.

From a Marxist position, these shows mask a reality in which the vast majority of talented and hard-working people get pitiful rewards for their labour. However, because viewers believe the ideologies promoted by these reality TV shows, they are kept in a state of false consciousness. They accept their own lack of personal reward in society. Furthermore, they do not realize that the real winners of the *X Factor* are the media industries that make vast profits from the show.

These versions of Marxism have problems explaining the complexity of media cultures. The problems include:

1 They present the media as a mouthpiece for the views of the dominant class. As you have already learned, few owners of the media directly intervene in the content of the media. They use their investments in the media industries to make a profit and so strengthen their economic power rather than to promote specific ideologies.

2 Some mainstream media texts oppose dominant ideologies and demonstrate how capitalist society is based on inequality. For example, the US television series *Mr Robot* centres around a computer hacker confronting an evil corporation.

3 The idea of false consciousness supposes that audiences passively take on board ideas that they are exposed to. As you will learn in Chapter Fourteen, audiences do not simply absorb media messages.

4 These ideas are based on the idea that ideology masks the 'true' nature of reality. However, as you learned in the last chapter, representations do not simply represent or misrepresent reality. Instead, our understanding of 'reality' is constructed through representation.

Key idea

Marx argues that, in capitalist societies, ideology represents the interests of the dominant class and prevents the working class from recognizing that society is organized against their interests.

Gramsci, ideology and hegemony

The Italian Marxist Antonio Gramsci revised Marx's theory to develop new ways of understanding how ideology works in capitalist societies. Because Gramsci was interested in the political role of popular culture, many researchers have used his ideas to think about how ideology works in media texts.

Gramsci examined how powerful groups established hegemony, the authority to lead. He argued that rather than being able to impose their ideas on others the dominant class have to win consent to their rule. In order to achieve this, they have to form alliances with other influential groups. They also need to create ideologies that convince other people of their right to lead. Through ideology, they persuade people that their own interests are also in the common interest.

The hegemonic ideologies in a particular historical period are those that appear to be 'common sense'. They provide ways of thinking that appear to just make sense and to relate to people's everyday experiences. This is not because people are in a state of false consciousness but because these ideologies appear to successfully capture the meaning of a particular historical moment.

Spotlight: Who was Antonio Gramsci?

Born in 1891 in Italy, Gramsci was a Marxist thinker. He had a key role in the Italian Communist Party. However, he was imprisoned in 1926 by Mussolini's fascist regime and remained in jail until just before his death in 1937. While in prison he wrote his best-known work in notebooks that were smuggled out. These were only published – as *The Prison Notebooks* – in the 1950s.

Key idea

Dominant groups achieve hegemony – the authority to lead – by making their ideologies appear to be common sense.

In their book *Policing the Crisis*, Stuart Hall et al. (1978) demonstrated how Gramsci's ideas could be applied to the media. They examined how British news coverage of crime in the 1970s created consent for new government policies which called for tougher policing and legal controls. People consented to these ideas because they appeared to be 'common sense'.

Hall et al. identify how a large number of news stories created fears about 'mugging' (violent robberies) and, in particular, 'black muggers'. While there was very little evidence for widespread mugging, these stories had two effects. First, they associated young black men with criminality. Second, the idea that 'black muggers' were a major problem became a form of common sense.

Policing the Crisis demonstrates the ideological role of the media. News reports represented crime as out of control. The need for action against rising crime appeared to be common sense. Ideology worked to create mugging as a concern that required action. This generated public consent for powerful groups' demands for increased increased measures to promote law and order. However, the new laws and increased policing helped to maintain the hegemony of dominant groups against other potential threats to their power.

Gramsci did not assume that ideology is simply imposed on people. The leadership of dominant groups is never assured

and consent has to be continually won. Ideology is a site of struggle between competing interpretations of the world. Media cultures can create space for alternative viewpoints and ideas to be heard.

Rap music provides one example of how hegemonic views are challenged within media cultures. In her book *Black Noise*, Tricia Rose demonstrates how the early hip hop scene gave African-Americans opportunities to challenge dominant meanings. Rap created space for young black people to talk about their experiences of oppression and to criticize institutions such as the police and the government.

> *Rap music, more than any other contemporary form of black cultural expression, articulates the chasm between black urban lived experience and dominant, 'legitimate' (e.g., neoliberal) ideologies regarding equal opportunity and racial inequality [...] To suggest that rap lyrics, style, music and social weight are predominantly counterhegemonic (by that I mean that for the most part they critique current forms of social oppression) is not to deny the ways in which many aspects of rap music support and affirm aspects of current social power inequalities.*
>
> Tricia Rose 1994: 102–3

Rose argues that hip hop expressed counterhegemonic ideas, ideas that challenge the dominant ways in which meaning is constructed in society. Rappers reimagined the meaning of urban life and created powerful criticisms of the ways in which African-Americans faced discrimination and oppression. For example, rappers contested the idea that the police are a positive force that maintains law and order. Instead, their raps talked of the discrimination and routine harassment young black men faced at the hands of the police.

However, this does not mean that all aspects of rap were counterhegemonic. Although rappers frequently challenged racist ideologies, hip hop lyrics and videos often reinforced women's oppression. African-American women were often represented as little more than sexual objects for male pleasure.

Key idea

Popular culture is a site of struggle between competing interpretations of the world.

The study of ideology helps us to understand how the media play a powerful role in defining meaning. Ideologies create frameworks that constrain how people think about the world, and how they experience it. Ideologies are not neutral. They provide ways of understanding the world that legitimate inequalities between different groups within society.

However, Gramsci's ideas help us to understand how ideologies are not simply imposed on people. Furthermore, as the example of hip hop demonstrates, ideology is a site of struggle between different interpretations of the world. Media texts do not simply express the interests of dominant groups. They can also be used to challenge or resist hegemonic ideas.

Understanding discourse

The concept of discourse provides an alternative way of understanding how meaning is organized in society. Discourses are systematically organized sets of statements that produce knowledge about the world. For example, medicine produces discourses that construct how we understand and experience the body. Discourses act as frameworks to organize meaning and shape how we understand ourselves and the world we live in.

These ideas come from the French philosopher and historian, Michel Foucault. He argued that discourses produce 'truths' about the world. He did not think that they reveal 'real' truths that are waiting to be discovered. Rather he suggests that what we know to be true is, in fact, produced through discourses. For example, medicine does not reveal how the human body works but, through discourse, creates what becomes recognized as true about it.

Foucault (1998) argued that discourses organize knowledge and meaning within specific historical periods. He developed his ideas by examining how discourses produce the meaning of sexuality. For example, the term 'homosexual' did not exist until the 1860s.

Before then, homosexual acts were sometimes judged to be immoral but these acts were not associated with a particular type of person – 'the homosexual'. When the identities 'heterosexual' and 'homosexual' were invented in the mid-nineteenth century, a whole series of 'truths' became associated with each identity through discourse.

Spotlight: Who was Michel Foucault?

Born in 1926, Michel Foucault was a French philosopher and historian. He worked at a series of universities and influenced thinking in many disciplines. Although his theories broke with many Marxist ideas, he was sympathetic to socialist causes. He was also engaged in political struggles to combat racism and homophobia. He died in 1984.

Key idea

Discourses are systematic sets of statements that organize meaning and produce 'truths' about the world.

Discourses do not simply shape how we understand the world, they also place people in the world. Identities such as 'gay' and 'straight' – or 'male' and 'female' – come with a whole range of meanings and expectations attached to them. Discourses compel us to accept the positions that have been created for us.

A host of discourses and social practices construct the female body as a flawed body that needs to be made over, hence the popularity in magazines and TV of the 'makeover'. The media images of perfect female beauty that bombard us daily leave no doubt in the minds of most women that we fail to measure up; we submit to these disciplines against the backgrounds of bodily deficiency, perhaps even of shame. It is... the very pervasiveness of this sense of bodily deficiency... that accounts for women's widespread obsession with the body and the often ritualistic nature of our daily compliance.

Sandra Bartky 2002: 248

Discourses regulate and discipline our behaviour. For example, the identity 'woman' is associated with beauty. Discourses about female beauty are constantly restated across advertising, film and women's magazines. These discourses do not just create the idea that a woman must be beautiful. They also compel women to discipline their bodies in an attempt to come close to the idea of female beauty.

As Sandra Bartky argues, in order to be recognized as a 'woman', women are required to engage in constant work to improve their appearance. Although they can choose to reject these demands, they risk being labelled 'unfeminine' and 'abnormal' if they do not strive to make themselves beautiful.

Key idea

Discourses regulate and discipline people, compelling them to behave in particular ways.

Many researchers use Foucault's ideas to make sense of media texts. They identify how a particular idea is repeated across a range of texts so that it appears to be 'true'. This enables researchers to identify patterns and examine the effects of particular discourses.

Neoliberalism and reality television

Research on reality television series often highlights how these texts have an ideological function. In particular, many researchers argue that these programmes promote neoliberal ideologies. Therefore, before analyzing reality TV in more detail, it is first necessary to understand the concept of neoliberalism.

At first glance, neoliberalism seems to have little to do with reality television. It is an economic and political strategy that claims that societies function most effectively if all areas of life are treated like a marketplace. This means that everything is presented as something to be bought and sold. This does not just include commodities such as food and clothes but also healthcare, education and culture.

In the mid- to late-twentieth century, many governments took responsibility for people's welfare. This resulted in policies such as free healthcare, free education and welfare benefits for people unable to work. Neoliberals claim that this prevents the economy from working efficiently and they call for a dramatic reduction in government regulation. They argue that deregulation benefits business because it frees entrepreneurs to seek out money-making opportunities. They also argue that deregulation benefits consumers. As businesses compete for custom, they claim, consumers get to choose the product that is best for them.

You have already seen these ideas in action when you learned about arguments in favour of deregulation of the media in Chapter Seven. Neoliberals argue that increasing the range of TV stations on offer gives consumers more choice. They argue that this market can only function efficiently with the removal of public funding for organizations such as the BBC.

Critics of neoliberalism argue that neoliberal ideologies are being used to create increasingly unequal societies. Neoliberal societies operate in the interests of big business and the wealthy. Society is increasingly organized to optimize opportunities to make profit rather than in the interests of the public.

Key idea

Neoliberalism is associated with the idea that all aspects of society should function like a marketplace.

These debates about neoliberalism may sound far removed from a discussion of media texts. However, some researchers highlight how a wide range of media texts naturalize neoliberal ideology so that it appears to be 'common sense'. Neoliberalism is presented as the best way of organizing society to meet everyone's needs.

Neoliberal ideologies encourage people to think of themselves primarily as consumers. For example, people taking a degree are encouraged to see themselves as customers who seek value for money rather than students seeking an education.

Neoliberal ideologies also encourage people to treat themselves as a commodity. People are urged to become 'entrepreneurs of the self' who display qualities such as 'self-reliance, personal responsibility, boldness and a willingness to take risks' (du Gay 1996: 60).

Qualities such as personal responsibility are emphasized for other reasons too. Because neoliberalism is associated with cutbacks in government provision of services such as health and education, neoliberal ideology demonstrates the importance of taking care of ourselves because we should not rely on the state to take care of us.

The importance of these qualities is portrayed in many reality TV series. In one episode of *America's Next Top Model*, the host Tyra Banks shouts angrily at Tiffany, a contestant who has just been eliminated. When Tyra tells Tiffany that she is 'disappointed' in her, Tiffany says that she 'cannot change' her life. In a startling scene, Tyra tells Tiffany that she must 'stand up and take control' of her 'destiny'. She continues: 'Learn something from this... you take responsibility for yourself because no one's going to take responsibility for you'.

While this scene was particularly dramatic, the themes are common in many reality series. The idea that people must take responsibility for themselves and take charge of their own lives becomes a form of common sense. These ideologies suggest that people have individual control over whether their life is a success or a failure, over whether they are healthy or ill. They suggest that people should not rely on the state to take care of them. These ideologies make it difficult to think about society in other ways. For example, reality television rarely suggests that people's life chances are shaped by wider inequalities and cutbacks in government services.

Key idea

Neoliberal ideologies emphasize individual responsibility, self-reliance, self-work and self-improvement.

Case study: *The Biggest Loser*

The Biggest Loser is a reality television show in which overweight people compete to see who can lose the most weight and be 'the biggest loser'. Contestants must change their diet and exercise in order to lose weight. The series suggests that anyone can improve themselves and transform their life for the better if they are prepared to change their attitudes and behaviour.

Although *The Biggest Loser* offers contestants a chance to make over their body, it also requires they make over their 'self' more generally. The series encourages participants to engage in self-improvement and self-work. Contestants are continually told to change their attitude and take responsibility for their own success or failure. Their trainers support them with statements such as 'Give 100 per cent every day or you're out of the game'. They are told 'don't accept defeat, don't let yourself down, fight for it'.

Like similar series, *The Biggest Loser* represents 'good' people as those who care for and govern themselves. An unwillingness to change – and an unwillingness to conform to neoliberal ideologies – is depicted as a failure.

In *The Biggest Loser*, obesity is represented as an individual problem. The series ignores the wider social and economic causes of obesity such as poverty or the practices of fast food corporations. The contestants' ill-health is represented as a failure to perform appropriately and as a burden on responsible citizens who are prepared to take control of their lives.

By presenting healthcare as an individual responsibility, neoliberal ideologies portray cutbacks in public spending on healthcare as appropriate. Series such as *The Biggest Loser* do not just encourage contestants to change but also their viewers. They invite their 'audiences to focus on issues of personal responsibility and self-discipline' (Sender and Sullivan 2008: 574; Ouellette and Hay 2008).

Research on ideology and discourse demonstrates how media texts shape the ways that people understand and experience the world. Ideologies and discourses make particular ways

of organizing the world appear to be common sense and the way things should naturally be. However, audiences do not necessarily accept the ideological positions in media texts. As you will learn in Chapter Fourteen, audiences contest and reject the ways in which media texts construct meaning.

Dig deeper

Barker, Chris (2012) *Cultural Studies: Theory and practice*, 4th edition, London: Sage, Chapters Two and Seven.

Hodkinson, Paul (2011) *Media, Culture and Society: An introduction*, London: Sage, Chapter Six.

Ouellette, Laurie and Hay, James (2008) Makeover television, governmentality and the good citizen. *Continuum*, 22(4): 471–84.

Rose, Tricia (1994) *Black Noise: Rap music and black culture in contemporary America*, Connecticut: Wesleyan University Press, Chapter Four.

Williams, Kevin (2003) *Understanding Media Theory*, London: Hodder Arnold, Chapter Six.

Fact-check

1 According to Marx, the bourgeoisie:
 a Sell their labour to the dominant class in exchange for a wage
 b Must overthrow capitalism in order to achieve equality
 c Live in a capitalist society that is organized against their interests
 d Have economic power because they own the means to sustain life

2 If people are in a state of false consciousness, they:
 a Formulate oppositional ideologies to challenge bourgeois dominance
 b Construct counterhegemonic ideas
 c View the world through the ideologies of the dominant class
 d Select texts that oppose dominant ideologies

3 In order to achieve hegemony, ruling groups use ideology:
 a To win consent to their leadership
 b To impose their ideas on other people
 c To keep people in a state of false consciousness
 d To misrepresent reality

4 *Policing the Crisis* demonstrated how:
 a Crime was out of control in the 1970s
 b The media generated public consent for increased measures to promote law and order
 c News reports revealed the true extent of crime by young black men
 d News reports brainwashed people into accepting the ruling class ideology

5 Aspects of early hip hop culture were counterhegemonic because:
 a They supported the interests of the dominant class
 b They reproduced images of black women as sexual objects for male pleasure
 c They challenged racist ideologies and criticized forms of oppression
 d They kept young African-Americans in a state of false consciousness

6 For Michel Foucault, discourses:

 a Are sets of statements that organize meaning and produce 'truths' about the world

 b Are bodies of thought that are imposed on people in order to legitimate the power of the dominant class

 c Reveal the truth about how the world is really organized

 d Are used by the dominant class in order to achieve hegemony

7 Neoliberalism is:

 a The use of ideology to promote greater tolerance in society

 b The organization of society to promote greater equalities for gays and lesbians

 c The use of counterhegemonic ideologies to promote equal rights for women

 d A strategy that argues that all areas of society should function like a marketplace

8 Which of the following narratives most effectively illustrates neoliberal ideology?

 a A group of women work collectively in order to persuade the government to provide free contraception for all

 b A hero from a poor family receives government funding to study at Cambridge and changes the face of science

 c A group of BBC journalists attempt to unmask how big business interests shape the content of newspapers

 d Through self-help and positive thinking, a woman overcomes both cancer and poverty and builds a biscuit business empire

10

Structuring Media Texts

Narrative and genre are two key terms that will help you to understand how media texts are organized and structured. These concepts provide ways of analyzing how media texts work, and how they are understood by both audiences and media industries.

Many texts use some kind of narrative. You may be familiar with the ways that television and film fictions are structured to tell particular stories. However, non-fictional forms such as news also shape events into narratives. Likewise, adverts use simple narrative structures in order to demonstrate how a product can improve our lives.

Studying narrative will help you to understand how media texts are constructed. This involves much more than describing the plot and enables you to see how seemingly different texts are organized in similar ways. The way in which texts are structured shapes how they construct meaning. The study of narrative, therefore, connects with questions about ideology that you encountered in the last chapter.

Audiences frequently make sense of media texts in terms of genre. Genres provide a way of classifying texts into different types. For example, many films are sorted into categories such as 'horror', 'romantic comedy', 'science fiction', and so on. Media industries use genre as a way of labelling texts and marketing them to audiences. Audiences use these labels as a way of classifying texts and deciding what they want – and don't want – to watch.

In Film and Television Studies, some researchers try to identify the key features that define a particular genre. They aim to pinpoint what exactly makes a particular TV show a soap opera or a particular movie a horror film. However, as you will learn, the study of genre is not just about highlighting the particular features of a text so that we can identify it as a particular type of film or TV series. The ways that media industries and audiences classify texts is also important.

This chapter will help you to understand:

▶ Forms of narration in media texts.

▶ How narratives construct 'reality'.

- Genre as a form of classification.
- Genre and the relationships between media industries, texts and audiences.

Telling stories

Narration refers to the way in which stories are told. The same material can be narrated in very different ways. Think of an argument you've had with a friend, partner or parent. When you tell people about the row, each of you will probably construct different narratives about the same event.

The same is true of media narratives. In news media, the same events can be narrated in different ways. For example, clashes between police and student protesters could form the basis of a range of narratives. They could be used to construct a narrative about how police aggression caused chaos as innocent students tried to protect themselves. Alternatively, the same events could be used to construct a narrative about how brave police restored order after militant students caused chaos and threatened local residents with their violent behaviour.

As these examples show, narratives don't just present events. They make judgements about them and their causes. In the process, they also make judgements about what – and who – is of value. This doesn't just apply to narratives about 'real' events but also to fictional narratives.

Key idea

Narrative refers to the ways in which events are put together to construct stories.

Spotlight: *Benefits Street*

In 2014, the UK's Channel 4 broadcast *Benefits Street*, a documentary series focusing on the residents of a street in Birmingham. The production team told the residents that they were making a show about community spirit. However, the series

constructed a narrative about people who chose to live on welfare benefits rather than work. Many people claimed that, rather than showing the residents battling to maintain a sense of community in difficult conditions, *Benefits Street* depicted them as lazy and, in some cases, criminal. The filmed footage of events on the street was used to construct a very specific narrative.

In Media Studies, some researchers have analyzed narrative by drawing on the work of a group of scholars known as the Russian Formalists. This work introduced two key concepts – fabula and syuzhet – which offer a way of making sense of narrative.

Fabula refers to all the events that are part of a story. These could be events in the real world which form the basis of news reports or events that form part of a fictional story.

Syuzhet refers to how these events are organized and structured to construct a narrative. Events in a narrative are organized so that certain aspects of the story are highlighted and given priority. In the process, we are shown *how* events relate to each other.

These ideas can be easily applied to news stories. Reports about the weather offer a straightforward example. In January 2015, much of Britain experienced snow. But the news headlines constructed different narratives out of these events. For the BBC, the snow was constructed as a general threat to the country: 'Snow and Gales bring Disruption to UK'. In the *Daily Mail*, the narrative prioritized travel and how this posed a threat to car drivers: 'UK Weather: Motorists Warned as Thundersnow hits Britain'. *Farmers Weekly* had a different priority, noting that 'Wintry Blast of Ice and Snow Batters Farm'.

This simple example demonstrates how narratives construct a sense of *how* and *why* events happen. It also raises an important point: narratives have a causal logic. In these news stories, snow is represented as the significant event that causes other events. However, this causal logic can be constructed in different ways to reflect different priorities. The same event can generate narratives about snow as a general threat to the UK, as a threat to motorists and as a threat to farmers. This also

happens in more complex narratives. For example, in different versions of the story of the famous US outlaw Jesse James, his criminality has been variously portrayed as a result of injustice, psychological disturbance and endearing non-comformity. He has also been represented as an innocent man.

These examples demonstrate how the media turn events into narratives. Narratives organize and structure the world to encourage us to understand it in particular ways.

> **Key idea**
>
> Fabula refers to the events that are part of a story and syuzhet refers to the ways these events are organized by a causal logic to construct a narrative.

Narrative structures and ideology

Narratives centre around problems. Many narratives establish a problem, work through the problem and then resolve the problem. The way that narratives construct and address problems is ideological because they encourage people to understand the world from a particular point of view.

Detective stories are a good example of a problem-solving narrative. The initial problem is often that a crime has been committed. The problem is then investigated: for example, the police try to discover who has committed the crime and identify the criminal's motive. The narrative is resolved when the criminal is caught and punished (Tilley 1991). However, these narratives rarely investigate or question the legal system within which these events take place.

Adverts often use a similar problem-solving structure. They present a problem – dirty clothes or smelly armpits – that can be worked through and resolved using a particular product.

Tzvetan Todorov argued that, although narratives may appear to be very different from each other, they share a common structure. His work was used extensively by researchers in Film and Television Studies in their analysis of media texts.

> *The minimal complete plot consists in the passage from one equilibrium to another. An 'ideal' narrative begins with a stable situation which is disturbed by some power or force. There results a state of disequilibrium; by the action of a force directed in the opposite direction, the equilibrium is re-established; the second equilibrium is similar to the first, but the two are never identical.*
>
> Tzvetan Todorov cited in John Hill 1986: 54

Todorov's model shows how narrative constructs a chain of events. Many crime films, for example, begin with a stable situation (a state of equilibrium). This is disrupted by the actions of a criminal which produce disorder (a state of disequilibrium). The actions of the police as they investigate the crime aim to restore stability by catching the criminal. Once this is achieved, the narrative is resolved as a state of order (the new equilibrium) is established.

Many narratives represent the key problem as an individual, a bad or misguided person who causes the state of disequilibrium. In many crime dramas, once this person has been caught and punished the initial problem is resolved. This encourages the audience to view crime as being caused by specific individuals rather than by wider social problems such as inequality and poverty (Hill 1986).

Such narratives have an ideological function because they suggest that all problems can be solved within the current system. Any problems that exist are the result of troublesome individuals rather than the system itself. As John Hill (1986: 56) comments, these individuals are represented as a 'problem *for* society, rather than *of* it'. The audience are encouraged to see the current system as fair and capable of coping with problems that arise.

This doesn't just apply to crime narratives. For example, some reality TV shows focus on problems such as obesity. In the last chapter, you studied *The Biggest Loser*, a reality series that represents obesity as a problem for both the contestants and society more generally. The show does not examine the wider social causes but represents obesity as an individual problem.

Through the intervention of experts, the problem of obesity appears to be solved as contestants change their habits. The narrative does not focus on how obesity is a problem *of* society caused by factors such as poverty or the activities of the food industry.

Key idea

In many narratives, a state of equilibrium is disrupted to produce a state of disequilibrium. The narrative is resolved once a new state of equilibrium is established.

Impersonal narration

Most people act as narrators in their everyday lives. When you tell friends or family about your day, you act as a narrator. You construct events into a narrative that is told from your point of view.

Some forms of media also use narrators to tell stories. Journalists often act as narrators, constructing stories which give meaning to events. Social media forms such as Twitter and blogs offer a wide range of people opportunities to construct public narratives about their lives and wider events.

Narrators are also used in film and television. While the narrator can appear on screen and talk directly to camera, they often provide a voiceover. Many documentary and reality shows use voiceovers to introduce – and give meaning to – events on screen. For example, in the British reality series *Come Dine With Me*, the narrator's witty and cutting commentary is an indispensable part of the show's success.

Many films and TV programmes have no explicit narrator. They use a form of impersonal narration where events appear to simply unfold before the viewer. This makes it seem like the story isn't told from any particular point of view but is the way things are naturally. Impersonal narration appears to offer 'the truth'.

However, there is nothing natural about media narratives. All narratives are constructed. In film and television, the arrangement of camera shots and the sound constructs the narrative.

Because the constructed nature of these narratives is not easily visible, impersonal narration appears to offer viewers a reflection of the world. Narratives appear to be 'realistic'. However, as you have already learned, media texts do not reflect reality but construct reality.

The way narratives are constructed in media texts, therefore, contributes to their ideological role. Impersonal narration makes particular versions of reality appear to be the way things are naturally. This makes it difficult to construct alternative ways of understanding the world.

Key idea

With impersonal narration, events appear to unfold naturally within the narrative, but this hides the extent to which all narratives are constructed.

As you watch a film or TV narrative, you may notice that many elements of the text do not advance the narrative. These elements appear to be redundant yet they have an important role to play.

> *Redundancy consists of the inclusion in the narrative of a number of signs that have a contextual or supporting role. These signs are unremarked, but deepen the consistency and believability of the narrative. They provide texture and tone for the audience. Details of setting, costume, much of the detail of dialogue and some of the narrative action are likely to be redundant from the point of view of getting the story itself across. But in programmes that claim to be **realistic**, redundancy has the crucial effect of embedding the story in a fully realized world.*
>
> Jonathan Bignell 2013: 102

Redundancy plays a crucial role in creating a sense of believability. This is as important in science fiction as it is in news. For us to recognize narratives about superheroes or alien invaders as realistic, science fiction texts need to create a believable world in which the narrative takes place.

Both impersonal narration and redundancy make media texts appear realistic. However, narratives are always constructed and do not reflect 'reality'. They use these techniques to create a sense of realism.

Types of narrative

Media texts employ a range of different narrative structures. These can vary across types of media. While there is not sufficient space here to examine the full range of narrative structures, examples drawn from television illustrate some of the different forms they can take.

There are two key forms of television narrative. These are:

1 **The serial.** Serials follow a narrative over a number of episodes. The narrative is resolved at the end of the final episode. TV dramatizations of novels such as *Pride and Prejudice* are a classic example of the serial form. Crime dramas such as *Line of Duty* and *The Killing* investigate a case over the course of a season.

 Although soap operas share many characteristics with serials, their narratives are open-ended. This means the narrative is never finally resolved (see Case study).

2 **The series.** Series often feature a regular cast and setting that the viewer becomes familiar with over time. Traditionally, a narrative is resolved at the end of each episode. Detective programmes such as *Law and Order* and *CSI*, and situation comedies such as *The Simpsons*, usually follow this format.

In contemporary TV, many shows combine elements of both the serial and the series. For example, the legal drama *The Good Wife* may resolve a particular case at the end of each episode but there are long-running narratives about the personal and professional lives of the characters that run throughout – and beyond – each season. Reality shows such as *America's Next Top Model* may offer a resolution to the question of who will leave each week, but there is an over-arching narrative about who will win the title.

Other media forms use different narrative structures. Audiences expect a film narrative to be resolved by the end of the movie (although, exceptionally, some films are split into parts – for example, *Harry Potter and the Deathly Hallows*). Audiences would have different expectations of many television shows.

Likewise, the narrative framework of computer games takes a variety of forms. Many computer games do not offer narrative resolution. They also offer the gamer considerable freedom over the form the narrative takes. Games designers often create spaces in which narratives can unfold rather than telling complete stories.

Different genres are associated with particular narrative structures that shape the way they tell stories. In the rest of the chapter, you will learn more about genres and their relationships to media texts, industries and audiences.

What is a genre?

Genres are categories that are used to classify media texts that have particular features in common. Some research tries to identify the distinctive features that characterize a particular genre such as horror or soap opera. Other research focuses on how ideas about genre inform the everyday practices of media industries and audiences.

Steve Neale (2008) argues that genre plays a crucial role in how audiences make sense of texts. When people encounter texts, they also encounter a set of clues that generate expectations about what kind of text it is. For example, if a movie is set in a futuristic urban landscape, you might classify it as science fiction and expect certain things from the film as a result.

Audiences do not expect all texts within a genre to be identical. While genres offer the pleasures of the familiar, texts also have to offer something different by working with the conventions of the genre in new ways. In order to offer both familiarity and novelty, the media industries also create hybrid texts that blend elements of different genres. For example, the films in the *Twilight* saga blend horror and romance while *21 Jump Street* blends the cop film with teen comedy.

Neale highlights how audiences' expectations about texts are shaped by marketing, publicity and reviews. These practices play a key role in labelling texts. For example, the title of *Jupiter Ascending* (2014) suggests a concern with a distant planet. Many people would quickly associate this with science fiction. The tagline 'Expand your Universe' cements this meaning, as does the film poster which features planets and spaceships. As a result, many people who chose to view *Jupiter Ascending* would have expected a science fiction movie. Other people might have deliberately avoided the film because they dislike science fiction.

Stars and directors can also be used as a way of labelling texts. Actors such as Seth Rogen and Will Ferrell are often associated with comedy while Jet Li is associated with action films and, in particular, martial arts movies. Likewise, directors Wes Craven and John Carpenter are strongly associated with horror.

Key idea

Genres are categories that are used to classify texts into distinctive types.

In the television industry, genre plays an important role in scheduling programmes. Particular timeslots are often associated with specific genres. A strategic way to highlight the genre of a new programme is to place it in the schedules at a time audiences already associate with a specific genre. In some cases, genre becomes the basis for the identity of whole channels such as SyFy, Horror and Comedy Central in the UK.

While texts within a genre share some characteristics and conventions, formats have much tighter boundaries. Formats combine specific ingredients for a programme in a distinctive recipe (Bignell 2013). For example, the *MasterChef* format is used to produce different versions of the programme in over forty countries, and there are over fifty international versions of the *Next Top Model* format. These types of series are increasingly important in the television industries because the originators of a format sell the rights to produce other versions.

Traditional approaches to genre

Traditional approaches to genre focus on media texts rather than media industries and audiences. These approaches were influenced by research in Film Studies. Researchers attempted to identify how films within a specific genre shared particular themes, visual styles, music, characters and locations. These researchers aimed to identify the central textual features of a genre. This enabled them to distinguish between texts that belong – and do not belong – within a particular category. Once the defining features of a genre had been established then researchers could proceed to construct histories of different genres.

Film researchers also examined how different genres had specific social and cultural functions. For example, many romantic comedies show how men and women must have appropriate kinds of masculinity and femininity in order to become the 'right couple'. Often the heroine must choose between the 'wrong' man (someone married to their career, or self-centred, or a player) and the 'right' man (someone who can be affectionate and committed). Many romantic comedies also reproduce ideologies of romantic love which suggest that to be a husband or wife is the only appropriate adult identity.

These approaches to genre enabled researchers to develop knowledge about the characteristics and histories of particular genres. However, critics such as Steve Neale argue that these approaches are also problematic. Many researchers devoted

themselves to finding 'ideal types', perfect examples of a specific genre. As a result, Neale (2008: 2) argues, these approaches end up 'specify[ing] what a genre should be rather than what it is'.

Key idea

Traditional approaches to genre analyze media texts in order to identify the defining characteristics of a genre.

Case study: TV soap operas – narrative and genre

The label 'soap opera' is applied to a wide range of texts that often vary considerably across historical and geographical contexts. These texts are categorized as soaps because they share key features in common.

Soaps are usually characterized as continuous, open-ended, episodic serials. Their narratives are open-ended because, unlike most films and serials, they rarely have narrative resolution. Any resolutions that are achieved are subject to further disruption from events such as an infidelity, a death or a feud. Furthermore, there are multiple narratives running simultaneously.

Many soap operas have similar approaches to time and space. Often their narratives unfold in 'real time'. Soap characters experience the changing seasons and national holidays at the same time as their audience. They also frequently centre around a shared space, whether a small community (for example, Albert Square in the UK soap Eastenders) or a family home or business (for example, in the US prime-time soap Empire).

Gender is a key concern in studies of soap opera as a genre. Soaps often emphasize domestic life, personal relationships and emotions. These are areas of life associated with femininity. Although narratives may unfold in public spaces, they are primarily associated with emotional issues. For example, while Nashville and Empire are both set in the world of the music industry, their narratives are primarily about personal relationships.

Furthermore, in many soap operas, stories are told from women's point of view. They present the way women see the world as 'understandable and rational' (Geraghty 1991: 47). Soaps often deal with common emotional situations which women share. They present women's concerns as normal and sensible. This contrasts with more masculine genres such as westerns and gangster movies. However, as prime-time soap operas attempt to attract a wider audience, some researchers argue they increasingly draw on conventions associated with masculine genres (Brunsdon 1981; Geraghty 1991).

Genre and classification

Jason Mittell (2001) also criticizes approaches that view genre in terms of special characteristics that lie within a group of texts. Mittell argues that the characteristics of genres do not simply reside in the texts themselves – a media text cannot classify itself – but instead that industries, institutions, reviewers and audiences classify texts.

Texts have many different components, but only some are used to define their generic properties. As many genre scholars have noted, there are no uniform criteria for genre delimitation – some are defined by settings (westerns), some by actions (crime shows), some by audience effect (comedy), and some by narrative form (mysteries). This diversity of attributes suggests that there is nothing internal mandating how texts should be generically categorized. In fact, some scholars have pointed to instances where the same text became 'regenrified' as cultural contexts shifted. If the same text is open enough to be categorized under various genres, then it follows that it is problematic to look for generic definitions solely within the confines of the text.

Jason Mittell 2001: 6

Mittell argues that Media Studies should focus on the processes by which texts are classified into particular genres. When producers, reviewers and consumers write and talk about media texts, they both produce and reproduce discourses about film and television. These discourses provide ways of evaluating texts. In the process, they also categorize and classify texts into genres such as 'romantic', 'comedy' or 'horror'.

This approach reveals that there is often considerable disagreement about what constitutes a particular genre and about how media texts should be classified. For example, horror fans often claim that *Alien* (1979) is a horror film while many science fiction fans claim it is a science fiction film.

Mittell argues that it is necessary to take a historical approach to studying genre. This enables us to identify changes in the ways that different genres are defined. It also enables us to see how the same text can be classified in different ways in different historical periods. For example, today, Alfred Hitchcock films such as *Laura* (1944) and *Woman in the Window* (1944) are classified as film noir. However, when they were released in the 1940s, they were categorized as horror. Indeed, the term 'film noir' was not invented until much later (Jancovich 2010).

Key idea

The discourses used by the people who create, market, evaluate and consume media create the meaning of genres and assign texts to specific genres.

Spotlight: What's in a name?

Walt Disney released *John Carter* in 2012. The film was based on a novel by Edgar Rice Burroughs called *The Princess of Mars*. Initially, the film was to have the same title. However, Disney worried that it suggested a 'princess' movie aimed at young girls. It was then called *John Carter of Mars* – until it was decided that this title might alienate women because it sounded too much like straight sci-fi. The film was finally released as *John Carter*. It is commonly considered to have been a major box-office flop.

Genres are used to categorize and label media texts. These labels are used by the media industries, reviewers and audiences to classify and give meaning to texts. As you read reviews and promotional materials, try to identify how they classify texts into genres. When your friends discuss media texts, listen to how they use labels to recommend or dismiss different texts.

Dig deeper

Bignell, Jonathan (2013) *An Introduction to Television Studies*, 3rd edition, Abingdon: Routledge, Chapters Four and Five.

Geraghty, Christine (1990) *Women and Soap Opera*, Cambridge: Polity.

Mittell, Jason (2001) 'A cultural approach to television genre theory', *Cinema Journal* 40(3): 3–24.

Neale, Steve (2008) Studying genre and television and genre. In Glen Creeber, Toby Miller and John Tulloch, eds, *The Television Genre Book*, London: BFI.

Fact-check

1 Fabula refers to:
- **a** How events are organized and structured to construct a narrative
- **b** An impersonal form of narration
- **c** The use of voiceovers to narrate a story
- **d** All the events that are part of a story

2 Syuzhet refers to:
- **a** How events are organized and structured to construct a narrative
- **b** An impersonal form of narration
- **c** The use of voiceovers to narrate a story
- **d** All the events that are part of a story

3 Todorov identifies the structure of the minimal complete plot as a movement between states of:
- **a** Disequilibrium, equilibrium, a new equilibrium
- **b** A new equilibrium, equilibrium, disequilibrium
- **c** Equilibrium, disequilibrium, new equilibrium
- **d** Equilibrium, new equilibrium, disequilibrium

4 Impersonal narration:
- **a** Features a narrator who makes a direct but impersonal address to the camera
- **b** Features a narrator who is a character in the drama
- **c** Makes events appear to unfold naturally in front of the viewer
- **d** Draws attention to the fact that all texts are constructed

5 In the analysis of media narratives, redundancy refers to:
- **a** Elements of the text that do not appear to advance the narrative
- **b** The increasing automation of media production reducing the need for skilled workers
- **c** The use of an off-screen narrator
- **d** The need to create a sense of resolution and stability

6 Soap operas are associated with narratives that:
 a Are resolved at the end of each episode
 b Are resolved at the end of each season
 c Are continuous and open-ended with little permanent resolution
 d Are geared towards producing a final state of equilibrium

7 In relation to television, the term format:
 a Is an alternative word for genre
 b Is a way of classifying texts
 c Is produced by the discourses used by creators, marketing, reviewers and audiences
 d Refers to a specific combination of elements that produce a tightly defined recipe for a programme

8 Traditional approaches to genre focus on:
 a How texts are assigned to genres by audiences
 b The distinctive features that make a text part of a genre
 c The discourses that are used to classify and categorize texts
 d The activities of film reviewers

9 Which of the following ideas is **not** associated with Jason Mittell?
 a Discourses define genres and their meaning
 b A film text can be categorized in different ways in different historical periods
 c Researchers should try to identify the 'ideal type' of text within a specific genre
 d Industries, institutions, reviewers and audiences classify texts into genres

11

Media, Representation and Identity

Media texts play a key role in defining the meaning of identity. They shape our sense of who we are and they also shape how other people view us.

The media have a powerful influence over how we understand and experience our own identity. Through representations, we are given ways of understanding what it means to be a man or a woman or to be 'black' or 'white'. Think, for example, about national identity. In what ways have the media shaped your sense of identifying with a nation?

Media representations do not only offer ways of thinking about our own identity but also those of other people. If you are a New Yorker, you may never have met a Parisian or Londoner, but you will still have a sense of the meanings attached to these identities. Likewise, if you have never met someone who is British, or Chinese or Afghan, the media will have shaped the ideas you associate with these identities.

Media representations of identity are powerful because they can limit and constrain how people think about themselves and others. For example, representations that define women primarily in terms of their bodies, appearance and sexuality can prevent people from thinking about all the other things that a woman can be.

This chapter introduces you to some key tools for analyzing how media represent identity. Research demonstrates how media define some identities as valuable and prestigious and other identities as inferior or troublesome. These representations are important because they are used to justify the power of some groups over others. For example, representations of colonized people as 'savage' or 'uncivilized' were used to justify the right of Western nations to rule them.

These ideas are illustrated through a range of examples that focus on media representations of nation, class and race. You will learn more about the key role the media play in shaping gender identities in the following chapter.

This chapter will help you to understand:

▶ How identities are constructed through similarity and difference.

▶ How different types of identities are represented in the media.

▶ How media representations of identity maintain the dominance of some groups over others.

▶ Diasporas and hybrid identities.

Identity, similarity and difference

A sense of shared identity is constructed through similarity, the things that a group of people have in common. You have probably experienced this in your everyday life. You may feel a connection with people from your town or region, or with fans of the same football team or music. You may feel you have an identity in common with these people that offers you a sense of belonging to a group.

Media play an important role in constructing a sense of shared identity and belonging. For example, as you learned in Chapter Six, they construct a sense of similarity and commonality between members of a nation. Before there were mass media, it was difficult for people scattered across a country to feel a connection to others living 200 miles away. However, the development of national newspapers enabled people to acquire a consciousness of belonging to a wider group called 'the nation'. The content of newspapers helped to produce a sense of a common national identity based on shared interests and values (Anderson 1991).

Broadcasting also plays a key role in constructing national identities. Members of a nation can feel a sense of unity and a common identity as they watch television footage of important news or sporting events. When they do this, people are not only engaged in the same practices, but many experience a sense of national belonging and a connection to other members of the nation.

However, identities are not just constructed on the basis of similarity. They are also constructed through difference. The meaning of one identity is defined through its contrast to other identities. For example, to be British is to be 'not American', 'not German' and 'not French'. This has two effects. First, it makes people strongly attached to the sense of a particular national

identity. Second, it produces perceptions of other groups and how they differ from 'us'.

Although this may appear to be a strange way to think about identity, these theories draw on ideas you've already learned from semiotics which show how the meaning of one sign is constructed through its difference to other signs. For example, the meaning of the sign 'man' is constructed through its difference to the sign 'woman'.

Key idea

The meaning of identities is constructed through similarity and difference.

Claude Lévi-Strauss used the term **binary opposition** to think about how meaning is constructed through difference. Binary oppositions are pairs of terms that are viewed as opposites; for example, man and woman, black and white, gay and straight, West and East. Meaning is organized through the difference between these terms.

As Western countries claimed other territories as part of their empires, they used binary oppositions to justify their rule. To be 'white' was to be seen as civilized, advanced and good. To be 'non-white' was to be seen as being all that white was not: primitive, retarded and evil. These oppositions established fundamental differences between what it meant to be white and non-white. They also had the ideological function of justifying the dominance of white Western powers over non-white people.

Binary oppositions provide ways of organizing and ordering the world. They make the differences between identities appear to be both significant and natural. For example, in the American South in the 1960s, public spaces such as toilets, buses and restaurants were segregated into 'white' and 'coloured'. So were many institutions such as schools and universities. The significance of the difference between 'white' and 'coloured' was seen as being so profound that different people required different spaces. Such arrangements seem shocking to most people today. However, this example demonstrates how the

culturally constructed meanings associated with different identities shape how people experience the world.

Binary oppositions do not simply define identities as different. They are used to create and justify inequalities so that one identity is viewed as superior over the other. The subordinate identity is defined as 'Other'. It is all that the dominant identity is not.

Key idea

Binary oppositions construct the meaning of an identity through a contrast with its opposite.

Key idea

Identities that are different to those of the powerful are defined as 'Other'.

Sexuality and binary oppositions

The binary opposition between heterosexual and homosexual – or straight and gay – is a key way in which identities are organized and ranked. In most cases, heterosexuality is defined as 'normal' so that homosexuality is defined as 'Other'. Media texts often represent heterosexuality as the only 'normal' way to be.

By treating heterosexuality as normative or taken for granted, we participate in establishing heterosexuality – not sexual orientation or sexual behaviour, but the way it is organized, secured and ritualized – as the standard for legitimate... behaviour.

Chrys Ingraham 2005: 4

Heterosexuality isn't just represented as normal but also *normative*. This creates a pressure to fit in with what is defined as normal. The term heteronormativity is used to explain how society is organized around the assumption that everyone is – and should be – heterosexual.

From childhood, people are surrounded by heteronormative images. It appears natural that people should be heterosexual. This can be seen in many Disney films which present romantic relationships with the opposite sex as the most important type, more important than those with friends or parents. They represent love as a natural thing as well as an amazing and magical thing (Martin and Kazyak 2009).

Heterosexual romantic love is also normalized through the emphasis on weddings in popular culture. Ingraham argues that a range of media texts represent heterosexual romantic love as natural and encourage the desire for marriage. Magazines and newspapers scrutinize the details of celebrity weddings. Some romantic comedies and dramas represent marriage as the natural result of true love. Films such as *27 Dresses* and *Bride Wars* present the wedding day as the most important day in a woman's life.

Because heterosexuality is constructed as the norm, non-heterosexual identities are constructed as 'Other'. There is a long history in which non-heterosexual identities are represented in the media as abnormal, a threat to heterosexuality or a problem. Despite increasing acceptance of gays and lesbians in many nations, the emphasis on heterosexuality as the norm in media texts means that non-heterosexual identities are often invisible.

For example, one study identified how only 17 out of 102 major Hollywood films in 2013 featured lesbian, gay, bisexual or transgender characters. All of the lead characters in these films were heterosexual (Beaumont-Thomas 2014). In other countries, representations of non-heterosexual identities are more actively discouraged. For example, in 2013, Russia passed a law banning 'propaganda of non-traditional sexual relations' to children. This was directed at media representations of sexuality.

Binary oppositions, therefore, create boundaries around identities. They mark out some identities as the norm and others as 'Other' to that norm. This reproduces inequalities and forms of discrimination.

Spotlight: *Beauty and the Beast*

The magical power of love in Disney films is well illustrated by *Beauty and the Beast* (1991). When Belle utters the words 'I love you', a magic spell is broken and the Beast is transformed back into a prince. To back up the message that romantic love is transformative, their kiss is accompanied by soaring music as fireworks explode. The lives of other characters affected by the spell are transformed for the better as normality is restored. Heterosexual romantic love is represented as magical and powerful, and brings about order and stability.

Stereotyping and identity

Although the term stereotype is quite widely used, Media Studies offers theories that explain how stereotyping works. These theories will help you to analyze stereotypes in the media.

> *Stereotyping reduces people to a few, simple, essential characteristics, which are represented as fixed by Nature ... [It]* naturalizes and fixes 'difference'... It symbolically fixes boundaries, and excludes everything that does not belong... Stereotyping tends to occur when there are gross inequalities of power.
>
> Stuart Hall 1997: 259

Stuart Hall identifies a number of key points about stereotypes:

1 Stereotypes limit the way we can think about groups of people because they represent them in very limited ways. For example, for much of the twentieth century, Hollywood depicted African-Americans in a very narrow range of roles.

2 Stereotypes make certain groups of people appear to be 'naturally' different to 'us'. Some stereotypes present themselves as natural because they make differences appear to be rooted in biology. They also work through repetition. If stereotypes are repeated frequently, the differences between people appear to be fixed and unchangeable.

3 Stuart Hall highlights how stereotypes create boundaries between people. These boundaries can be used to exclude particular groups.

This is illustrated by the experiences of Caribbean people who migrated to the UK in the period after World War II – and the experiences of their children who were born in the UK. At this time, 'black' and 'British' were represented as distinct identities, despite the fact that there was already a long-established black British population. Racist discourses constructed Britishness in terms of whiteness. This meant that black people were excluded from the identity 'British'. Furthermore, the very presence of black British people was represented as a threat to what it meant to be British.

4 Hall's final point is very important. Identities that are stereotyped as different from 'us' are usually associated with groups who have far less power. Stereotypes frequently work to maintain the dominance of one group over another.

This does not mean that stereotyping is the only way that identities are represented in the media. For example, although gays and lesbians are often represented in stereotypical ways, some media texts represent gay and lesbian identities in ways that ignore or challenge these stereotypes.

Key idea

Stereotypes create boundaries between groups of people and make identities appear to be fixed and unchanging.

Key idea

Stereotypes are used to maintain the dominance of powerful social groups.

> **Spotlight:** *Hollywood Shuffle*
>
> For much of the twentieth century black actors in Hollywood were offered a very limited range of roles. Male actors found they were repeatedly offered parts that reflected a narrow set of stereotypes of African-Americans such as slaves, criminals and butlers. Robert Townsend's film *Hollywood Shuffle* (1987) parodies this situation with an advert for a (fake) 'black acting school'. The school offers black actors the opportunity to learn 'jive talk' and 'walk black' so they can be more like the stereotypes they are expected to play. It features a successful graduate who has played 'nine crooks, four gang leaders, two dope dealers' and 'a rapist twice' (Hodkinson 2011).

Class and stereotyping

Stereotypes of social class create distinctions between identities. Middle class identities tend to be represented as 'normal' whereas non-middle-class identities are often stereotyped as 'Other'.

These processes have a long history. For example, in nineteenth-century Britain, sections of the working class were stereotyped as lazy and unwilling to work. They were associated with violence, drinking, drugs, sexual promiscuity, gambling and a general lack of morality. If you look at the contemporary British press, you will find some similar stereotypes. Newspapers such as the *Daily Mail* often feature stories about 'benefits cheats'. These portray the working class as people who are unwilling to work and who use welfare benefits to fund hedonistic lifestyles.

By stereotyping sections of the working class, the media implicitly represent middle-class identities as the only normal and acceptable identities. This makes the power of the middle classes over the working class appear to be legitimate, natural and the way things should be.

Studies of media representations of the British white working class in the 2000s demonstrate how class stereotypes continue to be used. During this period, representations of the working class often centred around a new stereotype, the 'chav'. The label was associated with marginalized young

people who, it was claimed, could be identified by their branded sports clothing, heavy gold jewellery and their anti-social behaviour in public places. 'Chav' quickly became a widely used term of abuse.

The stereotype of the chav was formed in the press, on television and on websites such as Chavscum. The chav was portrayed as a menace to society. As Jemima Lewis put it in *The Sunday Telegraph* in 2004, 'They are the non-respectable working classes: the dole-scroungers, petty criminals, football hooligans and teenage pram-pushers' (cited in Tyler 2008: 22). These images echoed nineteenth-century stereotypes of the working class as lazy, criminal, violent and promiscuous. This demonstrates how stereotypes represent particular social groups in terms of fixed characteristics.

Chavs were widely mocked in media from TV comedy sketch shows to student publications. While this may appear to be relatively innocent, Imogen Tyler (2008) argues that laughter is 'boundary-forming' and a means of expressing 'class disgust'. By laughing at chavs, people could mark themselves out as different from them. The stereotype therefore helped to reproduce class hierarchies.

Stereotypes of the working class have an ideological function. By associating working-class identities with a range of negative characteristics, they are used to justify an unequal society in which the middle classes have more power.

Case study: The stereotyping of refugees

In summer 2015, the refugee crisis was one of the major international news stories. Huge numbers of people from war-torn countries and repressive regimes sought asylum elsewhere in order to lead a life that was free from fear and persecution. While some press reporting demonstrated sympathy for the plight of refugees, other news stories used stereotyping to represent them in limited ways.

In the British press, the reporting of the 2015 crisis drew on established stereotypes in the representation of refugees . For example, Philo et al. (2013) identify how numbers are used to

represent refugees as a threat to 'us'. Their analysis of press coverage of refugees in 2011 identifies how negative terms such as 'waves', 'flooding in' and 'swamped' were used to represent refugees as a threat to British people. This was replayed in summer 2015. For example, one *Daily Express* headline warned of a 'New Wave of Migrants to Flood Britain' (15 June 2015) and another said, 'Send in the Army to Halt Migrant Invasion' (30 July 2015).

Stereotyping also dehumanizes refugees in various ways. Picking up on a word used by the prime minister, David Cameron, the *Daily Express* claimed 'Migrants Swarm to Britain' (29 August 2015) while the *Daily Mail* wrote of 'The "Swarm" on Our Streets' (31 July 2015). The use of 'swarm' likens refugees and migrants to insects rather than representing them as human like 'us'. In an earlier, much commented on, example, one columnist likened migrants to 'cockroaches' (*The Sun*, 17 April 2015). More generally, refugees are not represented as individuals like 'us' but as a horde or 'mob'.

Some sections of the British press also ignored the fear that causes many migrants to leave their home country and stereotyped them as 'illegal immigrants' who are 'benefits seekers'. By representing migrants and refugees as people after 'free hotels' in 'soft-touch Britain' (*Daily Mail*, 3 August 2015), they are represented as an economic threat to 'hard-working' British taxpayers like 'us'.

These representations work to fix the identities of refugees in extremely limited ways and create boundaries between 'us' and 'them'. They also undermine 'our' need to take responsibility in what was more widely seen as a humanitarian crisis.

So far you have explored how stereotypes represent groups of people in simplified ways. They also represent identities as fixed. However, identities do not have to be represented in this way. The next section explores how some representations challenge models of identity that are based on divisions and exclusion.

Diasporic identities

Media representations that use binary oppositions and stereotyping fix identities. They make identities appear to

be unchangeable. They also create divisions and boundaries between groups of people. In this section, you will learn about alternative ways of representing identity. These representations break down boundaries between fixed identities and create new, and more inclusive, forms of identity.

Many researchers have examined the experience of migrants to think about how identities change and combine in new ways. Many people's identities are shaped by the experience of migration. Their identity is shaped not only by where they currently live but also their homeland. This does not just apply to migrants themselves. The identities of their children and grandchildren are often shaped by connections to their family's homeland as well as by their place of birth.

The concept of diaspora is useful in thinking about these issues. A diaspora is a scattered network of people across the world who share a homeland or origins in common. For example, the Pakistani diaspora refers to people whose ethnic roots are in Pakistan but who are located in a wide range of countries across the world. Diasporic identities are shaped both by a connection to a homeland and by a connection to other migrants from the same homeland.

These ideas can be illustrated by thinking about the different groups who make up the population of the US. People may identify as Italian-American, Irish-American, African-American, Mexican-American, and so on. These labels give people a sense of connection with people who share the same roots even though most of the people who share these identities were born and raised in the US. However, a 'home' culture elsewhere offers a sense of belonging and investment. For example, traditional Irish music is very popular with some Irish-Americans in the US.

Diaspora is a useful concept for thinking about representation and identity. While binary oppositions encourage us to understand identity in terms of simple opposites, diasporic identities are often complex and hybrid. Their meaning is not simply rooted in the past but created through change and through engagement with a range of cultures.

Key idea

Diaspora refers to a scattered network of people across the world who share a common homeland or origins.

> *Black Britain defines itself crucially as part of a diaspora...
> In particular, the culture and politics of black America and
> the Caribbean have become the raw materials for creative
> processes which redefine what it means to be black, adapting it
> to distinctively British experiences and meanings. Black culture
> is actively made and re-made.*
>
> Paul Gilroy 1987: 154

Paul Gilroy demonstrates how popular music is used to create diasporic identities. Early rap was a distinctively American style of music which originated in New York's South Bronx. However, hip hop drew on a wider black diaspora and, in particular, aspects of Jamaican sound systems. By combining elements from the US and the Caribbean, rap enabled African-Americans to create a sound that represented identities that were both American and shaped by a wider black diaspora.

Recent black British music also illustrates Gilroy's argument. Associated with acts such as Dizzee Rascal, the grime scene combined a wide range of musical styles. Some of these had their roots in British dance music scenes. Other elements came from Jamaican dancehall. Further elements were drawn from US hip hop. This demonstrates how grime brought together musical styles from a wider black diaspora. It combined them with distinctively British themes, which were often particularly apparent in lyrics.

Hybridized identities challenge the way that binary oppositions and stereotypes create fixed identities and boundaries. For example, whereas traditional forms of Britishness are associated with whiteness, black British music creates hybrid identities which demonstrate that people can be both black *and* British.

Key idea

Hybridized identities combine elements from different cultural forms and identities and break down boundaries between groups.

Spotlight: Bollywood's diasporic audiences

Diasporic communities can be important to media industries in their 'homeland'. For the Bombay film industry, diasporic audiences are so financially important that some films are made with this market in mind. Examples include *Dilwale Dulhania Le Jayenge* (1995) and other 'family' films. Up to 45 per cent of the total revenue of these films came from overseas markets (Mehta 2005).

Representation shapes how we understand ourselves and other people. The media play a central role in constructing the meaning of identities. Media texts that fix identities in narrow ways set limits on how we understand and experience our own identities, and those of other people.

However, media do not simply stereotype identities. Nor do media representations only enforce divisions between people. Representation is also used to negotiate new forms of identity that challenge traditional boundaries and resist stereotyping.

Dig deeper

Gilroy, Paul (1987) *There Ain't No Black in the Union Jack: The cultural politics of race and nation*, London: Hutchinson.

Hall, Stuart (1997) The spectacle of the 'Other'. In Stuart Hall, ed., *Representation: Cultural representations and signifying practices*, London: Sage.

Hodkinson, Paul (2011) *Media, Culture and Society: An introduction*, London: Sage, Chapter Ten.

Ingraham, Chrys (2008) *White Weddings: Romancing heterosexuality in popular culture*, 2nd edition, New York: Routledge.

Fact-check

1 Which of the following is **not** accurate?
 a In binary oppositions, meaning is constructed through difference
 b Binary oppositions are pairs of terms that are viewed as opposites
 c Binary oppositions are used to justify the power of some groups over others
 d Binary oppositions break down the boundaries between identities

2 Which of the following is **not** an example of a binary opposition?
 a Homosexual and lesbian
 b Male and female
 c Black and white
 d East and West

3 Within binary oppositions, identities that are represented as 'Other' are:
 a Associated with dominant groups
 b Associated with subordinate groups
 c Established as the norm
 d Are associated with a range of socially valued qualities

4 Which of the following film narratives best supports the idea of heteronormativity?
 a A gay architect has a series of brief affairs as he takes a tour of Europe's best buildings
 b A heterosexual woman gives up on her cheating fiancée, decides that she cannot have it all and happily opts for a career over marriage
 c A waitress and a handyman overcome their ethnic differences and find true love
 d Rival ministers overcome racism when they enter their churches into a competition to find America's best gospel choir

5 According to Stuart Hall, stereotypes:
 a Challenge binary oppositions
 b Make the characteristics of a social group appear to be fixed and natural
 c Usually support the interests of subordinate groups
 d Produce hybrid identities

6 In the British media, chavs were:
 a Used to legitimate working-class lifestyles as superior
 b Represented as responsible citizens who were down on their luck
 c Used to portray the middle classes as 'Other'
 d Represented as having immoral and illegitimate lifestyles and behaviour

7 Diaspora refers to:
 a A scattered network of people who share a common homeland or origins
 b An opposition between two fixed identities
 c Hybrid identities
 d Simplistic forms of representation which naturalize the differences between groups

8 Hybridized identities tend to:
 a Be stable and unchanging
 b Fix differences so they appear to be natural
 c Break down the idea of fixed differences between social groups
 d Be the product of stereotypical thinking

12

Media, Representation and Gender

This chapter focuses on how media texts construct the meaning of gendered identities. Building on what you have already learned about representation and identity, it examines how the media play a crucial role in defining what it means to be a man and a woman.

The binary opposition between men and women shapes the way that people understand and experience their identities. This opposition creates the sense that men and women are fundamentally different. As you will learn in this chapter, these differences matter because they reproduce inequalities between men and women.

Media representation helps to construct and reproduce the meanings associated with masculinity and femininity. If you take a look at advertising, computer games or films, you should quickly realize that men are associated with very different qualities to women. This chapter will help you to learn about how the media represent gender so you can make sense of these differences.

Although media representations continue to define the meaning of masculinity and femininity in different ways, this does not mean that these meanings are fixed. Because the meanings associated with gendered identities change, they need to be studied historically.

The media are frequently criticized for the ways in which they represent women. However, the media do not operate in a uniform way. Some TV shows and films challenge aspects of gender inequality while others reproduce these inequalities. Campaigners use social media to protest against the representation of women as sexual objects while facing sexist abuse from trolls. The media operate as a site of struggle over the meaning of gender.

This chapter will help you to understand:

▶ Debates about how the media represent gender.

▶ How feminism has contributed to our understanding of gendered representations.

- How representations of gender have changed.

- Debates about post-feminism and contemporary representations of gender.

What is gender?

Some critics find it useful to distinguish between two key terms: sex and gender.

- Male and female are terms used to categorize a person's sex. From birth, most people are assigned one of these identities. Sex is often seen as a natural attribute and is used to describe biological differences between men and women.

- Masculinity and femininity are terms used to categorize a person's gender. Gender is used to describe the cultural differences between men and women. What it means to be masculine and feminine are culturally constructed. These meanings are mapped on to male and female bodies.

As a result, the meanings of gender can change over time. What it meant to be feminine in the nineteenth century is different to what it means to be feminine today. However, there are also continuities. For example, in magazines and popular novels in nineteenth-century Britain, femininity was associated with beauty and caring for others. Many contemporary media texts still associate femininity with these qualities.

Key idea

Gender refers to the culturally constructed categories, masculinity and femininity.

As you learned in the previous chapter, male and female – and masculinity and femininity – are examples of binary oppositions. The meaning of femininity is created through a contrast with its opposite, masculinity. To be feminine is to be 'not masculine'; to be masculine is to be 'not feminine'.

Further meanings are mapped on to these binary oppositions. For example, masculinity is associated with strength and femininity with weakness. Men are required to be hard and tough while women are expected to be caring and sensitive. These meanings provide ways of understanding and ordering the world. For example, the association between femininity and caring is used to position women as the primary caregivers to children.

You may consider some of these ideas to be outdated. However, they are still common in contemporary media. If you look at photos of male and female models or film stars, you can see how ideas of strength and weakness are mapped on to male and female bodies. Many male stars have bulky, well-defined, muscular bodies that signify strength. Female stars' bodies are frequently much more fragile and delicate; they look weaker. Many people attempt to reproduce these ideas about appropriately gendered bodies in everyday life. Some men eat and exercise to bulk up whereas women are encouraged to diet and exercise to slim down.

This suggests that strength and weakness are not simply natural differences between men and women. They are differences produced by culture rather than biology. Characteristics that appear to be natural – for example, highly defined masculine muscles – are created in response to culturally constructed ideas about gender.

Media representations of gender both create and reproduce the meanings of masculinity and femininity. These representations shape how people understand their own identity. For example, as you learned in Chapter Nine, discourses that associate femininity with beauty are reproduced across a range of media including cosmetics advertising, women's magazines and close-ups of actresses on film. Many women may look at these images and feel they are not beautiful and not appropriately feminine. But these images also encourage women to work on themselves to become more beautiful and more feminine. In this way, they exert power over women.

What is feminism?

Feminism has shaped a range of approaches to understanding gender. This influence can be seen across many academic disciplines. In Media Studies, feminist researchers have highlighted the importance of the media's role in shaping gender identities and reproducing inequalities between men and women. However, before examining these ideas in more detail, it is useful to establish just what feminism is.

Feminism is a form of politics that aims to transform the unequal power relations between men and women. Feminist theories aim to explain why there are inequalities between men and women. Feminists use these insights in order to fight for equality.

Feminism has a long history but many contemporary feminist ideas came out of the women's movement of the late 1960s and early 1970s. In this period, feminists engaged in a series of struggles against gender inequality. These included:

▶ The fight for equal pay, equal access to education and equal job opportunities.

▶ The fight for free contraception and the right to abortion.

▶ The fight to recognize the value of women's unpaid labour in the home.

▶ The fight for free childcare provision

▶ The fight for economic and legal independence for women.

▶ The fight for women's right to define their own sexuality.

▶ The fight to protect women from sexual and domestic violence.

These struggles achieved considerable success in many nations, resulting in a series of legal, social and cultural changes. However, despite these successes, there was also significant resistance to feminism and gender equality has not been achieved. In recent years, feminism has been revitalized as new generations of women recognize there is still a wide range of barriers to equality for women.

The women's movement of the 1960s and 1970s highlighted the part played by the media in maintaining male dominance. Many feminists argued that the media helped to socialize men and women into narrowly defined masculine and feminine roles. The media, it was often claimed, created images of women that restricted women's aspirations and ambitions and made male dominance appear to be natural.

During the 1970s, feminist ideas increasingly influenced academic approaches to studying the media. These provided the foundation for feminist media studies.

Key idea

Feminism is a form of politics that aims to transform the unequal power relations between men and women.

Images of women

In the 1960s and 1970s, feminist approaches to media representations of gender focused on the effects that images of women had on their audience. Researchers argued that the media portrayed women in a narrow range of roles. They claimed that these images socialized girls and women into highly restrictive feminine identities.

This early research showed that adult women on television were primarily represented as housewives. Although women were increasingly taking on a wide range of roles in society, this was not reflected on screen. Gaye Tuchman (1978) therefore argued that the media misrepresented reality. Media representations were more sexist than society.

Research from this time also showed that women were under-represented in the media. There were far more men than women on TV. Tuchman called this 'symbolic annihilation'. Although women made up over half the population, the media did not reflect this reality.

The approach of researchers such as Tuchman drew on ideas about stereotyping that you encountered in the last chapter.

They argued that the media stereotyped women. As a result, children were socialized into narrow ideas about gender roles. For example, girls learned that their future lay in being a housewife rather than, say, an engineer.

In order to achieve equality, Tuchman argued, images of women had to change. Negative images, which stereotyped women as housewives, needed to be replaced with positive images of women in the workplace. If images of women were more like those of men, then women could be represented as equal.

Key idea

Early feminist research highlighted how women were both misrepresented and under-represented by the media.

These ideas sound appealing and they still inform popular debates about the media. However, there are also some problems with these arguments:

1 The idea that the media misrepresent reality is based on a simplistic understanding of how representation works. As earlier chapters demonstrated, the media do not simply reflect or misrepresent reality but define how we understand it. Media representations construct reality for us.

2 If negative images of women are to be replaced with positive images, how do we decide what is a positive image? Many early feminists defined positive images as more 'realistic' images of women. However, this depends on your view of what a 'real' woman looks like.

Consider the following women: tennis player Venus Williams, politician Hilary Clinton, singer Rihanna, actress Lena Dunham and model Heidi Klum. How would you decide who represents the most 'realistic' image of women?

3 This early research often focused on the types of roles women occupied in media texts rather than how these roles were given meaning within a text. For example, numerous adverts for cleaning products in the UK show men doing the

housework. This may appear to be a positive move. However, these adverts frequently portray men's contributions as exceptional and a source of humour. They work on the assumption that housework is not normally defined as a masculine activity.

4 These approaches assumed that media texts had direct effects on women. Many researchers in Media Studies challenge the idea that audiences passively absorb messages in the media. You will learn more about this debate in Chapter Fourteen.

Representing gender

You have already learned that media texts do not reflect or misrepresent a pre-existing reality. Media representation constructs and reproduces our ideas about what 'reality' is. Therefore, thinking about how the media misrepresent women is problematic.

Later approaches to gender and representation examined how the meanings of femininity and masculinity are produced through representation. Media texts are one of the crucial spaces in which these meanings are produced and reproduced.

Some researchers argue that media texts reproduce patriarchal ideology. Patriarchy is a term that refers to a system of male dominance. From this perspective, the ideological function of media texts is to support patriarchy.

During the 1970s and 1980s, some feminist critics examined how mainstream cinema supported patriarchal ideology. Hollywood films, they argued, construct masculinity as the 'norm' and represent femininity as 'Other' to the norm. For example, if masculinity is associated with activity, femininity can only be associated with absence of activity – passivity.

In a world ordered by sexual imbalance, pleasure in looking has been split between active/male and passive/female.
Laura Mulvey 1981: 209

These ideas were developed in film theorist Laura Mulvey's work on Hollywood cinema. She argued that, in these films, men are active while women are passive. Men act as the heroes of movies, as subjects whose activity shapes the narrative. Women, she argued, rarely occupy these roles. They are portrayed as objects for men's viewing pleasure. They are the male hero's reward for his endeavours when, at the end of the film, he 'gets the girl'.

Mulvey demonstrates how the association between active masculinity and passive femininity is built in to the very structure of film narratives. It is not just that women are associated with passivity and represented as objects. The structure of mainstream cinema, she argues, makes it impossible to think about gendered identities in any other way.

However, other researchers argue that there are many films that do not conform to this model. Films addressed to a female audience are often organized around an active female subject. These movies put women at the centre of the action. Women drive the narrative.

Since the 1980s, there have been more opportunities for women to occupy action roles that were traditionally reserved for men. For example, films such as *Aliens* and *The Hunger Games: Catching Fire* feature female action heroes and the narrative is structured around their activity. Nonetheless, the majority of movies continue to put men at the centre of the action.

Key idea

Some research highlights how the structure of media texts reproduces patriarchal ideologies which reinforce male dominance.

Spotlight: Female characters in computer games

Research into Nintendo and SEGA games in the 1990s demonstrated that female characters were absent from many games. When women appeared, they were often 'damsels in distress' rather than action heroes. Later games continue to represent female characters as sexualized objects, the reward

for the hero's actions. However, this has been accompanied by changes. Lara Croft in *Tomb Raider* is an active lead character, although one represented in highly sexualized ways. Others games such as *Everquest* enable players to choose whether to be a male or female character while *Quake* allows gamers to create female skins (Bryce et al. 2006).

Other research challenges the idea that media texts only reproduce patriarchal ideology. Instead, some feminists argue that representation is a site of struggle over the meaning of masculinity and femininity. Considering representation in this way produces a more historical understanding which demonstrates how the meanings associated with gender are not fixed. They are open to change over time.

This approach encourages us to examine media texts to identify whether they reproduce or challenge conventional ideas about gender. Many texts do reproduce dominant ideas about masculinity and femininity. However, there is also space for these views to be contested. You will learn more about this in the rest of the chapter.

It is also important to remember that men and women do not have a single identity. People are not *only* men and women. Identities are also shaped by class, race, sexuality, ethnicity, age, and so on.

In a similar way, representations of masculinity and femininity are also shaped by the ways gender intersects with other forms of identity. For example, models of white and middle-class femininities have often been idealized in ways that black and working-class femininities have not. Likewise, white and middle-class forms of masculinity are ranked more highly than the stereotypical images of black masculinity you learned about in the last chapter. Different gendered identities are ranked so that some masculinities and femininities are represented as more desirable than others.

Key idea

Media texts are a site of struggle over the meanings of different masculinities and femininities.

Spotlight: *Ladette to Lady*

The TV series *Ladette to Lady* (2005–2010) was a reality show based on a contrast between 'acceptable' and 'unacceptable' femininities. It was set in a finishing school and the contestants were largely working-class 'ladettes' who were portrayed as loud, brash, drinking, swearing, promiscuous and out of control. The winner was the contestant who was most willing to submit to making over her identity. A series of experts advised the girls on how to achieve the desirable femininity of the lady – a demure, restrained, polite and submissive form of femininity. The show made it clear that to be a working-class ladette was to be the 'wrong' kind of woman.

Gender and magazines

Men's and women's magazines provide a useful way of understanding how the media construct the meaning of masculinity and femininity. These magazines are important because they shape how people understand themselves and their experience of the world. A glance at them should quickly reveal that they classify men's and women's interests in very different ways.

Magazines also provide a useful way of analyzing continuities and changes in the ways that masculinity and femininity are defined. For example, although fashion and beauty columns have been a fairly standard element of women's magazines over a long period of time, the meaning given to these activities has changed.

This rest of this section illustrates this by examining feminist research on girls' magazines in the UK. By considering these examples, you will learn how magazines define teenage femininity and how the meaning of teenage femininity has changed over the past forty years.

> In the mid-1970s feminist attention to girls' and women's magazines saw the magazines as exemplifying oppression... The magazines promoted romance... Inevitably this required submissive and compliant behaviour in relation to men and...

In the 1970s, the bestselling British girls' magazine was *Jackie*. Angela McRobbie (1991) argues that *Jackie* defined teenage femininity in terms of romance. The magazine constructed an ideology that encouraged girls to view love as the most important thing in their life. This ideology was central to *Jackie*'s romantic photo-stories and reinforced throughout the magazine. For example, fashion features encouraged girls to wear clothes that would appeal to boys. Music coverage portrayed pop stars as objects of romantic fantasy.

By defining teenage femininity in terms of romance, McRobbie argued, *Jackie* produced a very limited vision of what it means to be a teenage girl. A girl's life was constructed around the hunt for true love. Rather than encouraging teenagers to form friendships, it represented other girls as potential rivals for the right boy. The ideology of romance encouraged readers to see their future as wives and mothers. They were not encouraged to think about all the other things a woman could be.

In the 1980s and 1990s, McRobbie examined whether there had been changes in the way that teenage femininity was defined in girls' magazines. She discovered that new magazines, such as *Just Seventeen* and *More!*, no longer defined girls' lives in terms of romance. Instead, teenage girls were encouraged to be creative, confident and active.

These themes were reiterated across the different parts of the magazines. Fashion and beauty pages urged girls to have fun and to create an individual style. Problem pages educated girls about sex so they could be more confident and assured in their sexual lives. Although these were not feminist magazines, they drew on some feminist ideas in their definition of teenage femininity.

However, McRobbie argues, these magazines also defined their readers as consumers. Girls were taught how to construct femininity through consumer goods such as clothes and music. They showed their readers that being a good consumer was an essential part of being a girl.

By the 2000s, sex and shopping were still key elements of young women's magazines. However, there was much less emphasis on fun and pleasure. Instead, being feminine was increasingly represented as hard work. In the next section, you will learn more about the reasons for these changes.

Key idea

The meanings associated with masculinity and femininity are unstable. They are reworked and reshaped in different historical periods.

Case study: *Men's Health*

First launched in the US in the late 1980s, the lifestyle magazine *Men's Health* is now a huge success and published in over 35 countries. The magazine focuses on fitness but its central concerns are revealed in the pictures of men with 'six pack abs' that usually feature on the front cover.

These covers reflect the way the magazine constructs masculinity in relation to a 'hard' muscular body. *Men's Health* defines masculinity as the presence of muscle and the absence of fat. Readers are repeatedly advised how to achieve the masculine body through exercise and diet. In the process, the magazine plays on men's anxieties about how to be a 'real man' (Alexander 2003).

Peter Jackson et al. (2001: 101) investigated *Men's Health*'s 'excessive concern with masculine physique' in their book *Making Sense of Men's Magazines*. They argue that, conventionally, a preoccupation with the body is associated with femininity. However, *Men's Health* transforms this preoccupation into something 'manly' through its use of language. For example, men are encouraged to view their bodies as machines – a traditionally masculine interest.

Readers are not told how to eat but how to 'refuel' their bodies. This creates the sense that men's bodies can be as invincible and tireless as machines. Taking control of the body is also represented as a masculine pursuit. Readers are encouraged to 'tune' their bodies as they would their cars. While women's magazines frequently feature the relaxing pleasures of pampering, *Men's Health* gives its readers quick fixes and shortcuts to achieving the perfect body.

Despite its preoccupation with the body, *Men's Health* reaffirms the differences between masculinity and femininity. The magazine encourages readers to work on their bodies in ways that are recognizably masculine and presents sex with women as the primary reward for their work.

Postfeminist media cultures

Contemporary media representations of women are partly informed by feminism. Since the 1970s, feminist ideas have had some impact on media cultures. For example, in TV dramas women are frequently represented as professional career women rather than being restricted to domestic roles. Some film and TV narratives take on issues such as rape and domestic violence.

However, this does not mean that media texts promote gender equality. Because media representations are a site of struggle between different ideas, feminism has to compete with alternative perspectives. For example, an advert which claims that a mascara can empower women also encourages them to define their identity in terms of ideas of feminine beauty. This can make it difficult to analyze contemporary representations of gender.

Many researchers use the concept of postfeminism to make sense of these issues. Rosalind Gill (2007a) defines postfeminism as a 'sensibility' that emerged in the 2000s. She argues that post-feminism responds to feminist ideas but is not feminist. Instead, it 'entangle[s] feminist and anti-feminist discourses'.

> *Feminist ideas are at the same time... expressed and disavowed... On the one hand, young women are hailed through a discourse of 'can-do girl power', yet on the other hand, their bodies are powerfully reinscribed as sexual objects; women are presented as active, desiring social subjects, but they are subject to a level of scrutiny and hostile surveillance which has no historical precedent.*
>
> Rosalind Gill 2007b: 163

Gill uses these ideas to make sense of contemporary media representations of gender. In a postfeminist media culture, she argues:

1 Femininity is defined as 'a bodily property'. Women's magazines promote the idea that a 'sexy body' is crucial for the contemporary woman. While young women are told that this body will make them feel powerful, magazines also present the female body as a 'problem'. Readers are advised how to deal with all their imperfections and engage in work to make themselves appropriately feminine.

For example, celebrity magazines display images of sexy celebrity bodies. However, they also scrutinize these celebrity bodies and highlight their problems. Female celebrities are ridiculed for being too fat or too thin, for having cellulite or a bad hair day. These texts teach women to scrutinize their own bodies for signs of 'failure' in the same way.

2 The meaning of gender is defined within an increasingly sexualized culture. In this culture, women are represented in highly sexualized ways. Rather than simply being objectified by men, women are encouraged to objectify themselves by turning themselves into sexual objects.

3 Femininity is related to 'individualism, choice and empowerment' (Gill 2007a: 259). Media texts encourage women to take control and choose who they want to be. These themes echo feminist ideas that women should have the right to define their own lives and identities.

Yet the types of choice offered to women in women's magazines are often extremely limited. For example, cosmetic surgery has become increasingly popular and is represented as a way of taking control over your life. It is claimed that bigger breasts can boost women's confidence and help them to discover their true identity. Although taking control of the body through cosmetic surgery might seem to offer women a choice, it is an extremely limited one. It is a 'choice' to resemble media definitions of a desirable female body.

4 Makeovers are represented as a necessary feature of life. They are a key feature of women's magazines and newspapers, and of TV reality and lifestyle shows. These makeovers demonstrate that women need to take responsibility for transforming themselves into 'better' women. They encourage audiences to take control of themselves and make themselves into the best they can be.

5 Irony and knowingness are widespread. This enables people to make sexist comments while claiming that they are 'just a joke'. This enables women to be ridiculed and to be represented as sex objects.

Despite the many positive changes in women's lives, Gill argues that contemporary media culture is profoundly sexist. While women are represented as equal to men, they are also ridiculed and attacked. While women are encouraged to choose who they want to be, they are also encouraged to see their identity in terms of their bodies.

Key idea

For Rosalind Gill, contemporary media culture is characterized by a postfeminist sensibility that combines elements from feminism with anti-feminist themes.

Spotlight: Twitter and sexist abuse

Many people have been alarmed by the way women have been subjected to sexist abuse on Twitter. Those who have campaigned

for women's rights and feminist causes have been key targets. In 2013, Caroline Criado-Perez led a campaign to make the Bank of England celebrate important women – not just men – on British banknotes. Her success provoked a torrent of sexist abuse on Twitter, including sustained threats of rape and murder. As a result, feminist politicians such as Yvette Cooper have called on Twitter to produce mechanisms for users to report abuse.

Representations of gender in contemporary media are complex. Recent research by critics such as Rosalind Gill highlights the way in which contemporary representations of femininity still contribute to wider gender inequality.

However, the media are not uniform. Although social media are used to threaten women who call for greater sexual equality, the same media are used to organize protests against sexist images of women. Celebrities such as Beyoncé may represent themselves as sexual objects but also campaign on feminist issues and encourage female empowerment. As you start to analyze representations of gender in the media, it is important to be aware of this complexity.

Dig deeper

Gauntlett, David (2008) *Media, Gender and Identity: An introduction*, Abingdon: Routledge.

Gill, Rosalind (2007) *Gender and the Media*, Cambridge: Polity

Hollows, Joanne (2000) *Feminism, Femininity and Popular Culture*, Manchester: Manchester University Press.

Jackson, Peter, Stevenson, Nick and Brooks, Kate (2001) *Making Sense of Men's Magazines*, Cambridge: Polity.

McRobbie, Angela (1991) *Feminism and Youth Culture: From Jackie to Just Seventeen*, Basingstoke: Macmillan.

Fact-check

1 Which of the following campaigns is **not** associated with feminism?

 a Equal pay for men and women
 b Women's right to define their own sexuality
 c Freely available contraception and abortion
 d Women's right to be the legal property of men

2 The 'Images of Women' approach:

 a Focused on how women were both misrepresented and under-represented in the media
 b Used a semiotic approach to how woman is constructed as a sign
 c Focused on how media narratives were organized around active masculinity and passive femininity
 d Examined postfeminist media cultures

3 According to Laura Mulvey, the structure of mainstream film narratives is organized around:

 a The depiction of women as housewives and mothers
 b The representation of unrealistic and negative images of women
 c The representation of men as active subjects and women as passive objects
 d The symbolic annihilation of women

4 Angela McRobbie's research on girls' magazines demonstrates how:

 a Representations of femininity are fixed and unchanging
 b An ideology of romantic love is a consistent feature of girls' magazines
 c The meaning of femininity is reworked over time
 d Girls have always been represented as creative and confident

5 Which of the following ideas is **not** associated with *Men's Health* magazine?

 a Men should treat their body as a machine

 b Men should engage in quick fixes and shortcuts to the perfect body

 c Real men should have toned and 'hard' bodies

 d A preoccupation with the body makes a man appear feminine

6 Rosalind Gill argues that postfeminism:

 a Is the name for a new wave of feminist struggle

 b Defines women as primarily wives and mothers

 c Combines feminist and anti-feminist ideas in a complex way

 d Promotes the idea that women should be happy with how they look naturally

13

Media Effects

Popular debates about the significance of the media often focus on media effects. Newspaper headlines warn of the dangerous effects of violent films or computer games. The media, they claim, make their audiences obese, depressed or aggressive. They can even transform people into killers.

These newspaper reports portray various media technologies and texts as the *cause* of a whole series of *direct* and *negative* effects. They often focus on the power of the media to change people's behaviour. For example, some newspaper reports claim that games such as *Call of Duty* can make young people aggressive and violent.

These claims seem persuasive and commonsense. However, they are deeply problematic. In this chapter, you will learn why the evidence used to back up these claims relies on a simplistic understanding of the relationship between audiences and the media.

This is the first of a series of chapters on media audiences. Although the following chapters examine how people interpret and use media texts, this chapter explores research that focuses on what texts do to audiences. You will evaluate studies that suggest that media texts have direct effects on the audience. In particular, this chapter examines claims about the impact of media representations of violence on young people's behaviour.

Debates about media effects also raise issues about regulation. Fears frequently build into moral panics that highlight how the media pose a threat to society. As you will learn later in the chapter, these panics are often accompanied by demands for tighter regulation of media texts and/or the activities of audiences.

This chapter will help you to understand:

▶ The differences between types of media effects.

▶ The assumptions that underpin research into media effects.

▶ Moral panics about media effects.

▶ How to challenge ideas about the direct effects of the media.

Thinking about media effects

As you learned in Chapter Two, there is a long history of concerns about the powerful effects that media have over their audiences. People have worried about the influence of newspapers, novels, cinema, radio, TV, comics, computer games and the Internet. Each new technology brings with it new waves of concern about the effects of the media.

These claims usually focus on what the media do to *other people*; critics are rarely concerned about what the media do to themselves. Instead, they identify particular groups as susceptible to the power of the media. Fears about media effects are often focused on women, the working class and, in particular, children. Claims about media effects, therefore, usually assume that some audiences are more gullible than others.

As you learned in Chapter Two, some early critics focused on the political effects of the media. For example, Theodor Adorno and Max Horkheimer argued that, as media technologies became more sophisticated, they had increasing power to dominate their audience. They believed audiences passively responded to this power.

Underlying Adorno and Horkheimer's argument is the hypodermic syringe model of the relationship between media texts and media audiences. A hypodermic syringe is used to inject substances into the body and the model assumes that the media works in a similar way: media messages are simply injected into the audience's minds.

Many claims about the direct effects of the media on audiences rely on this model, assuming that audiences passively absorb media messages. You will learn much more about arguments that challenge this position in the following chapters.

Key idea

The hypodermic syringe model assumes that media messages are injected directly into the audience so that audiences passively absorb these messages.

David Buckingham (2000) identifies three key types of effect that people claim are caused by the media:

1 **Behavioural effects.** These arguments focus on how the media change the ways in which people act. This can be seen in the claim that violent media images cause people to behave in an aggressive manner.

2 **Emotional effects.** These arguments focus on how the media provoke emotional responses in audiences. For example, violent media images might make people feel scared or disgusted.

3 **Ideological effects.** These arguments focus on how the media cause people to adopt certain beliefs, attitudes or ideas. These effects are difficult to measure as most people claim they are the result of long-term exposure to particular ideas.

Many concerns about media effects focus on how the media have direct and immediate effects on people's behaviour. The following sections examine these concerns in more detail.

Spotlight: The effects of Elvis

In the 1950s, there were panics about the effects that rock and roll would have on its young audience. When Elvis Presley made his second TV appearance in 1956, the camera crew were directed to film him only from the waist upwards. It was feared that the sight of Elvis's gyrating pelvis would inflame the sexual passions of young women. This was part of a wider panic about the effects of rock and roll. People claimed that this new form of music would cause teenagers to become promiscuous and violent, posing a threat to social order.

Studying media effects

Most research on media effects attempts to measure direct effects on behaviour. This research tradition is strongly influenced by psychology. Researchers construct experiments to discover the extent to which the media have direct effects on audiences.

> *The 'effects tradition' focuses predominantly, but not exclusively, on the effects of television rather than other media – on effects on the child audience especially – on the effects of violent or stereotyped programmes, and on effects on individuals... By and large, it tests the idea that exposure to particular media content changes people's behaviour or beliefs [...] Media effects researchers argue that causal connections between media exposure and behaviour can only be inferred through controlled experiments.*
>
> Sonia Livingstone 2005: 23–4

Sonia Livingstone explains how research on media effects frequently takes place in laboratory conditions. Obviously, these are not the conditions in which people normally use the media. However, some researchers argue that laboratory settings help them to identify how one particular factor, such as media violence, causes particular effects. They conduct experiments in order to prove or disprove their ideas.

Key idea

Studies of media effects are often based on experiments conducted in laboratory conditions that aim to measure the effects that the media have on audiences.

In 1963, Albert Bandura and his colleagues conducted what has become the most famous experiment on media effects. These psychologists set out to measure the impact that screen violence had on children's behaviour. In particular, they set out to discover whether children copy acts of aggression they see on screen. Some of the children in the study viewed images of aggressive behaviour towards a 'Bobo doll', a large inflatable doll. As a result, Bandura's study became known as the Bobo doll experiment.

In order to measure the impact of screen violence on children's behaviour, Bandura allocated the children in his study into four groups:

▶ The first group watched 'real-life' acts of aggression against the Bobo doll.

▶ The second group watched filmed acts of aggression against the Bobo doll that had been shot in a 'realistic' style.

▶ The third group watched films of acts of aggression against the Bobo doll by a cartoon cat.

▶ The final group did not watch any acts of aggression towards the doll.

This study is often cited as proof that media violence causes violent behaviour in children. However, Bandura's findings do not really support this conclusion. There was little evidence that viewing aggression caused children to behave aggressively. Although some children in the study acted in an aggressive way towards the doll, very few of them imitated the actions they had seen on film. There was also little evidence that viewing aggression caused children to behave aggressively. Children who had not seen any examples of aggression towards the doll were more aggressive towards it than any of the other children (Messenger Davies 2010: 79–81).

There are many problems with laboratory studies of media effects. These include the following:

1 Máire Messenger Davies argues that these studies offer only 'weak' levels of proof of media effects. This is demonstrated by the Bobo doll experiment where viewing violence appeared to have little direct effect on behaviour.

2 Laboratories are very different from the everyday contexts in which people normally use the media. People may not respond in the same way outside the lab. Therefore the results of these studies may not apply to everyday media use.

3 These experiments often focus on very short-term effects. For example, they look at the immediate consequences of viewing particular kinds of media text. They tell us little about the longer-term effects of the media.

4 These studies assume that people passively absorb media messages. Audiences are far more actively engaged with the

media than this assumption suggests. You will explore this in more detail in the next chapter.

5 Because these studies focus on the media, they pay relatively little attention to other factors that might influence behaviour. There are a range of factors might cause someone to behave in a violent manner, rather than just the media.

> *While media violence could conceivably be seen to produce many different kinds of effects – to generate fear, for example... – the central preoccupation has been with its ability to produce aggressive behaviour, particularly among children... In the estimation of many other researchers, this research in fact fails to prove its central hypothesis: that media violence makes people more aggressive* than they would otherwise have been, or that it causes them to commit violent acts they would not otherwise have committed. *It may influence the form or style of those acts, but it is not in itself sufficient cause to provoke them.*
>
> David Buckingham 2000: 129–30

The idea that the media have direct effects on people's behaviour is deeply problematic. However, ideas about direct effects continue to shape how the media are understood in popular debates. In order to understand why this is, it is necessary to look more closely at the debates about the effects of media violence.

Key idea

There is little substantial evidence to support the idea that exposure to media violence causes people to become violent and aggressive.

Moral panics about media violence

Despite the many criticisms of media effects research, newspaper headlines continue to reproduce claims that media violence produces violent behaviour. 'Violent video games DO make people more aggressive' claims one headline. 'TV is "to

blame for violence"', claims another. These stories often focus on the alleged impact of media violence on young people. This can be seen in headlines such as 'TV violence *does* make your child aggressive' and 'Violent video games make children grow up into aggressive adults, study claims'.

Press reports which concentrate on the effects of the media on children and teenagers often represent young people as innocents who can be easily corrupted. The reports suggest that young people are particularly vulnerable audiences who will copy the behaviour they view in the media and become violent and aggressive as a result. In these debates, violent films, television programmes and computer games are held responsible for youth crime (Barker and Petley 2001; Buckingham 2000).

This is evident in a range of moral panics about media violence. The concept of a moral panic is used to describe a period of high-level anxiety within society about something that is defined as a threat to our way of life. The media play a key role in generating or escalating moral panics. They also publicize demands for legal action and increased regulation so the supposed threat can be neutralized. Of course, not all moral panics focus on media violence. Media-generated panics have focused on a range of 'threats' from youth subcultures to horsemeat in supermarket beefburgers.

Societies appear to be subject, every now and then, to periods of moral panic. A condition, episode, a person or group of persons emerges to become defined as a threat to societal values and interests; its nature is presented in a stylized and stereotypical fashion by the mass media; the moral barricades are manned by editors, bishops, politicians and other right-thinking people; socially accredited experts pronounce their diagnoses and solutions... Sometimes the object of the panic is quite novel and at other times it is something which has been in existence long enough, but suddenly appears in the limelight.

Stanley Cohen cited in Charles Krinsky 2013: 3–4

Moral panics present a particular thing or type of person as a threat to society. This threat is portrayed as a 'folk devil' – a

bad thing or person alleged to be responsible for a whole range of social problems. The folk devil acts as a kind of scapegoat, something or someone that society can blame for what appears to have gone wrong.

Key idea

A moral panic is a period of societal anxiety about a particular threat, often generated by the media and resulting in a legal response.

A classic example of how moral panics about media violence emerge occurred in the UK in the 1980s and 1990s. Two successive waves of public concern focused on the effects of horror videos that became known as 'video nasties'. These examples illustrate how moral panics often serve particular agendas.

The first wave was between 1982 and 1984 in response to a cycle of gruesome low-budget horror movies that were available on video. This coincided with the expansion of the home video market that enabled people to watch movies at home. The press generated fears that children would be able to watch these films at home and predicted disastrous consequences. As the *Daily Mirror* put it, 'Violent, sadistic and perverted video films are as great a danger to a child's mind as any infectious disease is to the body' (cited in Murdock 1984: 57).

The term 'video nasties' was first used by *The Sunday Times* but was quickly adopted more widely. Many press reports highlighted the threat video nasties posed to the nation's children. Various public figures called for something to be done to protect children from them. The result was new legislation, the 1984 Video Recordings Act. The Act imposed tougher regulations about what could be viewed on video that those governing cinema.

This may sound sensible but there are a few important issues highlighted by this case. There was little evidence that many children were watching video nasties. There was no evidence

that video nasties made children into monstrous killers. But the press continually reiterated the nature of the threat so that it appeared to be 'true'. Once this 'truth' was established, stricter censorship was put in place. This was done to protect children, although there was little evidence that they were in need of such protection.

Case study: Video nasties and 'copycat' crime

A second moral panic about video nasties occurred between 1993 and 1994. In 1993, there was widespread shock after two-year-old James Bulger was abducted and beaten to death by two ten-year-old boys. The boys were found guilty of murder. There was understandable concern about how such a thing could happen.

In order to explain these children's behaviour, people turned to an established folk devil – video nasties. The judge in the trial observed that 'violent video films' might explain why the boys had behaved in such a way. He highlighted similarities between the way in which Bulger had been attacked and a scene in the film *Child's Play 3*.

The press quickly jumped on the judge's comment, presenting his speculation about the film as fact. For example, one headline in *The Sun* claimed 'Horror Video Replay: Chilling links between James murder and tape rented by killer's dad'. Another headline called to 'Ban Movie Nasties' (cited in Thompson 1998: 98).

The link between the film and the children's violent actions initially appears to be troubling and suggests that they copied film violence. However, the police had no evidence to suggest that the boys had ever watched *Child's Play 3* or other video nasties. Despite this, the press followed the judge in deciding that the video nasties were to blame. Many journalists highlighted how children copy aggressive behaviour they have viewed on screen.

These exaggerated claims about media effects and copycat violence led to an amendment to the Video Recordings Act. This called for tight censorship of videos that might act as an 'inappropriate model' for children. The law was changed based on claims about effects of violent media, despite a lack of evidence about these effects.

Key idea

During moral panics about media violence, violent films and videogames are represented as folk devils that pose a major threat to society..

The problem with moral panics

Moral panics about video nasties – and about media violence more generally – have been heavily criticized. According to Martin Barker and Julian Petley (2001), the problems with moral panics about media violence include:

1 Commentators make claims about acts of violence in the media without examining how the violence is contextualized. A film that portrays acts of killing does not necessarily glorify violence. Indeed, many films focus on the negative consequences of violence.

2 The focus on the media as the cause of crime distracts attention from the more complex causes of crime.

3 When people watch films or play computer games, they draw on their existing ideas, values and moral codes (see Chapter Fourteen). If people already think that murder is generally bad, they are unlikely to change their mind because they've watched a horror film.

4 It isn't just adults who bring existing knowledge and values to their viewing. Children also respond in complex ways to film and television. They make their own judgements about what they think is appropriate – and inappropriate – to watch.

The panics over video nasties demonstrate how anxieties about media effects are always concerns about *other people*. The press coverage talked about irresponsible parents who let their children watch violent videos. This generated fears about the threat to innocent children and the activities of 'bad' parents. These moral panics were used to draw distinctions between 'good' and 'bad' media users. These distinctions were often based on social class.

Key idea

Moral panics about media violence ignore how violence is contextualized within media texts and assume that some audiences respond passively to media messages.

Spotlight: Panic as promotion

Oliver Stone's film *Natural Born Killers* (1994) focuses on the adventures of a 'white trash' couple who go on a killing spree. It uses adventurous film-making techniques and Stone claims that the film satirizes the obsession with violence in contemporary culture. However, even before its release in the UK, press reports claimed the film glorified violence. Commentators predicted that the film would cause copycat crimes. This panic had an impact on regulation: the release of the film was delayed while the BBFC investigated reports into copycat crimes in the US. In this case, the panic about the film helped it become commercially successful when it was finally released. Some viewers went to see it because the negative reports had given the film a cult status.

Continuing concerns about media effects

Ideas about the media's effects continue to shape public debates about the role of the media in society. In some cases, these debates take the form of moral panics. More generally, there is a steady stream of news stories about the alleged effects of media texts and technologies.

James Newman (2013) highlights how many recent laboratory studies focus on the effects of computer games on young people. Some studies highlight how the supposedly addictive nature of games causes players to develop more general forms of addictive behaviour. These concerns are replayed in newspaper headlines such as 'Can online games be as addictive as heroin?' and 'Gaming is "next major addiction"'.

As you have already seen, it is claimed that violent videogames also cause violent behaviour. These concerns are heightened when seemingly inexplicable acts of violence are linked to video game use. For example, in 1999, two school students killed 13 people – and injured many more – at Columbine High School. The killers were keen gamers and the idea that violent videogames caused the shootings was quickly established in news reports. Ideas about media effects provided easy answers to the more complex question of what had caused these acts of violence.

Claims that violent videogames cause violent behaviour are often based on a superficial engagement with the content of these games. First-person shooter games do contain violent images and often invite their players to kill their enemies. However, this tells us little about the 'attitudes, values and experiences' of gamers. Just because there are violent images in computer games, it does not follow that players become violent (Newman 2013).

Spotlight: 'Driven to kill by *Call of Duty*'

This front page headline is taken from the *Daily Mirror* (18 September 2013). It refers to Aaron Alexis who killed 12 people in a US naval yard in 2013. Below the headline, it claimed that 'Maniac spent 18 hours a day playing violent videogames'. These kinds of headlines help to reproduce the idea that media violence is the main cause of real-life violence. They distract attention from alternative explanations for the crime. In this case, as the article inside goes on to say, the killer was also alleged to have alcohol problems, a history of mental illness and prior arrests for violence.

The claim that the media have direct effects is deeply problematic. While the media do have some influence on audiences, people do not respond automatically to media messages.

This chapter has highlighted the relationship between audiences and regulation. As you have learned, panics about media effects are usually panics about the media's effects on *other people*. This usually results in calls for increased regulation – for

example, stricter censorship. In the case of moral panics, calls for more regulation are usually calls for more regulation of those audiences who, it is claimed, cannot be trusted to regulate their own behaviour.

In the next chapter, you will learn more about how audiences engage with the media. Research demonstrates the complex ways in which people interpret and make sense of media texts. The studies you will examine take us away from the artificial conditions of the laboratory and into people's living rooms to explore how they engage with media in everyday life.

Dig deeper

Barker, Martin and Petley, Julian (2001), eds, *Ill Effects: The media/violence debate*, 2nd edition, London: Routledge.

Buckingham, David (2000) *After the Death of Childhood*, Cambridge: Polity, Chapter Seven.

Critcher, Chas (2003) *Moral Panics and the Media*, Maidenhead: Open University Press.

Livingstone, Sonia (2005) Media audiences, interpreters and users. In Marie Gillespie, ed., *Media Audiences*, Maidenhead: Open University Press.

Messenger Davies, Máire (2010) *Children, Media and Culture*, Maidenhead: Open University Press, Chapter Five.

Fact-check

1 The hypodermic syringe model assumes that:
 a Audiences reject most media messages
 b Audiences are actively involved in making meaning
 c Media messages are absorbed by passive audiences
 d Media messages have no effects

2 If a horror film makes people feel scared, this is an example of:
 a A behavioural effect
 b An emotional effect
 c An ideological effect
 d A violent effect

3 If a violent film makes people act in a violent manner, this is an example of:
 a A behavioural effect
 b An emotional effect
 c An ideological effect
 d A typical effect

4 The Bobo doll experiment aimed to find out whether:
 a Viewing aggressive acts caused emotional effects in children
 b Children would imitate aggressive behaviour they had viewed on screen
 c The media has long-term effects on children
 d Children reacted differently to the media in their own homes

5 In moral panics about media violence, the media:
 a Exaggerate the level of the threat to society
 b Offer a realistic portrait of a genuine threat
 c Disguise the problems caused by media violence
 d Criticize the idea that the media cause behavioural effects

6 Moral panics about media violence are usually accompanied by demands for:
 a Deregulation of the media
 b Less censorship
 c Increased choice and freedom for media audiences
 d Increased regulation of the media

7 Moral panics about the effects of the media on children usually suggest that:
 a Children are active and discriminating media users
 b The media have little effect on children
 c Children are particularly vulnerable to the media
 d Children do not spend enough time using the media

8 The first wave of moral panic against video nasties:
 a Caused more horror films to be produced
 b Centred on *Child's Play 3*
 c Resulted in stronger regulations about what could be viewed on video
 d Resulted in less regulation of cinema audiences

14

Media Audiences

You have already encountered a range of ideas about media audiences. Audiences are central to the economics of media industries. Producers and distributors must win audiences in order to secure sales of movie tickets or (legal) music downloads. You have also learned that audiences are commodities: whether you run a blog or own a major television network, you can profit from your audience by selling it to advertisers.

Earlier chapters also explored debates about media effects and about the ideological control that media texts exert over audiences. These approaches focus on the power of texts over audiences. They represent the audience as passive. From these perspectives, there is no need to investigate how people interpret and make use of media.

Instead of assuming what texts do to audiences, this chapter examines research into what audiences do with media texts rather than that assuming what texts do to audiences. The research demonstrates how people are actively involved in interpreting media texts. This does not mean that texts have no power. Even active audiences are not free to interpret texts in any way they wish.

This chapter focuses on three elements of the circuit of culture: representation, consumption and identity. The ways in which audiences consume media representations are shaped by their cultural identities.

You will learn key concepts, methods and approaches, and look at studies that have been used to make sense of media audiences. Much of the chapter focuses on television audiences, reflecting some of the concerns of classic studies. However, you will also explore ways of thinking about the relationships between digital media forms and audiences.

This chapter will help you to understand:

▶ The uses and gratifications approach.

▶ How audiences interpret texts.

▶ How audiences respond emotionally to texts.

▶ Methods of studying media audiences.

▶ Audiences and digital media.

Uses and gratifications

Uses and gratifications theory was first developed in the 1940s and became popular again in the 1970s. This approach challenges the idea that audiences are mindless and passive consumers and demonstrates how individuals make rational and conscious choices about how to use the media.

Researchers who explored the theory were primarily concerned with how audiences selected media texts because they performed particular psychological functions. We might seek out a particular type of media because it provides us with information, or a particular genre because we find it relaxing. Some uses and gratifications theorists suggested that different personality types would seek to fulfill different needs through their use of the media.

The appeal of this approach is that it is relatively easy to relate to your own media use. If you think about why you put a particular song on your iPod, or watch a particular TV show or use your mobile phone on a bus journey, you can probably identify the particular needs you were attempting to fulfill. You may have been seeking to be entertained, to alleviate boredom, to be informed or to feel connected to other people.

Uses and gratifications theory was important because it demonstrated how audiences are active media users rather than being controlled by the media. It draws attention to how and why people choose to use different media.

Key idea

The uses and gratifications approach focuses on what individuals actively do with media texts in order to satisfy their psychological and social needs.

However, while this approach is still used today, it is no longer dominant within Media Studies because it has a range of limitations:

1 Uses and gratifications theory primarily understands audience members in terms of their individual psychological needs.

As you will learn, the social and cultural groups to which people belong can have a significant impact on how particular audiences engage with the media.

2 People's 'needs' are not simply rooted in their individual psychology but are socially and culturally constructed. For example, is a Western teenager's 'need' for information the same as that of a young farm worker in the seventeenth century?

3 Uses and gratifications theory underestimates the power of the media. Just because audiences make active use of the media, it doesn't mean that media texts have no power over their audience.

This created a problem for Media Studies. Media effects research portrayed texts as having total power over a passive audience. Uses and gratifications research portrayed audiences as active and powerful but did not tackle the potential power of media texts over their audiences. It also ignored how power relations shape the ways that different groups interpret and engage with the media. The task was to develop a way of thinking about the relationships between texts and audiences in a more complex way.

Spotlight: Watching audiences watch TV

In recent years, what audiences do with the media hasn't just been of interest to academics. Watching how audiences interpret TV has become prime-time entertainment. In the UK, Channel 4's *Gogglebox*, which allows viewers to watch other viewers watch TV, has been both a critical and ratings success. Although most people do not have cameras in their living rooms, *Gogglebox* demonstrates how the same text can provoke both very similar and very different interpretations and reactions from different audiences. The format has been sold internationally, with versions in the US (*The People's Couch*) and Australia (*Gogglebox Australia*).

The Encoding–Decoding model

The encoding-decoding model was developed by Stuart Hall (1993) to explain the relationship between texts and audiences.

Drawing on theories that you've already encountered about semiotics and ideology, Hall believed that texts work to privilege the ideologies of dominant groups. However, he argued, this does not mean that texts have straightforward ideological effects on their audience.

TV news can be used to illustrate these ideas. In putting together news stories, media workers draw on familiar conventions and their professional knowledge to construct the meaning of – or to encode – the story in particular ways. Researchers can use semiotics to identify how meaning is organized in these stories. This also enables researchers to identify key ideological themes.

By analyzing how meaning is organized, Hall argued, we can identify how texts such as news stories construct a dominant or 'preferred' meaning. These meanings encourage audiences to understand and interpret the text in specific ways.

> *Because we all bring to our viewing those other discourses and sets of representations with which we are in contact in other areas of our lives, the messages we receive from the media do not confront us in isolation... Thus, how we respond to messages from the media depends precisely on the extent to which they fit with, or possibly contradict, other... viewpoints we have come across in other areas of our lives.*
>
> David Morley 1992: 76–7

However, not all audiences share the same cultural frameworks and reference points as the producers of the text. This means that some audiences read – or decode – a text in ways that differ from the ways in which a message was encoded.

Hall suggests that audiences decode messages in three key ways:

1 A dominant decoding shares the preferred meaning constructed within a media text. This means that someone will accept the position offered by the text.

2 A negotiated decoding largely accepts the legitimacy of the preferred meaning but may reject specific elements of it that do not fit with the reader's own knowledge or experience.

For example, a news story might report findings that demonstrate a significant decrease in school bullying. An audience member might pause to reflect on their knowledge that both their cousins have recently been bullied. However, they go on to accept the news report's general conclusions and acknowledge that their cousins' experiences must have been the exception rather than the norm.

3 An oppositional decoding is made when an audience member, despite understanding the preferred meaning, might choose to reject it.

Key idea

There may be differences between how meaning is constructed in a text (how meaning is encoded) and how audiences interpret or make sense of that text (how meaning is decoded).

Hall's model does not assume that media texts have one straightforward meaning or message. He argues that texts are polysemic: they have the capacity to generate a range of meanings. As a result, different audiences may interpret the same text in different ways. Therefore, there is no guarantee that audiences will decode the meaning of a text in the same way as it has been encoded.

This model for understanding audiences was important. Hall's argument demonstrated why audiences do not simply passively accept media messages and how they were instead actively involved in interpreting media texts. However, he only produced a theoretical model. He did not study how real audiences made sense of media texts.

Key idea

Media texts are polysemic: they have the capacity to generate a range of meanings.

David Morley and the *Nationwide* audience

David Morley used Hall's ideas to carry out research into how different media audiences interpret texts. His study focused on the TV programme *Nationwide*. This was a popular BBC news magazine show of the 1970s that was broadcast on weekday evenings.

Together with Charlotte Brunsdon, Morley first conducted a semiotic analysis of *Nationwide* (Morley and Brunsdon 1999). They identified the show's key ideological themes and how *Nationwide* addressed its audience. This enabled them to identify the preferred meanings that were encoded in specific news stories.

Morley then investigated how different audiences decoded *Nationwide*. He wanted to find out how a person's position in the social structure shaped the discourses they used to decode the programme. He interviewed 29 groups of people with different occupations and levels of education. Each group was shown a video of *Nationwide* and invited to discuss the programme.

In order to make sense of audience responses to the programme, Morley looked for patterns in the ways different groups responded to the ideological themes of the show. He also analyzed how different groups interpreted the ways *Nationwide* addressed its audience. Morley did not just describe how a variety of groups made different interpretations of the texts, but also *why* they did so. This is a crucial element of audience research because it allows us to identify what is significant about the differences between audiences' readings of media texts.

Drawing on the encoding-decoding model, Morley identified how different groups produced dominant, negotiated and oppostional readings of *Nationwide*. For example, groups of managers produced a dominant reading, largely accepting the meanings constructed in the text. However, some trade union officials produced oppositional readings and drew on their own knowledge and experience to dispute the preferred meaning of the text.

Morley discovered that the ways in which different audiences made sense of *Nationwide* was shaped by the range of

discourses and cultural frameworks they used to decode the text. These discourses and frameworks had been shaped by the social and cultural positions that different groups inhabited. Class background was one factor influencing the way people engaged with *Nationwide*, but their readings were also shaped by their experiences as members of a range of other social and cultural groups.

Morley also found that the ways in which people engage with media texts is shaped by whether they find a text relevant or not. For example, Morley showed *Nationwide* to a group of young black students in further education. This group did not bother to produce an oppositional reading because they simply rejected the show altogether. They viewed it as utterly irrelevant to their lives and did not feel included in the way *Nationwide* addressed its audience.

> *Firstly, audiences must interpret what they see even to construct (or decode) the message as meaningful and orderly, however routine the interpretation may be. Secondly, the experience of viewing is socially and culturally located, so that viewers' everyday concerns, experiences and knowledge become a resource for the interpretative process of viewing. Thirdly, audiences differ in their interpretations, generating different readings of the same media text. Audience creativity and heterogeneity are not unlimited, however, for viewers are constrained by their position in the social structure.*
>
> Sonia Livingstone 2005: 41–2

Morley's research demonstrates that media audiences do not passively consume media texts. However he does not argue that people are free to read texts in any way they like. The way in which meaning is constructed in the text shapes how audiences engage with it.

Likewise, Morley's work does not suggest that we engage with texts on an individual basis. How we interpret media texts is shaped by our place in the social structure, by our cultural identity, background and experience.

Key idea

Audiences' interpretations of media texts are shaped by the social and cultural groupings they belong to and the discourses they draw on to engage with the text.

Changes in audience research

Morley's study of *Nationwide* was very influential and promoted further research into audiences. However, Morley (1992) identified a series of problems with his study which, he argued, needed to be addressed in future research. These problems included:

1 The *Nationwide* study was not conducted in an environment in which people usually watch television. He showed *Nationwide* to groups of people in a classroom, often to people who didn't usually watch the show. This artificial setting was very different from the contexts in which people normally engage with media.

Morley argued that future research needed to investigate how audiences interpret and use the media in the context of everyday life in their homes. In the next chapter, you will learn more about Morley's own research in this area.

2 Morley also argued that the *Nationwide* study was too narrowly focused on decoding and how audiences interpreted the preferred meaning of a text. This ignored many of the wide range of processes involved in watching television.

3 Morley suggested that future research should examine how different audiences classify different media texts as relevant and irrelevant, or comprehensible and incomprehensible. For example, different audiences are attracted to different genres. People may be attracted to genres that draw on the forms of knowledge, experience and ways of viewing the world that are important to them.

This is illustrated by Dorothy Hobson's (1980) research on housewives' use of the media. Her study demonstrates how gender shapes the ways in which people classify texts as

relevant or comprehensible. The housewives in her study had very clear ideas about radio and television programmes that were 'not for them'.

For example, the women she studied liked soap operas. The focus on family and personal life in soaps made sense to women who were responsible for looking after home and family. These housewives didn't like TV and radio news. They found it irrelevant because, they claimed, it focused on 'men's worlds'. These women's sense of which media texts were relevant and comprehensible was shaped by their social position and cultural identity.

Key idea

Different audiences classify media texts as relevant/irrelevant and comprehensible/incomprehensible based on their identities and experiences.

Case study: Ethnography and audience research

Many researchers use ethnographic research methods to investigate how audiences interpret and use media in their everyday lives. Ethnography aims to discover how people interpret and make sense of their world. Ethnographers aim to understand the world through the eyes of the people they are studying.

Traditionally, ethnography has been associated with long-term and in-depth studies. These enable researchers to immerse themselves in other people's worlds in order to gain a better understanding of the group they are studying.

This can be a problem for media researchers. Much media use takes place in the home and few of us would want a researcher living with us for a sustained period! As a result, ethnographic studies of media often use in-depth interviews to understand how people make sense of the media. These interviews frequently take place in people's homes or other places they feel at ease. This enables researchers to grasp the meaning of media consumption in the context of everyday life.

Nonetheless, some researchers have spent prolonged periods observing domestic media consumption. In Hugh Mackay's (2004) study of digital media, researchers not only conducted interviews but also observed how people used media in the home. As researchers spent more time with the households they were studying, their presence became more natural. They did not have to rely on people's accounts of how they used media because they could observe it first-hand.

Emotional responses to reality TV

When we watch television or listen to music, we do not just interpret texts. They can also provoke strong emotions, from anger to joy. These reactions are not automatic. Media texts are organized to provoke an emotional reaction but they cannot determine how people will react. Instead, people's emotional responses to texts are shaped by their identities and experiences.

Beverley Skeggs and Helen Wood (2012) examined audience reactions to reality TV in the UK. They began by doing a textual analysis to understand the specific features of reality TV. They also identified how the participants were used to provoke audience reactions. For example, many reality shows use close-ups that linger on the emotional responses of participants. These shots invite audiences to react and make judgements about the people on screen.

However, textual analysis cannot tell us how people react to reality television. In order to learn how different audiences responded to these shows, Skeggs and Wood carried out research with 40 women in south London. These women came from a range of classes and ethnic groups. This enabled the researchers to investigate whether there were any significant differences between the responses of women who came from different backgrounds.

The researchers combined a variety of methods. They carried out in-depth interviews and brought the women together in

focus groups. However, to understand how audiences reacted to specific shows, they also conducted 'text-in-action' viewing sessions. In these sessions, the researchers watched the women watch TV, observing how they interacted with the texts and established a relationship to them.

> *We were interested in the forms and types of connection they made with the television: enabling us to examine how people place themselves within the drama of the programmes; how they insert themselves into, or distance themselves from, the intimate relationships displayed; how they feel about characters on television in relation to themselves, friends and family; and how they enact their relationships to the participants.*
>
> Beverley Skeggs and Helen Wood 2012: 13–14

Skeggs and Wood's research focused on how television makes audiences feel. They discovered that the class position of women in their study had a significant impact on how they reacted to reality television. The middle-class women used their educational and social advantages to distance themselves from what they viewed. They criticized the shows and the experts who took part in them.

The working-class women shared a class background with many of the participants. They were far more emotionally involved in the shows than the middle-class women. Their strongest emotional responses were against participants who shared a similar class background. These responses were often hostile and were used to demonstrate differences between them and the women on screen.

Skeggs and Wood's research demonstrates the continuing importance of research into audiences. Their use of the 'text-in-action' method enabled them to study how audiences make emotional responses to media texts. Programming such as reality TV is designed to provoke reactions in audiences. However, different audiences have different emotional responses that are shaped by their own experiences and social position.

Key idea

Social and cultural differences shape the emotional responses that audiences make to media texts.

Spotlight: Clickbait

Clickbait is content designed to generate traffic to a website. It often consists of sensational or outrageous comments, although videos of cute animals are used in a similar way. Clickbait frequently aims to generate a strong emotional response. The British tabloids use outspoken and outrageous columnists as a form of clickbait to attract audiences to their websites. Outrage generates its own publicity. For example, when Katie Hopkins, a columnist for *The Sun* newspaper, compared migrants to 'cockroaches', over 300,000 people signed an online petition demanding that she should be sacked.

Digital media audiences

The idea of 'the audience' is usually associated with forms of mass communication such as TV. It is imagined as a huge group of people engaged in the same activity at the same time – for example, watching a popular television show. It is important to remember that, as you have already learned, large audiences still exist for important television events and popular series.

Digital media challenge this image. Today's media users are often envisaged to be individuals who simultaneously use a range of screens and platforms. This has led some people to question whether the concept of the audience is still relevant in contemporary media landscapes.

Sonia Livingstone and Ranjana Das (2013) argue that the audience is still an important concept. Just as audiences interpret more established media forms such as television and newspapers, so audiences interpret digital texts such as webpages and tweets.

However, digital media also require us to think about the activity of interpretation in new ways. For example, as audiences use search tools to navigate the Internet, they make judgements about whether websites are trustworthy or reliable. In making these judgements audiences are interpreting webpages.

Livingstone and Das argue that literacy and legibility are useful concepts for understanding how audiences make sense of digital texts.

▶ Legibility refers to how open a text is to being read, decoded or interpreted by audiences. For example, some websites are badly designed or deliberately misleading or 'obscure'.

▶ Literacy refers to the kinds of knowledge and skills that audiences need in order to interpret texts. To understand a written text, people need to be able to read. To make sense of television, they need to be familiar with its codes and conventions. Likewise, audiences need particular competences and knowledge to be able to interpret and engage with social networking sites.

For Livingstone and Das, the ways in which people use and interpret digital media are related to their social position. Whether people have the knowledge and skills to do so is shaped by factors such as class, gender, age and ethnicity. These factors shape the contexts in which people use the Internet and how they interpret different types of texts.

Research into media audiences highlights how people's knowledge and skills have an impact on their media practices. For example, soap opera audiences need to be familiar with conventions such as the cliffhanger so they do not expect the narrative to be resolved at the end of each episode.

Likewise, Das and Livingstone argue, social networking sites such as Facebook require audiences to understand the conventions of the site. This knowledge shapes how people interpret and use it. For example, some people may pay close attention to the various privacy settings that Facebook offers,

or monitor the information they share, in order to try to protect their privacy.

Spotlight: What is digital literacy?

In order to use the Internet, people do not just need to have access to devices such as computers and broadband connections. People also need digital literacy, the knowledge and skills that enable them to use, interpret and create content using digital devices. Although we might assume people use digital devices in the same way, evidence suggests that this is not the case. For example, in 2013, only 49 per cent of internet users in the UK had ever shared a link to a website or online article (Ofcom 2014b).

This chapter has given you arguments to challenge claims that the media have direct and powerful effects on passive audiences. Research demonstrates that audiences are actively engaged in interpreting and reacting to media texts.

Audiences do not engage with media texts as individuals. Instead, audiences are shaped by the social and cultural contexts they occupy. How people interpret, classify and react to media texts is influenced by their social and cultural position. The responses of different groups are further shaped by the types of discourses and knowledge to which they have access. Factors such as class, gender, sexuality, ethnicity and age may all have an impact on how different audiences respond to media texts.

Audience studies are not just concerned with how people make sense of texts. The following two chapters explore two other directions that audience research has taken. The next chapter considers how audiences consume media technologies and the one that follows looks at the practices of media fans.

Dig deeper

Livingstone, Sonia (2005) Media audiences, interpreters and users. In Marie Gillespie, ed., *Media Audiences*, Maidenhead: Open University Press.

Livingstone, Sonia and Das, Ranjana (2013) The end of audiences? Theoretical echoes of reception amid the uncertainties of use. In John Hartley, Jean Burgess and Axel Bruns, eds, *A Companion to New Media Dynamics*, Oxford: Wiley-Blackwell.

Moores, Shaun (1993) *Interpreting Audiences*, London: Sage, Chapters Two and Three.

Morley, David (1992) *Television, Audiences and Cultural Studies*, London: Routledge, Chapters Three and Four.

Skeggs, Beverley and Wood, Helen (2012) *Reacting to Reality Television: Performance, audience and value*, London: Routledge.

Fact-check

1 Uses and gratifications theory views audiences as:
 a Passive
 b Engaged in resistance
 c Rational and selective
 d Powerless

2 Uses and gratifications theory underestimates:
 a How the social and cultural groups to which people belong can shape how they engage with the media
 b. How people use the media to entertain themselves
 c How people's media use relates to their individual needs
 d The psychological functions of the media

3 Decoding refers to:
 a How meaning is constructed in a text
 b The preferred meaning of a text
 c How messages are encoded
 d How audiences interpret a text

4 In his study of the *Nationwide* Audience, Morley argued that:
 a Audiences' interpretations of a text are shaped by their social and cultural position
 b Audiences interpret a text according to their individual psychological needs
 c There are as many different interpretations of a text as there are people
 d Audiences usually make active interpretations of texts that challenge the dominant class

5 Ethnographic research:
 a Is usually associated with large-scale surveys
 b Aims to produce statistical information
 c Aims to understand how people interpret and understand their worlds
 d Is usually carried out using experiments in laboratory conditions

6 Skeggs and Wood's research on audiences watching reality television demonstrates that:

 a Each audience member's emotional reaction to reality TV is unique

 b The use of close-ups in reality TV shows causes the same emotional reactions in each member of the audience

 c Audiences react passively to reality TV

 d Social and cultural differences between audiences shape their reactions to reality TV

7 Which of the following statements best describes Silverstone and Das's arguments about new media audiences?

 a The concept of the audience is no longer useful in the age of digital media

 b The decline of mass audiences for television means that media users are best thought of as individuals rather than audiences

 c Audiences are primarily producers rather than consumers of digital media texts

 d The concepts of legibility and literacy are important in understanding how audiences interpret digital media texts

15

Consuming Media Technologies

Media Studies does not only examine how audiences engage with media texts. When people watch a soap opera or play *World of Warcraft*, they are also engaging with media technologies. Research into the ways people use these expands our understanding of the role that media play in our everyday lives.

Popular debates often claim that people are controlled by media technologies. Just as it is claimed that media texts have effects on people's behaviour, so it is also claimed that media technologies determine how people behave. You may recall news reports that declare people are addicted to their smartphones or suggest that videogames cause obesity.

Media Studies challenges these common assumptions. Audiences are not controlled by technologies. Instead, people make active use of media technologies as they make them part of their everyday lives.

In many of the studies that you will explore, researchers examine the role of media technologies in the home. In the twentieth century, most media consumption was home-based. Even today, the home is a key site in which people engage with the media. Because media technologies seem to be such a normal part of many people's domestic space, it is easy to take them for granted. Indeed, it is worth pausing for a moment and reflecting on your own life. Think about the number of media technologies in your home, where they are and who uses them. What would your home be like if these technologies disappeared?

This chapter focuses on three key issues related to how audiences consume media technologies. First, you will learn how media technologies become 'domesticated' as people put them to use in their everyday lives. Second, you will examine studies that focus on how people use media technologies and how they become part of household life. In particular, this requires us to think about how people use technologies to construct relationships and identities within the home. Finally, as media technologies become less home-based, this chapter examines how audiences use mobile technologies such as smartphones and iPods. In the process, you will also learn more about two elements of the circuit of culture: consumption and identity.

This chapter will help you to understand:

▶ How media audiences make active use of media technologies.

▶ How media technologies are domesticated.

▶ How media technologies are used to negotiate identities and relationships.

> **Key idea**
>
> Audiences do not just consume media texts. They also consume media technologies.

What is consumption?

The concept of consumption has specific meanings in Media Studies that differ from the way the term is used more generally. In everyday life, consuming is associated with two key meanings. First, it is associated with using up: for example, when you consume an apple, it no longer exists. Second, it is associated with buying. We often think of consumers as people who are engaged in purchasing things.

In Media Studies, consumption has both a wider and more specific meaning. It doesn't just refer to the act of buying objects but also to the ways that object is put to use by people as they make it part of their everyday life (Jackson 1993). People do not only consume games consoles when they purchase them in a shop. They are also consuming the games console as they find a place for it in their homes, when they play alone or with friends, and as they make it part of their everyday routines.

Consumption involves appropriation. This refers to the process through which people establish a sense of 'ownership' of an object. For example, someone may decorate their iPod with a skin that says something about their identity. They also make it their own through the music they add to it and the way they organize playlists. They may make the iPod part of their everyday life as they use it to

create a soundtrack to their activities. Through these acts of appropriation, people adapt objects, invest them with meaning and make them their own.

As this suggests, consumption is strongly related to identity. Through the way people consume objects – and appropriate them – people construct their identities. How people customize and use their smartphones or laptops says something about who they are.

Consumption isn't just about individual identities but also about the relationships between people. When a household acquires a new media technology, the members of the household have to negotiate what role that technology will have in their domestic life. There are decisions to be made about who gets to use the technology, about who it is used with and when it is used.

Key idea

Consumption refers to the ways in which people use and appropriate objects in their everyday lives.

Domesticating media technologies

Roger Silverstone (1994) was a researcher who was interested in audiences' relationships with media technologies. He used the term 'domestication' to refer to the processes through which people shape the meaning and use of media technologies in the home. This section explains this concept in more detail and illustrates Silverstone's ideas by looking at examples of how different technologies were domesticated.

When new media technologies are launched and purchased, people have to find ways of living with them and making them fit in with their lives. They have to be 'house-trained' (Berker et al. 2006: 2). To people who have grown up with television, this statement may appear to be ridiculous. It seems self-evident that people know how they will use and live with TV. However, this is only because this technology has already been domesticated.

The early years of radio give an example that helps to illustrate and explain Silverstone's ideas. In the early 1920s, radio sets began to be popular in the UK. These sets looked nothing like contemporary radios but were a messy jumble of metal and wires. They looked like they did not belong in the home. For male radio enthusiasts, this was of little consequence. They enjoyed playing with what they saw as a wonderful new toy. However, in this period, many women viewed them as unwelcome and ugly intruders in the home. Radios looked out of place in their domestic space (Moores 2000).

Silverstone argues that media technologies are often 'pre-domesticated'. This refers to the way that designers and producers will attempt to make new devices look like objects that belong in the home. For example, radio ownership did not become widespread until the radio was redesigned to resemble familiar domestic objects. It no longer resembled an 'alien invader' (Moores 2000).

Media texts offer another means of pre-domestication. For example, in the 1930s, the BBC created radio programmes that addressed listeners as families. It also created schedules that fitted in with the rhythms of everyday life in the home. Early radio was designed for individual consumption via headphones. By the 1930s, it was imagined as a technology that could bring the family together around programmes with homely themes.

Spotlight: The TV is spying on me!

When media technologies are first introduced, they can cause fear among some audiences. Some early radio and TV users in the UK were convinced their technologies were being used to spy on them. The BBC had to reassure listeners and viewers this was not the case. Nonetheless, there are still stories of people who did not want to undress in front of the TV, just in case people could see them (Moran 2013).

> *[Domestication refers to] the capacity of a social group... to appropriate technological artefacts and delivery systems into its own culture – its own spaces and times, its own aesthetic and its own functioning – to control them, and to render them more or less 'invisible' within the daily routines of daily life.*
>
> Roger Silverstone 1994: 98

Media technologies only become properly domesticated through audiences' consumption practices. Households appropriate technologies and make them 'at home' in their domestic spaces.

Think about the way in which television sets are often the focal point of people's living room. Sofas and armchairs are arranged around the set, as if the TV were a member of the family. This dates back to the early days of mass television ownership. In the 1950s, US families were encouraged to think of the television as part of the 'family circle', an indispensable new member of the family. The grouping of furniture and people around the TV set reinforces this idea (Spigel 1992).

Television sets are also domesticated through the ways in which they become intertwined with household life. They may be the focus of family mealtimes as people sit around the TV while they eat. People may choose to spend 'quality time' as a household by gathering around the TV set to watch their favourite progamme. Through processes such as these, media technologies become part of the rhythms and rituals of everyday life.

Silverstone suggests that once media technologies are domesticated, they become 'invisible'. This may seem like a strange comment: technologies such as television often dominate people's living rooms. By 'invisible', Silverstone means that technologies become so normal, so 'everyday', that people just take them for granted.

Existing media technologies can be used strategically to domesticate newer media technologies. Despite the proliferation of media devices throughout the home, the television in the living room acts as a focus for a range of devices such as games consoles, DVD players and Sky+ or TiVo boxes.

These technologies become part of everyday life through their connection with the 'normalized and routinized technology' of the television (Thornham 2011: 93). In contrast to the television, personal computers are still hidden away in bedrooms and in alcoves.

Studying domestication provides one way of understanding how people consume media technologies. Domestication focuses on how people are actively involved in shaping the meaning, position and use of media technologies in the home. Technologies do not determine how we use them.

Key idea

Domestication refers to the consumption strategies through which households shape the meaning, role and use of media technologies in their homes.

Media consumption and gendered relationships

Media consumption appears to happen 'naturally'. However, it is not as straightforward as it first appears. How and when people use the media – and who they use it with – has to be coordinated and negotiated by members of a household. Media consumption, therefore, takes place within the relationships that exist in a household.

David Morley's classic study from the 1980s – *Family Television* (1986) – examined these issues. Morley used this study to address some of the problems he identified in his *Nationwide* research (see Chapter Fourteen). He wanted to discover how people consumed the media in the normal context of everyday life.

In *Family Television*, Morley focused on how families consume media technologies in the home. He carried out an ethnographic study of ten families. This enabled him to identify the range of processes and practices that go into 'watching TV'.

His most important finding was that power relationships within the home shape how people use the media. In particular, he

discovered that gendered power relationships shaped how men and women consume television. As you learned in Chapter Twelve, men tend to have more power than women in society. These power relationships are reproduced in the home. Media consumption is no exception: men's media use reflects the power they have within the family.

Key idea

The consumption of media technologies is shaped by power relations in the home.

Most of the people in Morley's study lived in traditional nuclear families with men paid for work outside the home and women responsible for unpaid domestic work within it. This arrangement gives men economic power within the family. It shapes how men and women view their leisure time. Most of the men in his study viewed the home as a space where they could relax after a hard day at work. This is much more difficult for housewives: because the home was their place of work, they find it hard to claim time out for leisure.

Morley discovered that these gendered relationships to work and leisure shaped how people used television. Men asserted their power as wage earners through the ways in which they engaged with TV. They took possession of the remote control and controlled what everyone else could watch.

Most of the men in Morley's study carefully planned their evening's viewing. Because they saw the home as a place for leisure, they devoted themselves to concentrated viewing of their favourite programmes. This also allowed them to assert their own programme preferences over those of other family members.

Most of the women in the study had a very different relationship to the television. They felt that they had little right to leisure because the home was their workplace. They had little opportunity for concentrated viewing as they tried to juggle watching TV with doing a range of other tasks. They put other people's viewing preferences before their own in an attempt to maintain family harmony.

Morley did not think that there was anything natural about these different relationships to the television set. The differences instead stemmed from the different social positions that men and women occupied. This is illustrated by the one family he studied where a woman worked full-time outside the home and was the main financial provider. This woman's social position enabled her to claim time for leisure in front of the television.

Morley's research enables us to see how the context of television consumption shapes our practices. The social positions that people occupy shape how they consume media texts and technologies.

> New technologies arrive into an already gendered setting: with a gendered domestic division of labour, gender-specific household technologies, gendered access to the economic resources of the household, and gender differences in the right to spare time within the routines of the household.
>
> Elaine Lally 2002: 105

Key idea
Gendered roles, responsibilities and power relations shape the way people use media technologies.

Morley's study appears a little dated now that greater numbers of married women work full-time outside the home. Nonetheless, later research demonstrates how gender influences people's relationship to a range of media technologies. Although there have been changes, media use continues to reproduce existing gendered divisions and identities.

Parents, children and media technologies

Media technologies are also used to construct and negotiate relationships between parents and children within the home. Although television is an established technology, there are still fierce debates about how much television children should watch

and how they should watch it. Newer technologies such as computer games and iPads have provoked similar debates.

These examples demonstrate that the ways in which media technologies are used by households is far from straightforward. Families must engage in complex negotiations about what role these technologies will play in their domestic life.

Today this happens in a context where there is an increasing range of media technologies available. While a television in the living room was the focal point for families in Morley's study, many homes today have a large number of televisions. Other screens, such as laptops and tablets, compete with television. In this context, it is often claimed that media consumption becomes much more individualized. This can make children's media use more difficult to regulate.

Spotlight: How much television?

There are longstanding concerns about the impact of television on children's development. Contemporary headlines claim that too much television produces children with damaged brains and bad behaviour. Whether or not they believe these claims, parents have to negotiate a perception that watching too much TV is bad for children. Recent evidence in the UK suggests that children's television viewing has fallen to less than two hours a day. However, this is because other screens are competing for their attention. For example, many children enjoy watching amusing YouTube clips on tablets and smartphones (Jackson 2015).

Parents must negotiate conflicting advice which represents media and communications technologies as both a benefit and a threat to children. Some studies demonstrate that parents' decisions to invest in a new media technology are motivated by a desire to improve their children's lives. For example, computer and Internet access often are represented as being essential for children's educational success (Lally 2002).

Frequently, the same technologies are represented as a threat. There are longstanding concerns that media technologies import dangerous material from the public sphere into the home and

put children at risk. This can be seen in panics about violence in television cartoons, video nasties and the dangers of unrestricted access to the Internet.

Parents have to decide how – and if – they want to regulate their children's media use. Consuming media involves difficult negotiations over access to media in the home. This tension also highlights how issues of media regulation are bound up with everyday media practices.

Although we might assume that parents have power and authority over children's media use, children also use media technologies to resist parental control. Some research demonstrates how children undermine parental authority over 'appropriate' media use. For example, friends may meet up to play computer games in a home which has more lenient rules about how much time they can spend gaming.

Other studies demonstrate how children use Internet technologies to create privacy within the home. The Internet allows children to maintain their friendship networks from within the family space of the home. It enables people to escape the tensions of family life and use the media to 'live together separately' (Flichy, cited in Livingstone 2005: 21).

Much research has focused on Internet use by older children and teenagers. However, very young children are increasingly using the Internet via smartphones and tablets. This presents parents with new questions about how to negotiate their children's media use (Holloway et al. 2013).

> *Parents are seeking the means, again using media, to counter the individualizing effects of diverse and multiple media so as to sustain some degree of common culture within the home. Hence they may encourage eating together in front of the television, using sports and soaps to share some intimate time on the sofa, interacting together through a website, even instant messaging each other... Where once the structure of the home, and the media, demanded 'togetherness', today it must be more deliberately sought out.*
> Sonia Livingstone 2005: 177

Key idea

Media technologies are used in the context of generational power relations in the home. Media consumption is the result of complex negotiations between parents and children about how technologies should be used.

Case study: Young people and new media

Sonia Livingstone (2007) led a research project called 'Young People, New Media'. Using interviews and surveys, the research team investigated the media use of children and young people in 1997 and then again in 2004.

She identifies two trends in children's media consumption. First, children are spending an increasing amount of time at home. Parents view public spaces as potentially dangerous and believe that it is safer for their children to spend their leisure time at home.

Second, Livingstone identifies a shift from the 'family television' viewing studied by Morley to 'individualized media lifestyles'. Many children and young people today have 'media-rich bedrooms'. Much of their media consumption takes place in this bedroom environment rather than communal spaces in the family home.

Although younger children gravitate towards family spaces in the home, teenagers tend to prefer to use these spaces when their families are out of the house. More frequently, they turn their bedrooms into 'private living rooms'.

This doesn't necessarily mean that their media consumption is isolated. In these spaces, teenagers can focus on identities and relationships that extend beyond their family, using gaming and social media to maintain connections with friends outside the home. Furthermore, families still spend time together with the media. However, family viewing is no longer a routine and everyday practice. Families make choices about when to view together (Livingstone 2007).

Consuming mobile media

Many studies of the ways in which audiences consume media technologies have focused on family media use in the home. Portraits of collective media consumption are challenged by a shift to more individualized media use as a result of the proliferation of screens in the home. In addition, mobile technologies offer increasing opportunities for media consumption to move outside of domestic space.

Walk down the street, sit on a train or stop at a café and you're likely to see many people using media and communications technologies. Some commentators claim that technologies such as iPods and smartphones encourage people to isolate themselves from the world around them. However, the meanings associated with mobile media consumption are not as straightforward as they initially seem.

There is certainly evidence to suggest that people use media technologies in public spaces to block out the surrounding world. For example, Michael Bull (2005) argues that iPods offer people a sense of sanctuary, a retreat from a chaotic and impersonal world. By imposing their own choice of music on the world around them, people make public space seem more personal and familiar.

Mobile phones also appear to enable people to be 'private in public'. However, these technologies are more frequently used to connect people rather than promote isolation. Studies suggest that mobile communications technologies do not fragment the family. Instead, they are used to maintain and enhance connections to friends and family as people keep in touch while they are on the move.

Mobile media extend women's responsibility for maintaining connections between family members. This means that the consumption of these technologies also needs to be understood in terms of wider generational and gendered relationships. For example, research demonstrates how mobile phones create more work for mothers. Mobile media enable women to engage in 'remote mothering' as they can now care for children when they are away as well as when they are at home (Lim 2014).

Of course, mobile media are not only used on the move. In those households that have the economic resources to afford them, devices such as laptops and smartphones are also bound up with the everyday life of the home. Mobile devices are domesticated as they are put to use in everyday rituals and practices. Indeed, the mobile phone has replaced the alarm clock in many homes.

Spotlight: Smartphones and everyday life

A report by Ofcom in 2015 demonstrates the extent to which smartphones are bound up with everyday rituals in the UK. Within five minutes of waking, half of young people in the 18–24 age group check their phone. Nearly as many check them just before they go to sleep. Many people use apps on their smartphones to negotiate everyday tasks like finding a supermarket or navigating around a city. Although people complain about the 'anti-social' use of phones in settings such as restaurants, people primarily use their phones for social reasons, communicating with friends and family who are not present (Ofcom 2015).

Key idea

Mobile communications technologies do not isolate people but are used to maintain relationships with friends and family.

Dig deeper

Berker, Thomas, Jartmann, Maren, Punie, Yves and Ward, Katie J. (2006), *Domestication of Media and Technology*, Maidenhead: Open University Press.

Lally, Elaine (2000) *At Home With Computers*, Oxford: Berg.

Livingstone, Sonia (2007) From family television to bedroom culture: Young people's media at home. In Eoin Devereux, ed., *Media Studies: Key issues and debates*, London: Sage.

Moores, Shaun (2000) *Media and Everyday Life*, Edinburgh: Edinburgh University Press.

Morley, David (1992) *Television, Audiences and Cultural Studies*, London: Routledge

Fact-check

1 In studies of media audiences' use of media technologies, the concept of consumption is used to focus on:
 a How media technologies are purchased
 b How media technologies get used up
 c How people use and appropriate media technologies within their everyday lives
 d How people's media use is determined by the nature of a media technology

2 Appropriation refers to:
 a The techniques used by parents to regulate children's media use so that it is appropriate
 b The appropriate use of media technologies by men and women
 c The ways in which audiences consume media technologies in ways that are primarily shaped by producers
 d The ways in which audiences establish a sense of ownership of media technologies

3 In studies of the domestication of media, researchers focus on:
 a The strategies through which households shape the meaning and use of media technologies in the home
 b The ways in which media technologies lose their edge as they become tamed
 c The ways in which the domestic consumption of media technologies is totally determined by the way they are designed
 d The ways in which media technologies are increasingly used to do domestic tasks

4 Which of the following is **not** an example of pre-domestication?
 a Advertising that demonstrates how television can become a valued part of family life
 b Advertising that displays parents and children using a games console together in the living room
 c Design strategies that make media technologies resemble other items of household furniture
 d The ways in which parents regulate how much time the family should spend using the Internet

5 David Morley's research demonstrated that men and women consume television in different ways because:

 a They have naturally different relationships to technology

 b Traditionally women are not very good at using new technologies

 c There are unequal power relations between men and women in the home

 d Women do not have time to watch television because they are engaged in other leisure pursuits

6 According to Sonia Livingstone, which one of the following is **not** associated with young people's use of new media?

 a Young people have 'media-rich bedrooms'

 b Young people build 'individualized media lifestyles'

 c Young people become 'increasingly isolated' through their media use

 d Young people use gaming and social media to maintain connections with friends outside the home

7 Which of the following best illustrates how people use mobile media to maintain relationships with family and close friends?

 a iPods offer young people a 'sanctuary' from the outside world

 b Some women use mobile phones to engage in 'remote mothering'

 c Many people use their smartphone as an alarm clock

 d People use laptops to check the weather

16

Media Fandom

Spend a short amount of time online and you'll quickly encounter examples of media fandom. You will find hundreds of Internet forums where fans discuss their favourite stars and texts. There are films on YouTube, produced by fans inspired by their favourite movies or TV shows. There are Twitter feeds where fans discuss their favourite football team or band.

Often fans are represented as obsessive, as isolated losers who need to 'get a life', or, in extreme cases, as psychologically unstable and dangerous. In Media Studies, research into fans often has been motivated by a desire to challenge these stereotypes. This research demonstrates that fandom involves a complex, creative and meaningful engagement with media cultures.

Research into fandom complements the research on media audiences that you studied in previous chapters. As you will learn in this chapter, fan audiences are usually portrayed as active audiences. They are often characterized by the sheer amount of time and energy that they devote to interpreting and investigating the meaning of their favourite texts.

This chapter also considers how fans are not just active but also interactive. Fandom is used to build communities. The media consumption of fans is often collective and involves interacting with other fans and texts. By studying fandom, you will also expand your knowledge of the range of practices that media audiences engage in.

Examining media fandom requires you to engage with all five elements of the circuit of culture. Fans are consumers who express their identities through their practices. Some fans also produce representations by creating texts such as fanzines and videos or discussing the meaning of their favourite shows online. Furthermore, some fans engage in struggles with the media industries and this raises questions about regulation.

Digital technologies make it easier for fans to produce and circulate their own texts. They also make it easier for fans to use their collective power to speak back to the media industries. This returns us to the questions about democratization of media that you explored in Chapter Five.

This chapter will help you to understand:

▶ Why fans are represented as 'abnormal'.

▶ Some of the key features of fan practices.

▶ Fandom as a participatory practice.

▶ How fans are both consumers and producers.

▶ The relationship between fans and the media industries.

▶ The relationship between fans and 'ordinary' audiences.

Negative representations of fans

Popular representations often portray fans as out of control or dangerous. This is not new. Fans have been represented as obsessive, irrational or hysterical for a long time, in both the media and early academic work on fandom.

In her critique of these representations, Joli Jenson (1992) argues that there are two main ways in which fans are represented as a problem.

1 **Fans as 'obsessed individuals'.** Sometimes fans are represented as losers and loners whose fandom expresses psychological problems. While this type of fan may be presented as 'sad' or pathetic, in some high-profile cases, they are represented as dangerous. One well-known example is the case of Mark Chapman, the John Lennon fan who killed his idol.

These types of representations of fans still circulate. For example, there are frequent newspaper reports about 'crazed' fans that become stalkers and threaten the safety of film stars such as Sandra Bullock and Jennifer Aniston.

2 **Fans as a 'hysterical crowd'.** These representations often focus on young, female fans. You may be familiar with news stories about weeping and screaming girls devoted to pop stars. As a crowd, they are portrayed as dangerous because they are seen to be out of control in the presence of their idols.

Images of the 'hysterical crowd' can be found in news coverage of Beatlemania in the 1960s. More recently, similar

images have been reproduced in reports about fans of One Direction and Justin Bieber.

Spotlight: #Cut4Zayn

Today's female fans are sometimes represented as dangerous 'virtual' crowds on Twitter. In 2015, many newspapers reported on the 'disturbing' behaviour of 'hysterical' fans in response to Zayn Malik's decision to quit boyband One Direction. Journalists expressed concern over fans' use of a Cut4Zayn hashtag that, they claimed, encouraged young fans to engage in self-harm in order to force Zayn to reconsider his decision. While there was understandable concern that fans were promoting self-harm, these representations added to images of girls as emotional, hysterical, irrational and out of control. The hashtag was later revealed to have been a hoax and not to have been created by One Direction fans.

These negative representations of fans are persuasive because they are repeated so frequently. They represent fans as psychologically vulnerable and easily influenced by the media and other people. However, researchers in Media Studies have challenged these representations by demonstrating how they create artificial distinctions between fans and 'normal' people.

Key idea

Fans are often represented as dangerous, out of control or psychologically unstable.

Cultural hierarchies and the representation of fans

Fans' interests and activities are often represented as stupid, pathetic and trivial. However, the practices involved in being a *Star Trek* or *Twilight* fan are frequently remarkably similar to those of the fine art or opera enthusiast.

In contrast to fans, people who have a passion for opera or art are usually seen as connoisseurs, as educated and as being engaged in valuable activities. Knowing about opera or art, we are often told, demands expertise and skill (Jenson 1992).

However, fans and connoisseurs engage in similar activities. Whether viewing episodes of *Dr Who* or listening to Verdi's operas, they may closely scrutinize texts and search for new meanings in them. Both fans and connoisseurs might strive for an encyclopedic knowledge of their subject. So why are fan activities ridiculed and the connoisseur's activities praised?

One of the reasons is that the fan is devoted to popular culture whereas the connoisseur is devoted to high culture. In many societies, high culture is viewed as more valuable than popular culture.

The different value given to the tastes of the connoisseur and the fan are the product of class inequalities. There are cultural hierarchies in society. These rank cultural texts and practices so that some are viewed as superior and others as inferior. The cultural tastes of the dominant classes are ranked more highly than those of the working class.

The French sociologist Pierre Bourdieu explained why the cultural practices associated with the dominant classes are valued more highly in society. He argued that the dominant classes use their power to ensure that their tastes are viewed as legitimate in society. These classes have a taste for what is usually termed high culture such as classical music and high art.

As a result, the cultural and leisure pursuits associated with the working class are seen as less valuable, as illegitimate. A passion for opera or high art is seen as more valuable and prestigious than a passion for punk or comics. It is important to note that Bourdieu did not believe that opera was better than popular culture, or that the tastes of the dominant classes were superior to those of the working class. Instead, he argues that the dominant classes have the power to make their cultural preferences appear to be the only legitimate cultural preferences.

Bourdieu's research has been used to understand why fan practices are ridiculed. The fan's emotional investment in the pleasures of

popular culture is associated with the tastes of the working class. Because fans devote themselves to texts that are viewed as having little cultural value, their tastes and practices are seen as illegitimate.

Studies of media fandom frequently try to challenge these hierarchies. They demonstrate that fan practices are complex, meaningful and valuable activities that are worth taking seriously. The remainder of the chapter looks at studies of fan cultures in more detail.

Key idea

Fans are devalued because of wider cultural hierarchies that privilege a taste for high culture over a taste for popular culture.

Fandom as participatory culture

Henry Jenkins is an important figure in debates about fandom. He challenged how fans are commonly represented and played a crucial role in developing the study of fans. He drew on his own experience as a fan to think about the significance of fandom in new ways. Much of his research is based on extensive ethnographic research into fans of television series.

He argues that fans are not isolated loners but members of lively communities. They are active audiences of the shows they love. They create a wide range of meanings from their favourite shows. Furthermore, many fans do not just consume media texts. They also produce their own fan media.

It proposes an alternative conception of fans as readers who appropriate popular texts and reread them in a fashion that serves different interests, as spectators who transform the experience of watching TV into a rich and complex participatory culture... Their activities pose important questions about the ability of media producers to constrain the creation and circulation of meaning. Fans construct their cultural and social identity through borrowing and inflecting mass culture images, articulating concerns that so often go unvoiced within popular culture.

Henry Jenkins 1992: 23

Jenkins identifies five elements that characterize the practices of the television fans he studied:

1 **Fans are actively engaged in interpreting texts.** They produce detailed readings of their favourite series, mining them for knowledge and information.

2 **Fan practices are collaborative.** Fans work together to interrogate the meaning of texts. They identify links between their favourite series and other media texts. Fans produce 'collective intelligence' through sharing ideas, criticisms and gossip (see Chapter Five).

3 **Fandom is based on a participatory culture.** Fans are not isolated loners but members of communities that express their ideals and interests. They are active participants in their chosen community.

4 **Fandom involves consumer activism.** Most audiences have little power to challenge the media industries. They have few opportunities to determine what gets produced. However, fans use their 'collective bargaining power' to influence the media industries (Jenkins 2006: 260).

For example, some fan communities complain to the producers of a TV show if they do not like the direction of the narrative. There are also well-coordinated campaigns to save series from being cancelled. To give one example, fans worked together to persuade the CBS network to create a second season of the US science fiction series *Jericho*.

5 **Fans engage in cultural production.** They produce their own media such as fanzines and novels based on the media they love. Fans create 'alternative institutions of production, distribution, exhibition and consumption' (Jenkins 1992: 279). They share these texts among the fan community.

Fan media were well developed prior to the Internet. For example, fanzines, amateur magazines produced and consumed by fans, were a form of alternative media first produced by fans of science fiction in the 1930s. Some of the best-known examples were the punk fanzines produced

in the late 1970s. The content and style of these influenced some mainstream music magazines.

Jenkins focuses on how film and television fans appropriate media texts. For example, they produce stories and videos with plotlines that speak to their own investment in a television series. Fans appropriate the texts produced by media industries and make these texts serve their own interests.

Key idea

Fans produce a participatory culture through which they build a sense of community, exchange ideas and gain collective power.

Key idea

Fans are not just consumers of media but also produce their own texts.

Henry Jenkins' study of fandom also offers useful ways of thinking more generally about more general media audiences. He demonstrates the range of creative ways in which audiences can interpret and engage with media texts. However, by focusing on the creativity of active fan audiences, his work can suggest that 'ordinary' audiences are largely passive and unengaged.

Spotlight: Slash fiction

Some fans produce fan fiction in which they create their own narratives about their favourite texts and characters. Slash fiction is a well-known genre of fan fiction that focuses on homoerotic relationships between characters. These are relationships that are not permitted, or are insufficiently developed, within the original text. For example, fans have created narratives which focus on romantic relationships between Kirk and Spock in *Star Trek*, and between Harry Potter and Draco Malfoy. Slash fiction enables fans to explore forms of sexual identity that may not be permitted in mainstream media.

Fans as producers

Chapter Five examined Henry Jenkins' work on 'convergence culture'. You explored his argument that increasing media convergence offers the potential to democratize media production. In his work on media convergence, Jenkins frequently focuses on fan cultures.

> *This book has argued that convergence encourages participation and collective intelligence... [It] shows what happens when people who have access to multiple machines consume – and produce – media together, when they pool their insights and information, mobilize to promote common interests, and function as grassroots intermediaries ensuring that important messages and interesting content circulate more broadly.*
>
> Henry Jenkins 2006, 256

Jenkins argues that media convergence enables the participatory culture, already established in fan practices, to flourish. This is because:

1. Digital technologies such as the Internet enable fans to exchange ideas, texts and creative works much more quickly and efficiently than ever before. Fan communities can be united much more easily and work together to fight for their interests.

2. Digital technologies fit with the do-it-yourself values of fans. Fans can now distribute and share creative work using the Internet. They can engage in forms of production such as video-making. The web makes it easier and cheaper for fans to distribute their work to a wider public.

3. The media industries promote transmedia flows of information. This means that media industries create an entertainment package that is offered across a range of platforms. By offering more opportunities to engage with a particular text, the media industries aim to build the audience's devotion to their favourite films and series. These strategies encourage all audiences to behave more like fans who often make connections and seek information across a range of media.

These industry strategies are also mirrored in the practices of fans. Fan communities often create their own transmedia content. For example, *Star Trek* fans write stories and articles, create videos for YouTube and organize online discussion groups.

Jenkins argues that these changes increase opportunities for fans to create 'collective intelligence'. This is the knowledge and understanding that arises from participating collaboratively as a community to produce forms of knowledge and understanding (see Chapter Five). He views media fandom as a 'test site for ideas about active consumption and grassroots creativity' (2006: 257). Therefore, he believes, fans pave the way for all audiences to become more actively engaged with media industries and media production.

Jenkins suggests that fandom offers a model for how more audiences could mobilize to make the media more responsive to their needs. Fans' use of digital technologies demonstrates how 'audiences are gaining greater autonomy and power' (Jenkins 2003: 280). His ideas are an example of digital optimism, a position you learned about in Chapter Five.

Key idea
Fans can use their collective power to fight to make the media industries more responsive to their interests.

Spotlight: Crowdfunding *Veronica Mars*.
Veronica Mars (2004–7) started life as a TV show in which a female student operated as a hard-boiled detective. It was cancelled after three seasons, much to the disappointment of its many fans and its creator Rob Thomas. After numerous failed attempts to revive the show, Thomas started a Kickstarter campaign to crowdfund a *Veronica Mars* movie. Fans donated $5.7 million and the film was released in 2014. While some people claim that the fans were exploited, others see this as an example of fans gaining new forms of control over production in the media industries.

Fans and the media industries

Fans often distinguish themselves from 'ordinary' audiences. They view themselves as creative and active users, and producers of media texts. In contrast, fans sometimes represent 'ordinary' audiences as passive consumers of media texts.

In these debates, fans often think of themselves as more independent and critical than other audience members. They demonstrate their independence by choosing to watch old TV and movies rather than the latest offerings of the media industries. Likewise, some music fans seek out second-hand vinyl copies of rare or relatively obscure tracks. Some of these fans see themselves as 'anti-consumers'. They resist the media industries' attempts to get them to consume more by repeatedly re-watching their favourite texts or buying second-hand records.

However, Matt Hills (2002) argues, fans are, in many ways, 'ideal consumers'. They often have predictable tastes and consumption patterns. This means that the media industries can market texts to fans because they have good knowledge about what fans are prepared to buy. For example, fans may buy special 'collector's editions' or the 'director's cut' of their favourite films.

> Cult TV fans are being directly targeted as a niche market, rather than emerging unexpectedly through 'grassroots' movements of TV appreciation. The supposedly 'resistive' figure of the fan has, then, become increasingly enmeshed within market rationalizations and routines of scheduling and channel-branding.
>
> Matt Hills 2002: 36

Hills also highlights how fans have become increasingly important to the media industries. There has been a rapid rise in niche television channels serving particular areas of interest. For example, the SyFy channel in the UK targets fan audiences by showing old science fiction television. Fans can be invaluable within this environment, as they form a loyal and dedicated audience.

Media industries also attempt to create loyal fans by offering interactive transmedia content. These fan spaces are run for profit.

They enable fans to purchase goods associated with their favourite series and movies. Internet sites also offer new opportunities to sell audiences to advertisers.

As the case study of *Glee* fans demonstrates, fans' practices are also a form of unpaid marketing for the media industries. In publicizing their devotion to a particular text, fans create valuable free advertising for media texts.

Indeed, some media producers solicit help from fans. Writers and fans of a television series sometimes work together to save a show from cancellation. Production companies ask for help from fans to boost viewing figures. For example, writers and actors from the US sitcom *Community* worked with fans in an attempt to boost ratings and ensure the longevity of the series.

Key idea

Fans have predictable tastes and this makes them into a profitable niche audience for the media industries.

Key idea

Fan activities often result in free advertising for the products of media industries.

Case study: *Glee* fans on Twitter

Megan Wood and Linda Baughman (2012) carried out research on the use of Twitter by fans of the US drama *Glee*. Their research highlights how fan practices can be creative and empowering while also serving the interests of the media industries.

They focused on fans who had a high number of followers for Twitter accounts based on a character from *Glee*. The fans used these accounts to weave fictional stories and comments as if they were one of the show's central characters. Wood and Baughman analyzed over 3,000 tweets written by ten fans over a three-week period.

Much of the activity consisted of tweeting along with an episode of *Glee* while it was shown on TV. The fans used their character-based accounts to 'augment the narrative' of the show, frequently in amusing ways (p. 335). For example, the fans' tweets enabled them to add to the narrative of the show by conducting additional conversations or commenting on how a character was feeling. This additional material added to the pleasure of the show for their many Twitter followers.

On the one hand, Wood and Baughman's findings support the work of researchers such as Jenkins. The fans used Twitter to create a participatory culture. This was partly based around viewing *Glee* as it was broadcast. During the show, the fans interacted with the narrative and with each other. This increased their sense of ownership of the series because their comments and discussions enabled them to invest *Glee* with their own meanings.

However, at the same time, their activities worked in the interests of the media industries. By watching the show as it was aired, they were more likely to watch ad breaks, pleasing advertisers and TV industries. Their activities helped to market the show and its associated products. Their fan activities 'became a source of free marketing labour' for the media industries (p. 340).

In this chapter, you have learned how research in Media Studies challenges stereotypes of fans as isolated losers and easily manipulated crowds. Fans make active use of the media. They are also members of interactive communities who use their collective knowledge to expand the meaning of texts.

Studying fandom also offers another way of thinking about the relationship between media audiences and the media industries. As you have learned, fans produce their own media texts, and fan communities use their collective strength to challenge the media industries. At the same time, fans are also attractive to the media industries because they are predictable consumers. Fan activities provide marketing for media texts. Most fans perform this work for no financial reward.

However, fan studies tend to represent fans as superior to 'ordinary' media audiences. Although fans may be highly

engaged audiences, it is important to remember that all audiences interpret and engage with media texts.

It is also important to remember that fans are not all the same. Many academic studies of fandom concentrate on the most active fans, those who belong to a visible participatory culture. Some fans do not participate in fan communities. Many fans do not produce fan fictions and videos.

Likewise, there are different types of fan groupings. For example, fans who view themselves as anti-consumers are often dismissive of fans who buy all the products associated with their favourite text. Similarly, some fans view their tastes as better or 'cooler' than those of others. Fans of an obscure indie band are unlikely to think they have something in common with fans of a boyband. This demonstrates that cultural hierarchies exist within fandom.

Dig deeper

Duffett, Mark (2013) *Understanding Fandom: An introduction to the study of media fan culture*, London: Bloomsbury.

Hills, Matt (2002) *Fan Cultures*, London: Routledge.

Jenkins, Henry (1992) *Textual Poachers: Television fans and participatory culture*, New York: Routledge.

Jenson, Joli (1992) Fandom as pathology: The consequences of characterization. In Lisa Lewis, ed., *The Adoring Audience*, London: Routledge.

Wood, Megan M. and Baughman, Linda (2012), Glee fandom and Twitter: Something new, or more of the same old thing?, *Communication Studies*, 63(3): 328–44.

Fact-check

1 Joli Jenson argues that fans are often stereotyped as:
 a Active and engaged readers
 b Obsessed individuals and hysterical crowds
 c Members of participatory cultures
 d Educated and discerning connoisseurs

2 Fans' tastes often are devalued:
 a Because of the activities of the media industries
 b Because they are seen as active and creative audiences
 c Because they are producers as well as consumers
 d Because of cultural hierarchies which privilege high culture over popular culture

3 Henry Jenkins views fan cultures as participatory cultures because:
 a All fans are engaged in writing slash fiction
 b Fandom is primarily concerned with re-enacting scenes from cult TV programmes
 c Fans are engaged as both consumers and producers in interactive communities
 d Fans are best viewed as passive audiences who are open to media manipulation

4 Which of the following offers the best example of consumer activism by fans?
 a Producing fanzines and novels
 b Campaigning to prevent a favourite television series being cancelled
 c Appropriating media texts to claim a sense of ownership
 d Producing 'collective intelligence'

5 Which of the following offers the best example of why fans see themselves as anti-consumers who resist the power of the media industries?

 a Fans buy special collectors editions of their favourite films and TV series

 b Fans provide free marketing for the media industries

 c Fans offer themselves as audiences that can be sold to advertisers

 d Fans repeatedly watch the same texts rather purchasing the latest releases

6 Cult television fans act as ideal consumers for the products of the media industries because:

 a They are a niche market with predictable tastes

 b They produce their own videos

 c They are a mass audience

 d They repeatedly watch the same TV series on DVD

17

Globalization and the Media

Think about your engagements with the media in the last 24 hours. You should find some evidence of how the media are globalized. You may have watched a movie or listened to music that comes from the other side of the world. You may have watched a reality show that was made in your country but based on a format developed elsewhere. You may have used Facebook to chat to your friend having a gap year abroad or your cousin who lives in another country. It is impossible to fully understand contemporary media without thinking about globalization.

Media and communications technologies make different parts of the world seem closer together. This is not a new process. In Chapter Two, you learned how the development of print technology enabled news of events to spread more quickly across Europe. Today, satellite and digital technologies have speeded up this process. It appears as if the distances between people are less important when many people across the globe can view the same images or communicate with each other online.

In this chapter, you will examine debates about the role of media in globalization. Some people argue that global media make the world an increasingly standardized and uniform place. They claim that when people across the globe consume the same media the differences between national cultures are wiped out.

Other people argue that global flows of media create greater diversity. Someone in Japan can listen to traditional Bulgarian folk music while someone in Bulgaria can watch Japanese anime films. This argument suggests that globalization enriches life rather than producing an increasingly uniform world.

These debates explore how media industries and texts move around the world and the impact they have on audiences. However, as people move around the globe, media audiences also become mobile. This makes it necessary to understand the different impacts that international communications have on different types of audiences.

Thinking about globalization requires thinking about media industries, media texts, media audiences, media regulation and

cultural identities. As a result, this chapter returns to some of the issues raised elsewhere in the book. This offers you opportunities to revise and refine your understanding of some of the key themes you have studied.

This chapter will help you to understand:

▶ How the media play a role in globalization.

▶ The concept of cultural imperialism.

▶ How media industries operate at an international level.

▶ The impact of globalization on media industries and media audiences.

▶ Migration and media consumption.

What is globalization?

Globalization is not a new process. People disagree about when exactly globalization began. However, many of the processes that we now associate with globalization were well underway in the nineteenth century.

> Globalization… denotes the expanding scale, growing magnitude, speeding up and deepening impact of transcontinental flows and patterns of human interaction. It refers to a shift or transition in the scale of human organization that links distant communities and expands the reach of power relations across the globe.
>
> David Held and Anthony McGrew cited in Terry Flew 2007: 67

Globalization is associated with a number of processes and patterns:

▶ The increasing scale of human activities. Many aspects of life are now organized at a global level, rather than a local or national level. World leaders meet to develop international plans for future energy consumption. Media industries plan how they can sell the texts they produce to as many people as possible across the globe.

- Increasing opportunities for people to make connections and interact at a global level. These include opportunities for international trade and travel. Media play a key role in these processes. For example, social media enable people in many different locations to create relationships, to interact and to exchange ideas.

- Technologies that enable faster communication. The sense of distance between people across the globe decreases as there are more opportunities to communicate more quickly. For example, contemporary digital technologies often enable near instantaneous communication between people who are separated by thousands of miles.

- People across the globe become increasingly interdependent. For example, as international trade increases, nations become more interdependent. For example, the cars in one country depend on the oil resources of another. The cocoa producers in one nation depend on the taste for chocolate in others.

- Global interaction between people and nations are shaped by power relations. In the rest of this chapter, you will explore how processes of globalization strengthen the power of some nations and economic enterprises over others.

Terry Flew (2007) argues that the media play a key role in globalization for three reasons:

1 Media corporations attempt to globalize their activities. Large media corporations try to expand the market for their products by finding new audiences at a global level. This offers increased opportunities for profit. They also try to establish themselves as media providers in new locations.

2 Media organizations invest heavily in developing infrastructure that enables global communication. This enables more general globalization processes but it also helps the media industries to target new markets.

3 The media shape how people interpret and understand other places and other people. As more people consume more of the same media texts, there is the potential for people across

the world to share common meanings and values. However, many people worry about *whose* meanings and values circulate in these texts.

These ideas touch on issues that you have already explored in this book. First, they raise ideas about the activities of media industries and the ways in which they are organized around making profits. Second, they highlight questions about whether – and how – the media industries should be regulated. Finally, they return you to issues about ideology and the power of the media to define how people understand the world.

Key idea

Media industries attempt to globalize their activities as they pursue new markets to increase profits.

Spotlight: Global media events

For those with access, there are some media events that happen on a global scale. The same media images are transmitted simultaneously across the world and bring together global audiences. Examples include major sporting events such as the Olympic Games. News events can also create a global audience On September 11, 2001 an estimated 500 million people watched together in real time as a second plane crashed into the World Trade Centre in New York.

Cultural imperialism

Many researchers view the globalization of media as a form of cultural imperialism. They argue that cultural imperialism is a process through which Western media and Western values become increasingly dominant across the world.

Theories of cultural imperialism explain the consequences of large Western media corporations becoming more powerful at a global level. These corporations aim to strengthen their economic power – and increase their profits – by selling their

products in international markets. As you learned in Chapter Three, the concentration of media ownership in the hands of a small number of powerful companies reduces the diversity of media texts at a national level. As these large Western media corporations become dominant in international markets, they threaten the diversity of media texts across the globe by driving out some forms of local media production.

However, theories of cultural imperialism are not just concerned with the economic dominance of Western media companies but also highlight how Western culture becomes the dominant form of culture at a global level. As audiences across the world consume Western media texts, it is argued, they absorb Western values. As a result, Western values become the dominant global values.

Media conglomerates may be regarded as agents of imperialism where they exercise business practices in ways that suppress the viability of media in countries other than their own, or suppress the viability of smaller media in their own countries of origin so that the diversity and inclusiveness of creative voices and expression in the media are diminished or access to these voices is reduced.

Oliver Boyd-Barrett 2015: 14

Many researchers view cultural imperialism as a problem because:

1 Cultural imperialism enables Western nations to impose their economic and cultural power on non-Western nations.

2 Cultural imperialism makes the world's culture increasingly the same. Supporters of the cultural imperialism thesis argue that globalization homogenizes culture. The spread of Western media texts wipes out distinctive local and national cultures and produces a uniform global culture. This global culture is modelled on Western culture.

3 Some researchers argue that cultural imperialism is not just about Western dominance but, more specifically, about the increasing global dominance of the US. They view globalization as a form of Americanization.

For example, some researchers worry about the impact of the spread of US pop music. It's not just that people are listening to US pop across the globe, but also that musicians in other nations increasingly model their music on US music. American pop, researchers fear, has become global pop.

Herbert Schiller took these arguments further when he claimed 'the media are American'. He examined how US models of media industries were exported across the world. For Schiller, globalization involves the increasing dominance of systems of media production based on advertising revenue and organized around maximizing profit.

Key idea

Cultural imperialism is the idea that media globalization enables the West to increase its economic and cultural dominance by spreading Western values throughout the world.

Key idea

The cultural imperialism thesis claims that media globalization causes increasing homogenization and produces a standardized global culture.

Theories of cultural imperialism are useful because they highlight the power large media corporations exert at a global level. However, many researchers have questioned whether the idea of cultural imperialism is the most effective way of understanding globalization and the media. These criticisms include:

1 Some researchers question whether globalization does, in fact, produce a homogeneous global culture modelled on Western values.

2 Some researchers question whether media production is still dominated by the West and, in particular, by the US. As you will see later in the chapter, globalization does not simply involve a one-way flow of media texts from the West to everyone else.

Indeed, globalization is also seen as a threat within the US. For example, in the late 1980s some US commentators feared the Japanization of the US film industry following the purchase of some film studios by Japanese companies such as Sony.

3 There is substantial evidence to suggest that audiences in different local and national contexts do not passively absorb Western values in media texts. As you learned in Chapter Fourteen, audiences interpret and reject texts based on their existing values, knowledge and experiences.

4 Local, national and regional media institutions still play an important role in media production.

5 There are strenuous attempts to regulate the influence of foreign media on national cultures. For example, in Chapter Seven, you learned how some governments set limits on the number of imported programmes that could be broadcast on free-to-air television. Many countries have strategies to support local media production and to promote national identity through the media.

In the remainder of this chapter, you will examine alternative ways of understanding globalization that respond to some of these criticisms.

The internationalization of media industries

Many researchers question whether the concept of cultural imperialism can capture the complexity of contemporary media. They suggest that there is not a single 'global culture'. Instead, critics such as David Hesmondhalgh demonstrate that there is a complex relationship between national media cultures and international media flows.

The US is still a major exporter of media texts. If you turn on a TV or look at the listings pages for your local cinema, you will probably find a range of texts produced in the US. If you turn on the radio, you may hear a substantial number of tracks by US artists.

However, in many parts of the world, the most popular television programmes are those produced for regional or

national audiences. For example, despite their shared language, very few of the most-watched TV programmes in the UK are produced in the US. Hollywood movies dominate cinemas in countries such as the UK but the biggest grossing films in India are usually home-grown productions.

This isn't as straightforward as it first appears. Some 'national' television shows are produced by companies owned by large international conglomerates. TV series that appear to be home-grown may be based on formats developed elsewhere. For example, *MasterChef Australia* is based on a format first created in the UK. It is produced by Shine Australia, a company part-owned by the multinational media conglomerate 20th Century Fox.

Even some series that are not based on foreign formats are influenced by television programmes from elsewhere. Producers may develop local versions of international hits. For example, the Chinese TV series *Pink Ladies* closely resembles HBO's *Sex and the City* (Flew 2007). However, this influence is not just extended from the US to elsewhere. The hit US series *Homeland* is based on the Israeli series *Hatufim* and *Ugly Betty* was based on the Colombian series *Yo soy Betty la fea*.

Researchers who focus on the dominance of US media often neglect how media texts do not just flow from the US to the rest of the world. Hesmondhalgh (2013) argues that there are a number of important geocultural markets for media. These are nations or regions that share media texts because they are geographically close and/or share a common language or interests. These geographical markets have their own centres of media production.

Hesmondhalgh identifies a number of important geocultural markets for media texts. For example, Brazil and Mexico dominate media production in Latin America. Likewise, a range of television series and formats flow between East Asian countries. This challenges the idea that media exports inevitably promote Western values.

Similar challenges to the cultural imperialism thesis can be found in the film industries. For example, India is a major centre for film production. Most films shown in Indian cinemas are produced in India. Indeed, in 2010, more films were produced there than in

Hollywood. India exports films around the world, in particular to the Arabian Gulf, Indonesia and Russia. Hong Kong is another important centre for film production and makes movies that are exported to other East Asian countries and beyond.

Key idea

There are a number of geocultural markets for media texts. This challenges the idea that the US is the main producer of media texts for international markets.

> *Producers from outside the 'core' countries still only have limited access to global networks of cultural production and consumption. The USA's cultural industries remain remarkably dominant [...] Nevertheless, we should not underestimate the very real changes in the extent and complexity of international cultural flows.*
>
> David Hesmondhalgh 2013: 307

While Hesmondhalgh acknowledges that US media industries continue to have considerable power at an international level, he argues that we should not overestimate their influence. Globalization does not involve a simple one-way flow of Western media texts to the rest of the world. Alternative centres of media production in places such as Brazil, India and Hong Kong also have a significant international influence.

Spotlight: Al-Jazeera

Channels such as CNN and MTV have an international reach and are often used as examples of US dominance of the world media. In terms of news and information, Al-Jazeera provides a different viewpoint. The channel is funded by the Emir of Qatar but many people argue that its staff are relatively free to shape the content of the channel. It offers an an international alternative to Western news and focuses on the Arab world.

US cultural dominance and national media cultures

There is a complex relationship between US media industries and media production in different national contexts around the world. National media production often aims to combat US dominance and create home-grown media texts. At the same time, the way that texts are produced in other nations is often influenced by the US media industries. By examining the example of South Korean film production, you can learn about how these processes operate.

South Korean film production is frequently seen as a success story in the fight against the global dominance of Hollywood. Korea has witnessed a boom in film production and its films are popular with national audiences. Korea has also become a successful exporter of movies, especially to other Asian countries (Flew 2007).

While South Korean cinema provides an example of resistance to the dominance of Hollywood, it is important not to overstate the extent of this resistance. Nikki J.Y. Lee (2011: 49) highlights how resistance to Hollywood has been used as a successful marketing tactic. Promotional materials invited audiences to 'Support Korean movies against the invasion of Hollywood'.

At the same time, she argues, the Korean film industry uses production, distribution and exhibition practices that are similar to those of Hollywood. Many Korean films are designed as spectacular blockbusters. They deal with stories that are meaningful to local audiences but use the same types of techniques, genres and visual styles as Hollywood blockbusters.

For Lee, Korean blockbusters demonstrate 'social and economic responses to anxieties over globalization'. These films try to 'emulate Hollywood movies' while offering 'a fantasy of local resistance to Hollywood' (p. 53). The case of South Korean cinema demonstrates the complex ways in which US media industries are both resisted and embraced in particular local contexts.

This demonstrates the importance of national responses to globalization. Many nations do not passively accept

globalization and foreign influence. They create policies to boost media production at a national level. They also attempt to regulate the circulation of 'foreign' media. However, national media production does not take place in a bubble. It is shaped by practices in international media industries.

Globalization, diversity and hybridity

You have already learned how some people argue that globalization produces a standardized and homogenous global culture. Wherever we travel, they argue, we are increasingly confronted by Starbucks' coffee and McDonald's burgers. Likewise, they claim, popular music in different countries increasingly sounds the same and television everywhere features the same genres, stories and formats.

However, many researchers challenge the idea that globalization produces homogeneity. They argue that globalization takes diverse media and cultural forms and transports them around the world. International flows of media enable a British teacher to listen to traditional Nigerian music and an Australian student to watch Al-Jazeera.

From this perspective, globalization is associated with deterritorialization. This means that culture and media are no longer just associated with a particular territory or nation. In contemporary society, things are no longer fixed in place.

Some researchers argue that this produces increasing diversity, not homogeneity. For example, in many towns and cities, globalization has produced a more diverse food culture. Walk down a British high street and you are likely to encounter Thai, Italian, Indian and Chinese restaurants where once you might have been faced with a limited range of choices about what to eat. Globalization has increased the diversity of the food on offer.

If you live in an English-speaking Western country, it is likely that online retailers and streaming services feature media texts from the US and your own country. However, if you

dig more deeply, you will probably find that many of these retailers and services offer media texts from a much wider range of places.

International flows of media and culture can be used to create new hybrid media forms. In Chapter Eleven, you learned how black British musicians drew on musical styles from the Caribbean and the US to create new forms of hybrid music such as grime. This music mixes elements from different regions of the globe. Likewise, young Turkish-Germans draw on elements of US rap, music from their Turkish cultural heritage, and their experience of growing up in Germany to produce a distinctive Turkish-German musical sound.

International versions of the same TV format often are seen as evidence of a standardized global culture. Sometimes media producers from different nations produce fairly faithful copies of the original. However, reality show formats are frequently adapted to examine issues that are important in a specific national context.

The activities of media audiences also challenge the idea that globalization produces standardization. Just because people consume US media texts in many national contexts, it does not mean that they absorb Western values. Media audiences interpret texts by drawing on the discourses and cultural frameworks that are important where they live.

This is effectively illustrated by studies of how audiences in different national contexts view US prime-time soap operas. Research by Tamar Liebes and Elihu Katz (1990) demonstrates that groups from different national and ethnic backgrounds interpreted the soap opera *Dallas* in very different ways. For example, Arab viewers were critical of the show's focus on decadent US lifestyles. These viewers did not passively absorb Western values but actively rejected them.

Key idea

Globalization can produce diversity because cultural and media forms are used in different ways in different places.

Spotlight: Mexico goes Morrissey

The international flow of media texts is sometimes unpredictable. The Smiths, a band from Manchester who were popular in the UK in the 1980s and 1990s, have today found a new audience among young Mexicans and Mexican-Americans. Many are devoted fans of the band's singer Morrissey. One explanation for his popularity is that the melodramatic themes of The Smiths' songs are common in Mexican music. Musicians such as Camilo Lara and bands such as Sweet and Tender Hooligans combine The Smiths' music with their Mexican musical heritage to produce new hybrid musical forms (Jonze 2015).

Migrants and media consumption

Globalization does not only involve the movement of ideas, texts and industries across the world. It also involves the movement of people. Media audiences are not necessarily fixed in place. This adds a further dimension to the ways in which Media Studies thinks about media and globalization.

Migrants contribute to international flows of media texts. They may use texts that remind them of their homeland. In the process, they diversify the range of media on offer in their new location. Shops sell international newspapers and magazines. Migrants and their descendants create new media for people who share a similar ethnic heritage. For example, in the UK newspapers such as *Asian Voice* target the South Asian community while *Polish Express* addresses the Polish community. Likewise, specialist radio stations serve different ethnic communities.

As you learned earlier in this book, the media play an important role in national life. Media forms such as radio and television invite audiences to participate in rituals of national life. This creates relationships between the daily life of people in their homes and the public life of the nation.

Migrants' media use complicates this association between media and place. Some migrants use media to maintain a connection to

distant homelands. For example, there are studies which show how South Asian migrants in the UK use media to maintain a sense of connection to a distant homeland.

These studies also demonstrate how migrants use media to teach their British-born children about South Asian culture. Some of these migrants use Indian films and Asian satellite channels to educate their children about their linguistic, cultural and religious heritage. However, these children often feel a greater sense of identification with British media (Gillespie 1995, Moores and Qureshi 2000).

Asu Aksoy and Kevin Robins (2000) studied how Turkish migrants in London used television. Many of these migrants were able watch Turkish TV in the UK at the same time as it was broadcast live in Turkey. This gave these migrants an opportunity to participate in the rituals of everyday life 'as if' they were still in their homeland. At the same time, television images did not magically transport them back to Turkey. Instead, it often increased their feelings of distance from their homeland.

Key idea

Migrants often use media to maintain a sense of connection to a distant homeland.

Case study: Migrants' changing relationships to media

How migrants interpret and use media texts is shaped by their location and experience. This is illustrated by Youna Kim's (2011) study of media use by young Chinese, Korean and Japanese women living in London.

Before moving to London, many of the women in her study enjoyed Western media. In particular, they were attracted to images of female freedom and independence in Western films and TV. While they knew these weren't accurate reflections of life in the West, the texts helped them imagine a new future that offered different

possibilities for themselves as women (Kim 2010). Western media were a resource that helped motivate them to travel.

However, once they moved to London, their media use changed. Everyday experiences of casual racism made them feel excluded in their new surroundings. British TV – which had once seemed to offer images of freedom – made them feel excluded too. It was 'too British' and didn't seem to address them.

Feeling like they didn't belong in Britain, the women turned to the Internet for a sense of identity and security. Through the Internet, they could read news and watch TV from back home and maintain networks with people with similar identities.

'Ethnic media' now played a crucial role in their lives. It offered these women 'a sense of belonging, self-esteem and confidence' (Kim 2011: 136). The media can be a vital resource for people trying to manage everyday life as a migrant.

In this chapter, you have learned how large media conglomerates help to shape international flows of media. Some people fear that this produces a homogeneous global culture that increasingly resembles US culture. However, there is significant evidence to suggest that globalization is a more complex process. The US is not the only important producer and exporter of media.

As media and people move around the globe, globalization can also increase diversity. Media audiences around the world may interpret and adapt media texts in different ways. Media texts from elsewhere can diversify national cultures and enable the creation of new hybrid forms.

However, many nations still attempt to regulate access to 'foreign' media. These regulations include quotas governing how many imported programmes can be shown on television and attempts to control which materials people can access on the Internet.

Dig deeper

Boyd-Barrett, Oliver (2015) *Media Imperialism*, London: Sage.

Flew, Terry (2007) *Understanding Global Media*, London: Palgrave Macmillan.

Hesmondhalgh, David (2013) *The Cultural Industries*, 3rd edition, London: Sage, Chapter Eight.

Kim, Youna (2011) Diasporic nationalism and the Media: Asian women on the move, *International Journal of Cultural Studies*, 14(2): 133–51.

Lee, Nikki J. Y. (2011) Localized globalization and a monster national: *The Host* and the South Korean film industry, *Cinema Journal*, 50(3): 45–61.

Fact-check

1 What is the primary reason large media corporations attempt to globalize their activities?

 a In order to promote tighter regulation of media production and distribution

 b In order to increase their profits by selling their products to new markets

 c In order to sell the American Dream to non-Western audiences

 d In order to promote increased diversity in media production

2 Which of the following is **not** associated with globalization?

 a Increasing opportunities for people to interact and communicate at an international level

 b Increasing interdependence between different nations

 c The sense that the distances between people are decreasing

 d Attempting to sell new media formats to other companies within national markets

3 Theories of cultural imperialism highlight:

 a How Western culture becomes dominant at a global level

 b The increasing importance of geocultural markets

 c How globalization creates increasing diversity

 d The central importance of South Korea in a global media marketplace

4 Which of the following ideas is most closely associated with theories of cultural imperialism?

 a Globalization enables the production of exciting hybrid media forms

 b Globalization offers people an increasingly diverse array of media texts to choose from

 c Globalization offers migrant groups new opportunities to communicate with people in their homeland

 d Globalization creates an increasingly standardized and homogeneous global culture

5 Which of the following is **not** a criticism of theories of cultural imperialism?

a Media texts do not just flow from the Western to non-Western nations

b In many nations, media regulation sets limits on the influence of foreign media

c Audiences in some national contexts reject the validity of texts that appear to promote Western values

d Globalization is best understood as a form of Americanization

6 Geocultural markets are:

a Shops that sell ethnic media in multicultural cities

b Nations or regions that share media texts because of their physical proximity or shared language

c Set up to ensure that the texts produced by the US media industries are sold throughout the world

d Mainly used in China in order to make local versions of global formats

7 In her study of South Korean cinema, Nikki J. Y. Lee argues that:

a Korean films are unpopular with South Korean audiences

b Many South Korean films have become box-office hits in the US

c The South Korean film industry creates distinctive movies that bear little resemblance to Hollywood films

d South Korean films emulate US films despite attempting to resist the domination of Hollywood

8 Which of the following best illustrates the argument that globalization produces increased diversity rather than homogeneity?

a The ability to buy Starbucks coffee in many places around the world

b The way in which audiences around the world passively absorb Western values when they watch US soap operas

c New hybrid musical styles that blend elements from a range of different cultures

d The ways in which films in many countries closely resemble Hollywood movies

A Quick Guide to Media Studies Assessments

Assessments can seem daunting in your first year of university. At school or college, you will have learned what is required if you want to do well in your assessments. When students start a degree course, they often panic because they don't know what is expected of them. If you are new to Media Studies – or have moved countries to study for a degree – assessments can seem even more scary or confusing.

This Guide aims to take the stress out of your first year assessments. It identifies some of the key characteristics of good student work in Media Studies and explains the key skills that your lecturers want you to demonstrate.

However, it's important to remember that there are different types of Media Studies degrees that emphasize different skills. Even within your degree course, different modules often focus on particular skills. This Guide is most relevant to media students in the UK. However, wherever you are studying, always make sure you also follow the advice offered by your own lecturers.

Demonstrate your learning

At a very basic level, your lecturers want to see what you have learned. This might sound obvious – and it is obvious! However, many students panic so much that they forget this basic step.

Your assessments are designed to test what you have learned in a module. Learning isn't just about absorbing information, it is

also about understanding ideas and developing skills. Therefore, it is crucial that the content of your assessment reflects *what* has been taught in the module, and *how* it has been taught. For example, if your lecturer has introduced you to political economy approaches to studying media industries, they want you to focus on political economy approaches. If you write an essay that focuses on business studies approaches, you wont be able to demonstrate your learning because you wont be able to show you've understood the ideas taught on the module.

However, this does not mean that your lecturer wants you to demonstrate *everything* you have learned in the module. Don't try to cram too much into a single assessment. Focus on the question and select material that helps you to answer that question. The ability to identify what is relevant – and irrelevant – is a key skill on many degree courses (see below).

How do you know what you should have learned? Most courses offer a wide range of guidance and you should make the most of it. These include:

▶ **Teaching:** Lectures and seminars introduce you to the crucial issues on a module. They highlight the approaches, concepts and research that your lecturers think are the most important. This should always be your starting point when approaching any assessment. Your assessments should never just reproduce your lecture notes because your lecturers want to know if you've understood what you've learned (see below).

▶ **Reading lists.** Most reading lists highlight the articles and chapters that your lecturers view as essential reading. Read these. If in doubt about what to read, ask your lecturer. If you've missed classes, key readings will help you to fill in gaps in your knowledge.

▶ **Assessment criteria.** Many modules have documents that tell you how you will be assessed. They highlight the particular skills that you need to demonstrate in order to pass an assessment.

▶ **Guidance on assessments.** Many lecturers will offer you additional guidance on assessments. This is vital information so do not ignore it.

▶ **Office hours.** If you don't know what is required of you – or you are struggling to get to grips with a particular idea – then sign up to see your lecturer or tutor. Many students think that asking for help makes them seem stupid. It doesn't. In fact, it's the smart thing to do.

The best way to demonstrate your learning is by showing that you have *understood* the ideas you've encountered on a particular module. The next section shows you how particular skills enable you to show you have understood the key issues.

Key Skills for Media Studies

Media Studies courses require you to demonstrate a range of skills. You may not have to demonstrate all these skills in a single assessment, but many essays will require you to use most of them at the same time. If you understand what these skills involve, you increase your chances of success.

▶ **Selecting relevant material.** You'll encounter a vast range of material on each module you take. By showing that you understand which ideas and information are relevant to a particular question or task, you start to demonstrate your understanding. Think carefully about the task or question that you've been set. Ask yourself which material is the most important? Use your notes and reading lists to help you to decide.

▶ **Explanation.** If you can explain ideas, you can demonstrate that you understand them. Explanation is one of the most important building blocks of most assessments but it is something that students often forget to do. An explanation focuses on *why* things happen or the *reasons* that people give to support a particular argument.

Some essay questions might explicitly ask you to explain an approach such as political economy or a process such as the

impact of the media on globalization. However, even when this isn't explicit, you are still usually required to construct explanations to show your understanding of ideas, concepts or approaches.

Some examples will help to demonstrate what this means in practice. If you introduce a concept such as 'media covergence' or 'vertical integration', you need to explain what these terms mean in order to show that you understand them. Likewise, you need to explain ideas you've encountered on your course. If you write 'Morley argues that men and women use television in different ways', this doesn't demonstrate that you have understood his ideas. You need to explain the reasoning behind Morley's argument and show that you have understood that the ways in which men and women use television are a result of the different social positions that men and women have in society (see Chapter 15).

Finally, you also need to explain your own ideas. If you write 'representations of female celebrities are sexist', you need to be prepared to explain *why* you think this is the case. This will help you to develop arguments (see below).

▶ **Applying ideas.** You can also demonstrate your understanding by applying the ideas you have learned to examples. This allows you show that you can use the theories and develop your own ideas. For example, after explaining key concepts from semiotics, you can put them into practice by demonstrating how they can be used to analyze a particular advert. This will help you to develop your analytical skills.

▶ **Analysis.** 'Too descriptive'. 'Not analytical'. These are typical comments made by tutors on Media Studies assessments. But what do they mean?

Analysis is crucial to Media Studies. Analysis requires you to make sense of something and explain what it means. It involves picking apart an advert, a TV show or a theory, explaining how it works and identifying what is *significant* about it.

A description of a news story may, for example, tell the reader about the information contained in the story. An

analysis examines how the story is constructed and what is significant about the way it is constructed. For example, an analysis of a press report about refugees might identify how the type of language used to describe refugees represents them as a threat to the nation.

This may sound daunting, but the theories you learn in Media Studies make it a lot easier to do your own analysis. You can *apply* ideas you've learned to analyze how things work.

► **Thinking critically.** Being critical isn't the same as being negative. By questioning ideas we discover which ones work as well as which ones don't work. By thinking critically, you learn to question, challenge and evaluate arguments and evidence. Your lecturers are looking for students who do not simply accept what they are told – either in a news report or a Media Studies book – but who can question ideas to see if they stand up to closer scrutiny.

► **Research.** Many students find that one of the biggest challenges they encounter when they start a degree is that they are expected to do their own research. Degree students are not just expected to attend classes but they are also expected to work independently. As a result, your assessments will test your ability to do your own research.

This is not as intimidating as it initially sounds. Many assessments simply demand that you research your topic by reading about it. Remember, you will be given advice on where to start in the form of your reading list. This is always the most important reading you can do. But remember as well, that you need to select the most relevant material from your research to put in your assessment. Don't put something in if it doesn't fit just to prove you have read it.

It's crucial that you use a range of sources. This enables you to see how there are different perspectives on the same issue. By highlighting the differences between arguments on a particular topic, you can demonstrate how you've really understood the issues. If you can evaluate these different perspectives and make an argument for which is the most

convincing, you should start to produce work that is of a high standard.

You are also researching the media as you go about your everyday life. Think about how the ideas you are learning intersect with what you observe. If you spot something relevant, you can use this knowledge to illustrate ideas in your assessments.

Some assessments require you to carry out other forms of research such as watching a particular group of films or carrying out interviews. If you do not know what is required of you, always ask your tutor.

▶ **Argument.** Degree students do not just have to explain, analyze and think critically. They also need to have a point of view on the material they are discussing. This also helps to demonstrate your understanding of the ideas you've encountered and to take a position in relation to the question.

Your argument should give your point of view but you need to be able to back up this viewpoint. You can do this by selecting ideas and theories that support your case and by using other forms of evidence.

This is where an argument differs from an opinion. When we express our point of view as an opinion, we don't need to back it up. We can just make a statement such as 'The media are all right wing' or 'The media control how people think'. You don't need to have studied the media to do this: lots of people have an opinion on the media.

Constructing an argument is more difficult. You need to be able to justify your point of view by selecting ideas and evidence that back it up. You should also engage with counter-arguments – viewpoints that are different to your own – to demonstrate why your argument is the most effective way of seeing things.

▶ **Communication.** You need to express your ideas clearly so that your lecturers understand what you are trying to say. Some students get demoralized because they devote lots

of time to their assessments, only to find that they can't communicate what they've learned.

Most universities have a team of staff who are devoted to helping students to develop these skills. Take advantage of these services. Many students find that their grades improve significantly when they get help with their writing skills.

► Referencing. All degree courses require you to reference your essays. There is not space here to discuss referencing in any detail but it is a crucial part of your coursework. Make sure you have guidelines on referencing from your university before embarking on any coursework.

If you have any concerns about what these skills involve, then don't panic. Your university will offer help. Sign up for 'study skills' sessions that offer invaluable advice on how to improve your work.

The best way to reduce the stress of assessments – and even begin to enjoy them – is to plan ahead. Give yourself time to research, write and revise your ideas. Give yourself time to get help if there is something that you don't understand. Good luck with your studies.

References

Adorno, T. and Horkheimer, M. (1997) *Dialectic of Enlightenment*, London: Verso.

Aksoy, A. and Robins, K. (2000) Thinking across spaces: Transnational television from Turkey, *European Journal of Cultural Studies*, 3(3): 343–65.

Alexander, S. (2003) Stylish hard bodies: Branded masculinity. In *Men's Health* magazine, *Sociological Perspectives*, 46(4): 535–54.

Allagui, I. and Kuebler, J. (2011) The Arab Spring and the role of ICTs, *International Journal of Communication*, 5: 1435–42.

Anderson, B. (1991) *Imagined Communities: Reflections on the origins and spread of nationalism*, revised edition, London: Verso.

Bailey, M. (2009) Editor's introduction. In M. Bailey, ed., *Narrating Media History*, London: Routledge.

Banks, M. (2007) *The Politics of Cultural Work*, Basingstoke: Palgrave Macmillan.

Barker, C. (2012) *Cultural Studies: Theory and practice*, 4th edition, London: Sage.

Barker, M. and Petley, J. (2001) Introduction: From bad research to good – a guide for the perplexed. In M. Barker and J. Petley, eds, *Ill Effects: The media/violence debate*, London: Routledge.

Barthes, R. (1977) *Image, Music, Text*, London: Fontana.

Barthes, R. (1972) *Mythologies*, London: Paladin.

Bartky, S. (2002) Suffering to be beautiful. In C. Mui and J. Murphy, eds, *Gender Struggles*, New York: Rowman and Littlefield.

Beaumont-Thomas, B. (2014) Hollywood criticized for negative portrayal of LGBT characters, *The Guardian*, July 23. [Accessed July 2, 2015: http://www.theguardian.com/film/2014/jul/23/hollywood-criticised-lgbt-gay-characters-glaad]

Berker, T., Hartmann, M., Punie, Y. and Ward, K. (2006) Introduction. In T. Berker, M. Hartmann, Y. Punie and K. Ward, eds, *Domestication of Media and Technology*, Maidenhead: Open University Press.

Beynon, W. (2014) Great British Bake Off: When iced buns meet intellectual property, *The Guardian*, October 1. [Accessed March 9, 2015: http://www.theguardian.com/media-network/media-network-blog/2014/oct/01/great-british-bake-off-intellectual-property-rights]

Bignell, J. (2013) *An Introduction to Television Studies*, 3rd edition, London; Routledge.

Bignell, J. (2002) *Media Semiotics*, 2nd edition, Manchester: Manchester University Press.

Born, G. (2004) *Uncertain Vision: Birt, Dyke and the reinvention of the BBC*, London: Secker and Warburg.

Boyd-Barrett, O. (2015) *Media Imperialism*, London: Sage.

Branston, G. and Stafford, R. (2010) *The Media Student's Book*, 5th Edition, London: Routledge.

Brunsdon, C. (1981) *Crossroads*: Notes on a soap opera, *Screen*, 22(4): 32–7.

Bryce, J., Rutter, J. and Sullivan, C. (2006) Digital games and gender. In J. Rutter and J. Bryce, eds, *Understanding Digital Games*, London: Sage.

Buckingham, D. (2000) *After the Death of Childhood*, Cambridge: Polity.

Bull, M. (2005) No Dead Air! The iPod and the culture of mobile listening, *Leisure Studies*, 24(4): 343–55.

Cammaerts, B. (2015) Did Britain's right-wing newspapers win the election for the Tories? *LSE British Politics and Policy*, May 13. [Accessed August 4, 2015: http://blogs.lse.ac.uk/politicsandpolicy/did-britains-right-wing-newspapers-win-the-election-for-the-tories/]

Campbell, W. J. (2011) The Halloween myth of the War of the Worlds Panic, *BBC Magazine*, October 30. [Accessed June 12, 2015: http://www.bbc.co.uk/news/magazine-15470903]

Chandran, R. (2015) Thanksgiving celebrations have nothing on Chinese New Year, *BloombergBusiness*, February 17. [Accessed August 3, 2015: http://www.bloomberg.com/news/articles/2015-02-17/thanksgiving-has-nothing-on-the-chinese-new-year-three-charts]

Comcast (2015) Company overview. [Accessed July 22, 2015: http://corporate.comcast.com/news-information/company-overview]

Croteau, D. R. and Hoynes, W. D. (2014) *Media/Society: Industries, images and audiences*, 5th edition, London: Sage.

Curran, J. (2013) Mickey Mouse squeaks back: Defending media studies, *Three-D*, 20. [Accessed April 17, 2015: http://www.meccsa.org.uk/news/mickey-mouse-squeaks-back-defending-media-studies/]

Curran, J. (2010) Media reform: Democratic choices. In J. Curran and J. Seaton, *Power Without Responsibility*, 7th edition, London: Routledge.

Curran, J. (2002) The sociology of the Press. In A. Briggs and P. Cobley, eds, *The Media: An introduction*, Harlow: Pearson.

Curran, J. and Seaton, J. (2010) *Power Without Responsibility: Press, broadcasting and the internet in Britain*, 7th Edition, Abingdon: Routledge.

Dimbleby, R. and Burton, G. (1998) *More Than Words: An introduction to communication*, 3rd edition, London: Routledge.

du Gay, P. (1996) *Consumption and Identity at Work*, London: Sage.

du Gay, P., Hall, S., Janes, L., Koed Madsen, A., Mackay, H., and Negus, K. (2013) *Doing Cultural Studies: The story of the Sony Walkman*, London: Sage.

Elliott, C. (2012) The Readers' editor on… the switch to a 'nesting' system on comments threads, *The Guardian*, December 23. [Accessed March 12, 2015: http://www.theguardian.com/commentisfree/2012/dec/23/switch-nesting-system-comment-threads]

Fiske, J. (2010) *Introduction to Communication Studies*, 3rd edition, London: Sage.

Flew, T. (2014) *New Media*, 4th edition, Oxford: Oxford University Press.

Flew, T. (2007) *Understanding Global Media*, New York: Palgrave.

Foucault, M. (1998) *The History of Sexuality: Volume 1*, Harmondsworth: Penguin.

Freedman, D. (2015) The resilience of TV and its implications for media policy. In K. Oakley and J. O'Connor, eds, *The Routledge Companion to the Cultural Industries*, Abingdon: Routledge.

Freedman, D. (2012) Web 2.0 and the death of the blockbuster economy. In J. Curran, N. Fenton and D. Freedman, eds, *Misunderstanding the Internet*, Abingdon: Routledge.

Freedman, D. (2008) *The Politics of Media Policy*, Cambridge: Polity.

Frith, S. (1986) Art Versus Technology: The strange case of popular music, *Media, Culture and Society*, 8: 263–79.

Fuchs, C. (2012) Critique of the political economy of Web 2.0 surveillance. In C. Fuchs, K. Boersma, A. Albrechtslund and M. Sandoval, eds, *Internet and Surveillance: The challenges of Web 2.0 and Social Media*, New York: Routledge.

Garnham, N. (1990) *Capitalism and Communication: Global culture and the economics of information*, London: Sage.

Garnham, N. (1987) Concepts of culture: Public policy and the cultural industries, *Cultural Studies*, 1(1): 23–37.

Geraghty, C. (1991) *Women and Soap Opera*, Cambridge: Polity.

Gill, R. (2007a) *Gender and the Media*, Cambridge: Polity.

Gill, R. (2007b) Postfeminist media culture: Elements of a sensibility, *European Journal of Cultural Studies*, 10(2): 147–66.

Gillespie, M. (1995) *Television, Ethnicity and Cultural Change*, London: Routledge.

Gilroy, P. (1987) *There Ain't No Black in the Union Jack: The cultural politics of race and nation*, London: Hutchinson.

Habermas, J. (2006) The public sphere: An encyclopedia article. In M. G. Durham and D. M. Kellner, eds, *Media and Cultural Studies: Keyworks*, Oxford: Blackwell.

Hall, S. (1997) The Spectacle of the 'Other'. In S. Hall, ed., *Representation: Cultural representations and signifying practices*, London: Sage.

Hall, S. (1993) Encoding/Decoding. In S. During, ed., *The Cultural Studies Reader*, London: Routledge.

Hall, S., Critcher, C., Jefferson, T., Clarke, J. and Roberts, B. (1978) *Policing the Crisis: Mugging, the state and law and order*, London: Macmillan.

Hesmondhalgh, D. (2013) *The Cultural Industries*, London: Sage.

Hesmondhalgh, D. (2010) Media industry studies, media production studies. In J. Curran (ed.) *Media and Society*, 5th edition, London: Bloomsbury.

Hesmondhalgh, D. and Baker, S. (2011) *Creative Labour: Media work in three cultural industries*, Abingdon: Routledge.

Hill, J. (1986) *Sex, Class and Realism: British cinema 1956–63*, London: BFI.

Hills, M. (2002) *Fan Cultures*, London: Routledge.

Hindman, M. (2009) *The Myth of Digital Democracy*, Princeton, NJ: Princeton University Press.

Hobson, D. (1980) Housewives and the mass media. In S. Hall, D. Hobson, A. Lowe and P. Willis, eds, *Culture, Media, Language*, London: Hutchinson.

Hodkinson, P. (2011) *Media, Culture and Society: An introduction*, London: Sage.

Holloway, D., Green, L. and Livingstone, S. (2013) Zero to eight: Young children and their Internet use, *EU Kids Online/ London School of Economics*. [Accessed August 22, 2015: http://eprints.lse.ac.uk/52630/1/Zero_to_eight.pdf]

Ingraham, C. (2008) *White Weddings: Romancing heterosexuality in popular culture*, 2nd edition, New York: Routledge.

Ingraham, C. (2005) Introduction: Thinking straight. In C. Ingraham, ed. *Thinking Straight: The power, the promise, and the paradox of heterosexuality*. Abingdon: Routledge.

ITU (2014) *ICT Facts and Figures*. [Accessed July 30, 2015: http://www.itu.int/en/ITU-D/Statistics/Documents/facts/ ICTFactsFigures2014-e.pdf]

Jackson, J. (2015) Children spending less time in front of the television as they turn to online media, *The Guardian*, August 6. [Accessed October 2, 2015: http://www.theguardian.com/ media/2015/aug/06/children-spending-less-time-in-front-of-tv-ofcom]

Jackson, P. (1993) Towards a cultural politics of consumption. In J. Bird, B. Curtis, T. Putnam, G. Robertson, and L. Tickner, eds, *Mapping the Futures: Local cultures, global change*, London: Routledge.

Jackson, P., Stevenson, N. and Brooks, K. (2001), *Making Sense of Men's Magazines*, Cambridge: Polity.

Jancovich, M. (2010) 'Two Ways of Looking': The critical reception of 1940s horror, *Cinema Journal*, 49(3): 45–66.

Jenkins, H. (2006) *Convergence Culture: Where old and new media collide*, New York: New York University Press.

Jenkins, H. (2003) Interactive audiences? In D. Harries, ed., *The New Media Book*, London: BFI.

Jenkins, H. (1992) *Textual Poachers: Television fans and participatory culture*, New York: Routledge.

Jenson, J. (1992) Fandom as pathology: The consequences of characterization. In L. Lewis, ed., *The Adoring Audience*, London: Routledge.

Jonze, T. (2015) Heaven knows I'm Mexican now, *The Guardian*, April 23. [Accessed June 5, 2015: http://www. theguardian.com/music/2015/apr/23/morrissey-mexrissey-latino-remix-heaven-knows-im-mexican-now-]

Keogh, B. (2015) Between Triple-A, Indie, Casual, and DIY: sites of tension in the videogames cultural industries, K. Oakley and J. O'Connor, eds, *The Routledge Companion to the Cultural Industries*, Abingdon: Routledge.

Kim, Y. (2011) Diasporic nationalism and the media: Asian women on the move, *International Journal of Cultural Studies*, 14(2): 133–51.

Kim, Y. (2010) Female individualization? Transnational mobility and media consumption of Asian women, *Media, Culture and Society*, 32(1): 25–43.

Krinsky, C. (2013) The moral panic concept. In C. Krinsky, ed., *The Ashgate Research Companion to Moral Panics*, Farnham: Ashgate.

Kuhn, A. (2001) British Board of Film Censors/Classification. In D. Jones, ed., *Censorship: A world encyclopedia*, London: Fitzroy Dearborn.

Lally, E. (2002) *At Home with Computers*, Oxford: Berg.

Lee, N. J. Y. (2011) Localized globalization and a monster national: *The Host* and the South Korean Film Industry, *Cinema Journal*, 50(3): 45–61.

Liebes, T. and Katz, E. (1990) *The Export of Meaning: Cross cultural readings of Dallas*, Cambridge: Polity.

Lim, S. S. (2014) Women, 'double work' and mobile media: The more things change, the more they stay the same. In G. Goggin and L. Hjorth, eds, *Routledge Companion to Mobile Media*, Abingdon: Routledge.

Lister, M., Dovey, J., Giddings, S., Grant, I. and Kelly, K. (2009) *New Media: A critical introduction*, 2nd edition, Abingdon: Routledge.

Livingstone, S. (2007) From family television to bedroom culture: Young people's media at home. In E. Devereux, ed., *Media Studies: Key issues and debates*, London: Sage.

Livingstone, S. (2005) Media audiences, interpreters and users. In M. Gillespie, ed., *Media Audiences*, Maidenhead: Open University Press.

Livingstone, S. and Das, R. (2013) The end of audiences? Theoretical echoes of reception amid the uncertainties of use. In J. Hartley, J. Burgess and A. Bruns, eds, *A Companion to New Media Dynamics*, Oxford: Wiley-Blackwell.

Livingstone, S. and Lunt, P. (1994) *Talk on Television: Audience participation and public debate*, London: Routledge.

Lunt, P. and Livingstone, S. (2012) *Media Regulation: Governance and the interests on citizens and consumers*, London: Sage.

Lynskey, D. (2011) The great rock'n'roll sellout, *The Guardian*, June 30. [Accessed October 2, 2014: http://www.theguardian.com/music/2011/jun/30/rocknroll-sellout]

Mackay, H. (2004) New connections, familiar settings: Issues in the ethnographic study of new media use at home. In C. Hines, ed., *Virtual Methods: Issues in social research on the Internet*, Oxford: Berg.

Martin, K. A. and Kazyak, E. (2009) Hetero-romantic love and heterosexiness in children's G-rated films, *Gender and Society*, 23(3): 315–36.

Marx, K. (2000) The German ideology. In D. McLellan, ed., *Karl Marx: Selected writings*, Oxford: Oxford University Press.

McRobbie, A. (1997) *More!* New sexualities in girls' and women's magazines. In A. McRobbie, ed., *Back to Reality? Social experience and cultural studies*, Manchester: Manchester University Press.

McRobbie A. (1991) *Feminism and Youth Culture: From Jackie to Just Seventeen*, Basingstoke: Macmillan.

Mehta, M. (2005) Globalizing Bombay cinema: Reproducing the Indian state and family, *Cultural Dynamics*, 17(2): 135–54.

Messenger Davies, M. (2010) *Children, Media and Culture*, Maidenhead: Open University Press.

Mittell, J. (2001) A cultural approach to television genre theory, *Cinema Journal*, 40(3): 3–24.

Moores, S. (2000) *Media and Everyday Life in Modern Society*, Edinburgh: Edinburgh University Press.

Moores, S. and Qureshi, K. (2000) Identity, tradition and translation. In S. Moores, ed., *Media and Everyday Life in Modern Society*, Edinburgh: Edinburgh University Press.

Moran, J. (2013) *Armchair Nation: An intimate history of Britain in front of the TV*, London: Profile.

Morley, D. (1992) *Television, Audiences and Cultural Studies*, London: Routledge.

Morley, D. (1986) *Family Television: Cultural power and domestic leisure*, London: Comedia.

Morley, D. and Brunsdon, C. (1999) *The Nationwide Television Studies*, London: Routledge.

Mulvey, L. (1981) Visual pleasure and narrative cinema. In T. Bennett, Susan Boyd-Bowman, Colin Mercer and Janet Woollacott, eds, *Popular Film and Television*, London: BFI.

Murdock, G. (1984) Figuring out the arguments. In M. Barker, ed., *The Video Nasties*, London: Pluto Press.

Murdock, G. and Golding, P. (1973) Towards a political economy of mass communications, *Socialist Register*, 10. [Accessed August 8, 2014: http://socialistregister.com/index.php/srv/article/view/5355/2256#.U-SvVIW0ZaE]

Neale, S. (2008) Studying genre. In G. Creeber, T. Miller and J. Tulloch, eds, *The Television Genre Book*, London: BFI.

Newman, J. (2013) *Videogames*, 2nd edition, Abingdon: Routledge.

Ofcom (2015) Half of smartphone users 'hooked' on their handset. [Accessed September 16, 2015: http://consumers. ofcom.org.uk/news/hooked-on-their-handset/]

Ofcom (2014a) The communications market report 2014. [Accessed July 30, 2015: http://stakeholders.ofcom.org.uk/ binaries/research/cmr/cmr14/2014_UK_CMR.pdf]

Ofcom (2014b) Adults' media use and attitudes report 2014. [Accessed September 11, 2015: http://stakeholders.ofcom.org. uk/binaries/research/media-literacy/adults-2014/2014_Adults_ report.pdf]

Ouellette, L. and Hay, J. (2008) Makeover television, governmentality and the good citizen, *Continuum*, 22(4): 471–84.

Philo, G. Briant, E. and Donald, P. (2013) *Bad News for Refugees*, London: Pluto.

Pimlott, W. (2014) Year abroad students join porn fans as victims of Germany's strict copyright laws, *Independent*, March 18. [Accessed May 12, 2015: http://www.independent.co.uk/ student/news/year-abroad-students-join-porn-fans-as-victims-of- germanys-strict-copyright-laws-9199554.html]

Press Gazette (2012) Ethnic minorities 'largely absent' from British media. [Accessed October 1, 2014: http://www. pressgazette.co.uk/node/48542]

Rose, T. (1994) *Black Noise: Rap music and black culture in contemporary America*, Hannover, NE: Wesleyan University Press.

Scannell, P. (2002) History, media and communication. In K. Bruhn Jensen, ed., *A Handbook of Media and Communication Research*, London: Routledge.

Scannell, P. (1997) Public service broadcasting and modern public life. In T. O'Sullivan and Y. Jewkes, eds, *The Media Studies Reader*, London: Arnold.

Screen Australia (2015) Audiovisual markets: Television, *Screen Australia*. [Accessed August 2, 2015: http://www.screenaustralia.gov.au/research/statistics/tvfreeregulation.aspx]

Select Committee on Communications (2015) *Women in News and Current Affairs Broadcasting*, London: House of Lords. [Accessed July 27, 2015: http://www.publications.parliament.uk/pa/ld201415/ldselect/ldcomuni/91/91.pdf]

Sender, K. and Sullivan, M. (2008) Epidemics of will, failures of self-esteem: Responding to fat bodies in *The Biggest Loser* and *What Not to Wear*, *Continuum*, 22: 573–84.

Sherwin, A. and Wright, O. (2015) Rupert Murdoch berated *Sun* journalists for not doing enough to attack Ed Miliband and stop him winning the general election, *Independent*, April 21. [Accessed July 22, 2015: http://www.independent.co.uk/news/media/rupert-murdoch-berated-sun-journalists-for-not-doing enough to attack-ed-miliband-10191005.html]

Silverstone, R. (1999) *Why Study the Media?* London: Sage.

Silverstone, R. (1994) *Television and Everyday Life*, London: Routledge.

Skeggs, B. and Wood, H. (2012) *Reacting to Reality Television: Performance, audience and value*, London: Routledge.

Smith, A. (2013) Statement of Aaron Smith – broadband adoption: The next mile, *Pew Research Center*. [Accessed on July 30, 2015: http://www.pewinternet.org/2013/10/29/statement-of-aaron-smith-broadband-adoption-the-next-mile/]

Spigel, L. (1992) *Make Room for TV: Television and the family ideal in Postwar America*, Chicago: Chicago University Press.

Sweney, M. and Kaiman, J. (2014) Chinese viewers in their millions captivated by Western television hits, *The Observer*, November 2. [Accessed August 3, 2015: http://www.theguardian.com/world/2014/nov/02/chinese-viewers-captivated-by-western-tv-hits]

Thompson, K. (1998) *Moral Panics*, London: Routledge.

Thornham, H. (2011) *Ethnographies of the Videogame: Gender, narrative and praxis*, Aldershot: Ashgate.

Tilley, A. C. (1991) Narrative. In D. Lusted, ed., *The Media Studies Book: A guide for teachers*, London: Routledge.

Tuchman, G. (1978) The symbolic annihilation of women by the mass media. In G. Tuchman, A. Kaplan Daniels, J. Benet, eds, *Hearth and Home: Images of women in the mass media*, New York: Oxford University Press.

Tyler, I. (2008) Chav mum, chav scum: Class disgust in contemporary Britain, *Feminist Media Studies*, 8: 17–34.

Ursell, G. (2006) Working in the media. In D. Hesmondhalgh, ed., *Media Production*, Maidenhead: Open University Press.

White, M. (2010) Clicktivism is ruining left activism. *The Guardian*, August 12. [Accessed March 13, 2015: http://www.theguardian.com/commentisfree/2010/aug/12/clicktivism-ruining-leftist-activism]

Williams, K. (2010) *Get Me a Murder a Day! A history of media and communication in Britain*, 2nd edition, London: Bloomsbury.

Williams, K. (2003) *Understanding Media Theory*, London: Bloomsbury.

Williams, R. (1966) *Communications*, London: Chatto and Windus.

Women Make Movies (2014) Film facts. [Accessed October 3, 2014: http://www.wmm.com/resources/film_facts.shtml]

Wood, M. and Baughman, L. (2012) *Glee* fandom and twitter: Something new, or more of the same old thing?, *Communication Studies*, 63(3): 328–44.

Fact-check: Answers

CHAPTER 2

1 c

2 c

3 a

4 a

5 b

6 d

7 a

8 b

9 b

CHAPTER 3

1 b

2 c

3 a

4 c

5 a

6 a

7 b

8 a

9 b

CHAPTER 4

1 a

2 c

3 c

4 b

5 a

6 d

7 c

8 b

9 d

CHAPTER 5

1 a

2 d

3 b

4 c

5 b

6 c

7 c

8 b

9 a

CHAPTER 6

1 b

2 a

3 c

4 b

5 d

6 a

7 c

CHAPTER 7

1 d

2 a

3 c

4 a

5 c

6 c

7 b

8 d

CHAPTER 8

1 c

2 c

3 a

4 b

5 a

6 d

7 a

8 d

9 c

10 a

CHAPTER 9

1 d

2 c

3 a

4 b

5 c

6 a

7 d

8 d

CHAPTER 10

1 d

2 a

3 c

4 c

5 a

6 c

7 d

8 b

9 c

CHAPTER 11

1 d

2 a

3 b

4 c

5 b

6 d

7 a

8 c

CHAPTER 12

1 d

2 a

3 c

4 c

5 d

6 c

CHAPTER 13

1 c

2 b

3 a

4 b

5 a

6 d

7 c

8 c

CHAPTER 14

1 c

2 a

3 d

4 a

5 c

6 d

7 d

CHAPTER 15

1 c

2 d

3 a

4 d

5 c

6 c

7 b

CHAPTER 16

1 b

2 d

3 c

4 b

5 d

6 a

CHAPTER 17

1 b

2 d

3 a

4 d

5 d

6 b

7 d

8 c

Index